ELIZABETH II

A QUEEN FOR OUR TIME

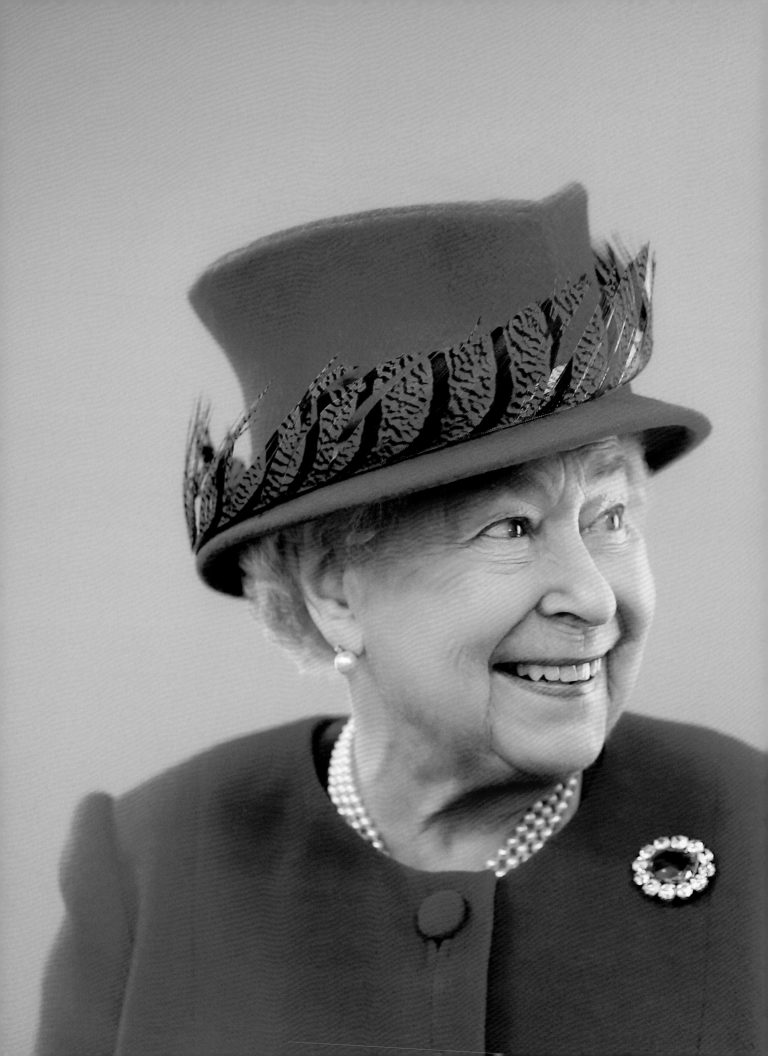

ELIZABETH II

A QUEEN FOR OUR TIME

PHOTOGRAPHY AND TEXT BY
CHRIS JACKSON

Rizzoli
NEW YORK

New York Paris London Milan

CONTENTS

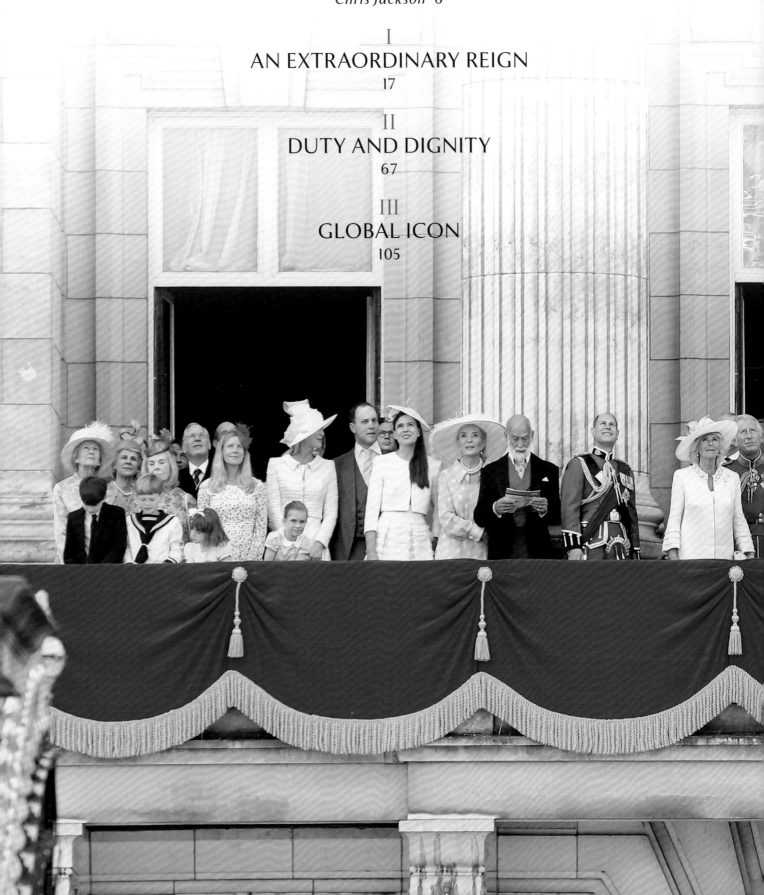

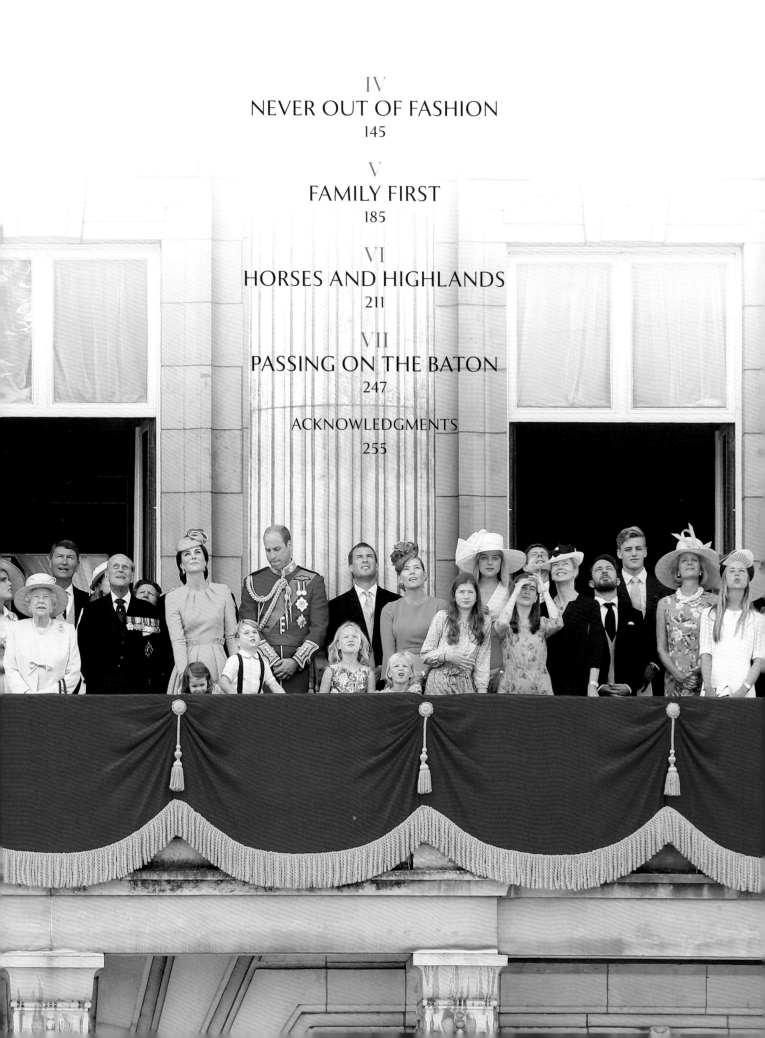

PHOTOGRAPHING THE QUEEN

For as long as many of us can remember, Queen Elizabeth II has been an omnipresent figurehead—an icon. As Head of the Commonwealth, she is respected and admired around the world in equal measure. Her stalwart presence has signalled stability, neutrality, and responsibility. The excitement I feel when I have the opportunity to photograph such a figure never diminishes. To this day, the irregularity of such opportunities makes every engagement all the more special. I still feel a certain weight of responsibility each time and undoubtedly a sense of nerves, which are essential to keep that edge to push the creative boundaries and not retreat into the comfort of routine.

Knowing that the Queen's appearances form part of the fabric of British royal history is especially exciting for a photographer. The banknote in my pocket features her portrait. The British public's psyche is built on the image of the monarch. "Iconic" seems almost an embarrassing understatement when discussing her impact in the world over the last century. If the light drops in the right way and it has that magic softness to it, and you are fortunate enough to capture an endearing or responsive expression, all at exactly the same moment, you have the potential to create an image that lives on in the public psyche for generations to come. It is the sense of anticipation, more often than not unfulfilled, that drives me on from engagement to engagement, in the constant search for something better. Above all, however, it is an honour to have the opportunity to document these moments, effectively acting as the eyes of the world at these engagements.

It seems like another age when I was developing black-and-white prints in the self-constructed "darkroom" of my student house at Cardiff University. My passion for photography somewhat eclipsed my dedication to the psychology and physiology degree in which I was enrolled, and most of my student loan was spent on film and photographic paper. I passed much of my time in between lectures in the poorly ventilated cellar poring

Pages 2–3
The Queen smiles as she meets people being supported by The Prince's Trust at the charity's centre in Kennington, London, in March 2016. This visit marked the fortieth anniversary of The Trust, one of the Prince of Wales's most successful endeavours. The charity has helped more than a million disadvantaged young people between the ages of eleven and thirty to get into education and employment.

Pages 4–5
Members of the royal family watch a traditional flypast from the balcony of Buckingham Palace as part of the Queen's Official Birthday celebrations, known as "Trooping the Colour." Trooping the Colour has marked the Official Birthday of the British sovereign for more than 260 years.

Above
Photographer Chris Jackson.

Opposite
Photographers capture the Red Arrows as they fly over Buckingham Palace during Trooping the Colour celebrations.

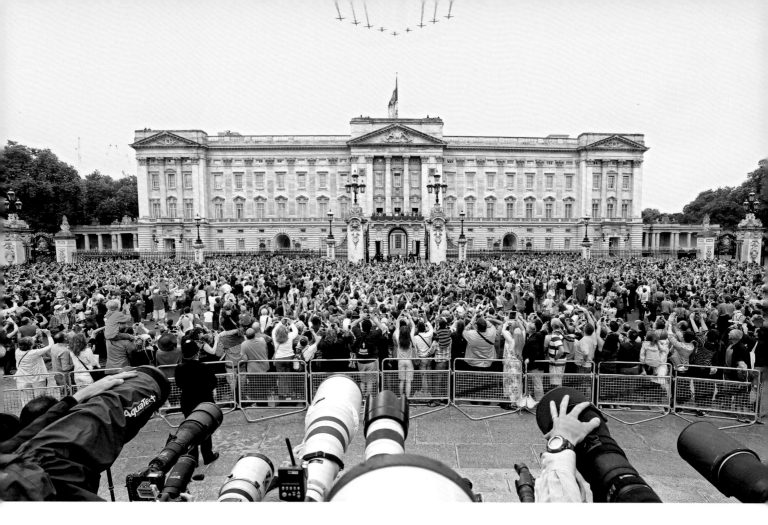

over the prints as they emerged during their mysterious development process, like ghosts appearing silently in the red light, as the chemicals worked their magic. As my flatmates stomped around upstairs, dust specks fell from the ancient ceiling of the previously derelict and unused space, landing like tiny black ants on the developing tray every time one of my fellow students arrived back from lectures, slamming the door behind them. Despite these challenges, it was these prosaic surroundings that ignited a lifelong passion for photography.

While I often marvel at how the advent of digital technology has changed the way photographers work, I have fond memories of that period and the process behind the creation of those images. It may not have had the immediacy of the technology on which today's photographer relies, but it certainly made up for it with the anticipation of the development process. At that time, fellow students and family formed my subjects. That first buzz of excitement on seeing my photographs on display around campus endures to this day whenever I see my images in print.

Fast forward two decades. As the royal photographer for Getty Images, I spend the majority of my time recording the daily official lives of the British royal family, a role that has developed organically over the years and led to a career that has taken me to more than a hundred countries around the world, and created a library of images featuring royal weddings, births, christenings, and so much more. I have had the privilege of photographing one of the world's most iconic and respected women. Not only have I documented the Queen on her everyday engagements—from the opening of a hospital, to school visits, and the multitude of ceremonial events that form the backbone of much of the royal year—but I have also documented royal tours around the world and family occasions. Taking official portrait photographs has been a huge honour and certainly the highlight of my career.

Each situation requires a different kind of photographic discipline and approach.

This combination of styles, techniques, and skills is something I have always found appealing in photographing the royal family. In this book, I endeavour to illustrate some of the Queen's personality—not only her famous resilience and dedication to duty, but also the warmth and humility behind the famously professional demeanour.

As you flick though these pages, you will not see every iconic image of the Queen. I look to photographers such as Dorothy Wilding, Marcus Adams, Sir Cecil Beaton, and Lord Snowdon with intense admiration, respect, and inspiration. The incredible stamina and endurance of the Queen have far outlasted any single photographer's career. It remains the duty of many photographers over the years to put across their representation of her life. The styles of these different photographers vary and often reflect the mood of the public and what society dictated at the time, as well as the technology available. For example, the switch to relaxed and candid images by photographers such as Lisa Sheridan, who made the Queen and royal family more accessible, was a significant change from the formal styles of the past and clearly resonated with the public.

My approach encompasses the formality dictated by the history and ceremony of many of today's royal engagements, but I also strive to record the relaxed informality that shows the humanity of the person too. In the modern era, the ability to produce a digital image and transmit it around the world in moments still never ceases to amaze me. Of course, when documenting a situation over which you have no control, an element of luck will always form a significant part of what you do. But bearing that in mind, the ease of capture takes nothing away from the need to *create* the image; composition, access, and light remain elusive. I chase all of these on a daily basis in the never-ending pursuit of the perfect image.

My humble and very personal journey of photographing the Queen for the last twenty years is presented here. Doubtless, you will recognise a huge number of the images—an example of the power of the media to disseminate photographs in printed and digital form to every corner of the globe. What is often untold are the endeavours that have gone into taking these photographs, the stories behind the images you see, as you browse the newspaper or your smartphone with your morning coffee. The Queen's unerring commitment to the role and position, her professionalism, and presence come across in many of the moments that are captured within.

Right
The Queen during a visit to Cyfarthfa High School, Merthyr, South Wales, in April 2012. The Queen and the Duke of Edinburgh visited the school as part of the Diamond Jubilee tour of the UK.

Pages 10–11
(Left) Wearing a distinctive yellow outfit, the Queen enters the parade ring in the royal carriage during Royal Ascot in June 2018.

(Right) The Queen laughs as she attends the Queen's Cup polo final at Guards Polo Club.

Pages 12–13
The Queen visits a new maternity ward at the Lister Hospital in Stevenage, Hertfordshire, in 2012. I love her expressions here as she took in the surroundings at the hospital and a wonderful soft light came in from above.

Pages 14–15
(Left) The Queen smiles as she leaves the Christmas Day service at Sandringham Church on 25 December 2009.

(Right) The Queen arrives at Holden Point to view the 2012 Olympic park in London, England.

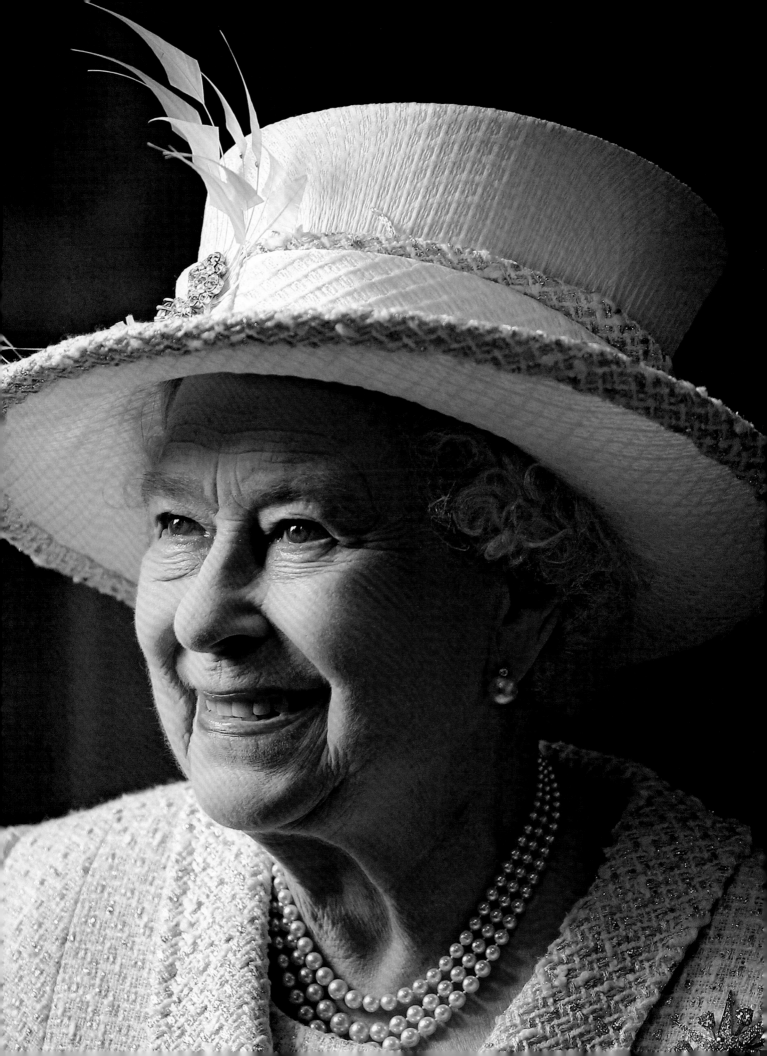

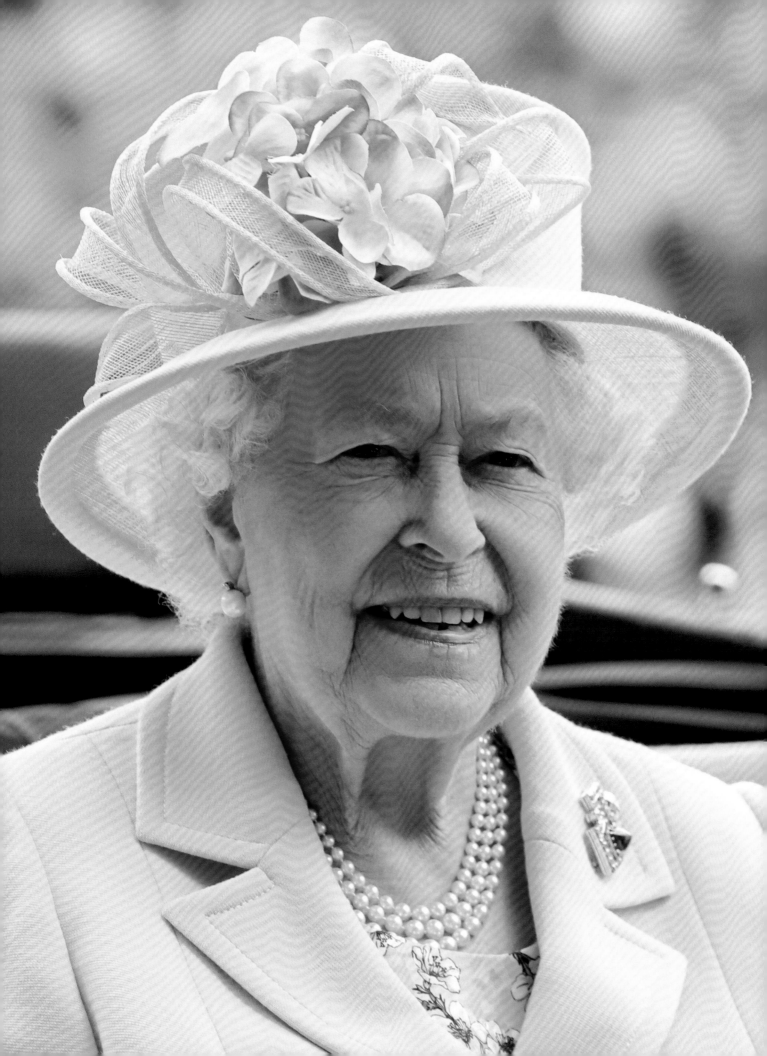

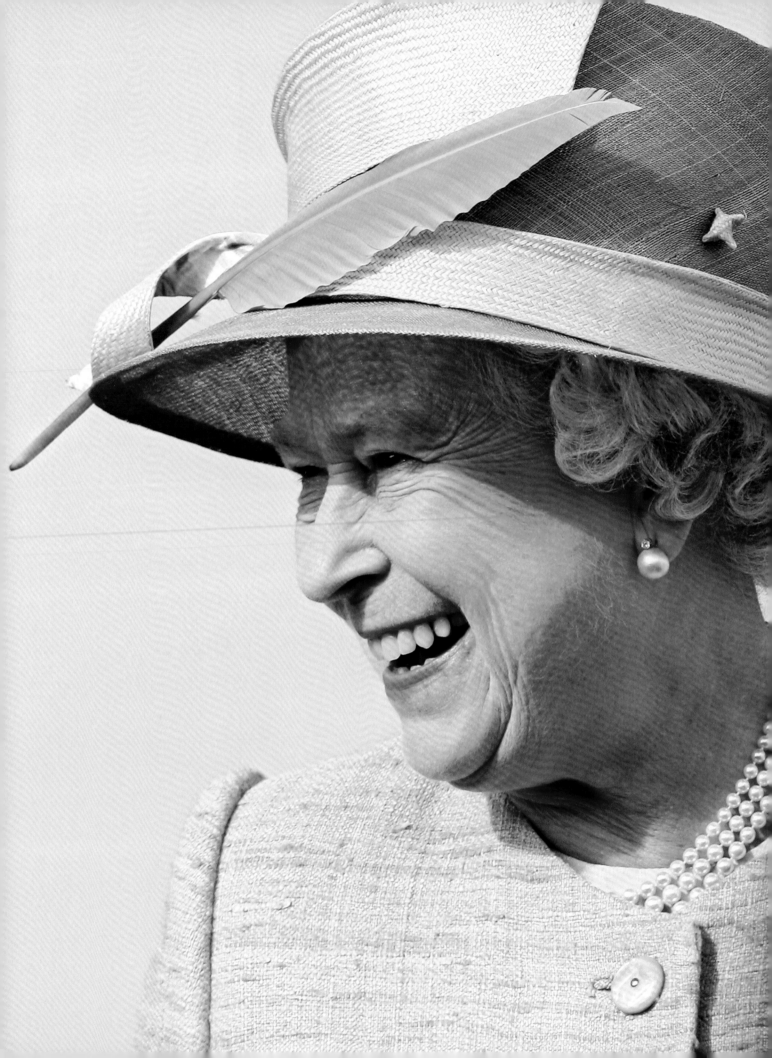

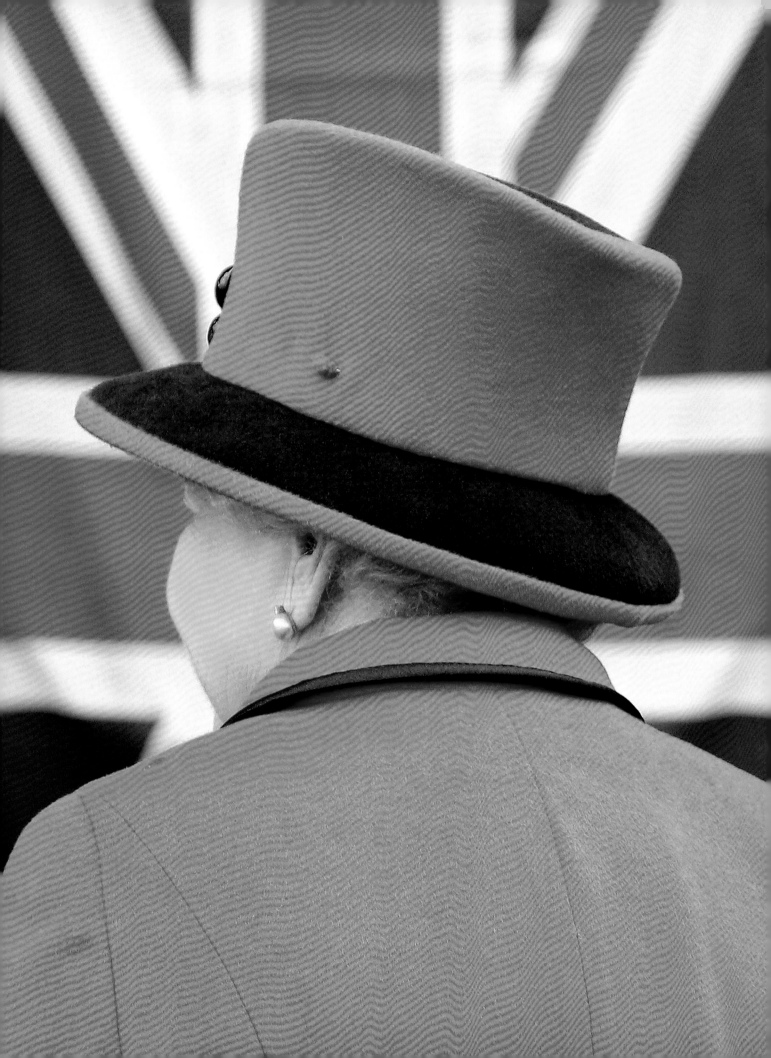

I

AN EXTRAORDINARY REIGN

The Queen is an integral part of the British identity. Many people around the United Kingdom, the Commonwealth, and the world do not remember life without her. Her presence feels comforting and reassuring, fostering an enduring sense of pride. As Queen of fifteen Commonwealth realms, her influence stretches far beyond the shores of the UK and encompasses more than 2.4 billion citizens. The Queen acts as monarch and head of state for each of the independent countries. This differs hugely from the situation she inherited on ascending the throne in 1952, when there were just seven states and a population of only 650 million.

As the Queen hands over her global travel responsibilities to the younger members of the royal family, we see her less frequently on the world stage while the focus on her domestic role has grown. The Queen once said, "I have to be seen to be believed." This philosophy remains key to her presence at events in the UK, many of which embody the very essence of Britishness. Some are regular occurrences dictated by tradition and the "royal diary," such as Commonwealth Day or Royal Ascot; others are one-off occasions, such as the Golden or Diamond Jubilees, weddings, christenings, and funerals. A constant throughout the following images is the celebration of all things British and what it means to be British. Many of the physical representations of the monarchy—the most famous being Buckingham Palace and Windsor Castle, where the Queen feels most at home—are also ingrained in the public psyche as timeless symbols of the enduring nature of British royalty. In this book you will also see my personal perspective, learn of some of the more peripheral moments, and read a little of what went into the making of each photograph.

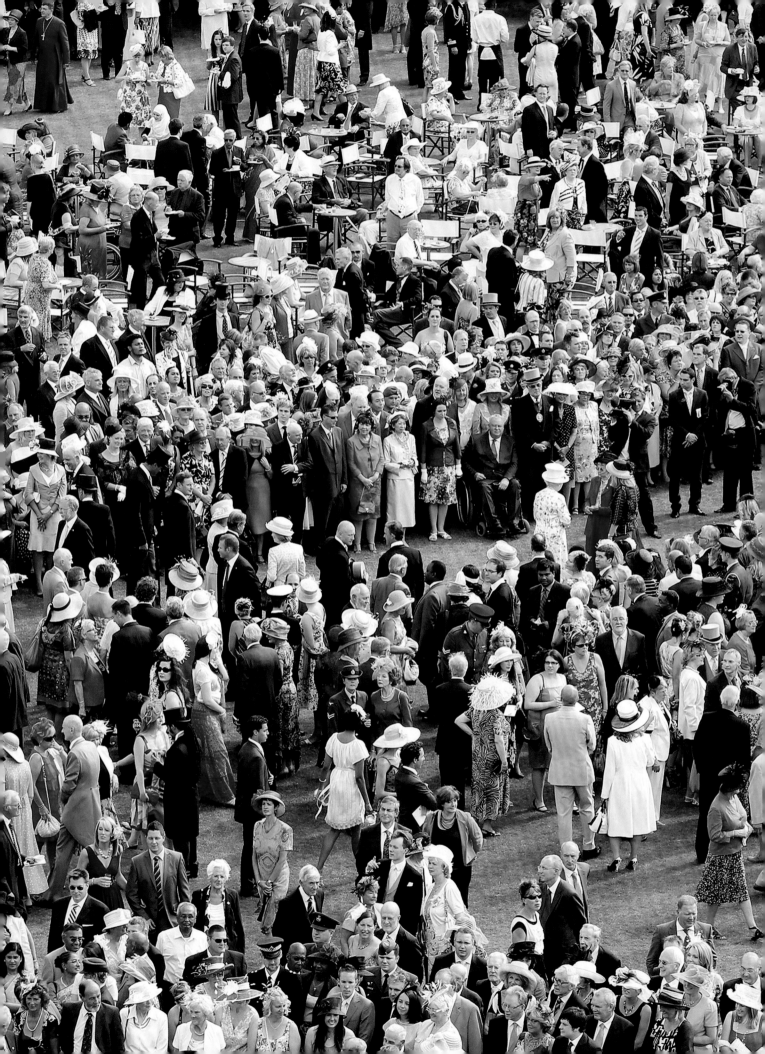

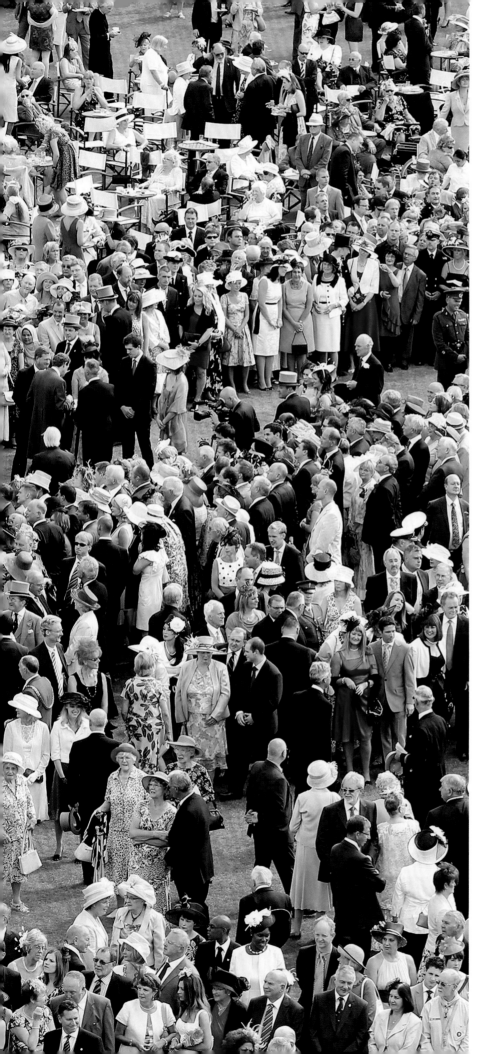

THE GARDEN PARTY

Each summer, the Queen hosts
three garden parties at Buckingham
Palace and one at the Palace of
Holyroodhouse in Edinburgh,
Scotland. These are grand affairs,
attended by thousands of members
of the public. They are generally
themed around charity or celebrate
a specific milestone. As the great
British weather dictates, umbrellas
are sometimes the most sought-after
fashion accessory on the day, but
when the sun shines, these parties can
be spectacular and uplifting events.

I have photographed the garden
parties from a number of different
positions, but it is this shot taken
from the roof of Buckingham Palace
that best conveys the feeling of the
occasion. On this particular day in
July 2010, I was ushered through a
labyrinth of lavishly decorated offices
and corridors to a tiny door onto the
roof of this iconic building. Rather
excitingly, it was here that Queen band
member, Brian May played "God Save
the Queen" on guitar to kick off the
Golden Jubilee concert in 2002.

This party at Buckingham Palace
in July was somewhat more restrained,
but nonetheless impressive. I watched
the Queen expertly negotiate the
guests—the crowds being parted like
some kind of biblical wave by the
Honourable Corps of Gentleman
at Arms. The view from my lofty
position gave a sense of the scale of
the proceedings, and despite there
being hundreds of people in the
image, the Queen is instantly visible.

Page 16
The Queen visits Sherborne Abbey, Dorset,
as part of her Diamond Jubilee tour of the UK
in 2012.

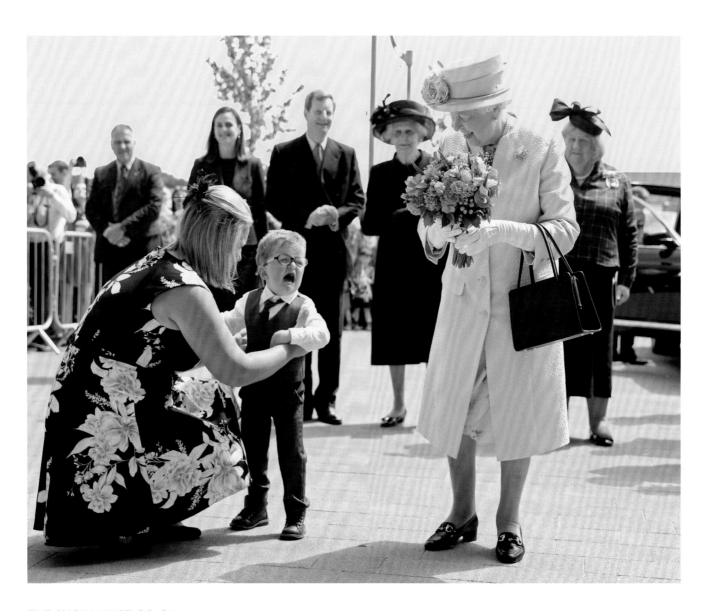

THE SHOW MUST GO ON

The saying goes "Never work with animals or children." The royals certainly work with their fair share of both, and things do not always go entirely to plan. The Queen and the Duke of Edinburgh were visiting Liverpool on 22 June, and had arrived at Alder Hey Children's Hospital to open it officially. The occasion was clearly overwhelming for two-year-old Lewis Connet, who burst into tears after presenting the Queen with flowers.

(Right) The Queen meets members of the public during a visit to Welshpool town centre, in North Wales, on 28 April 2010.

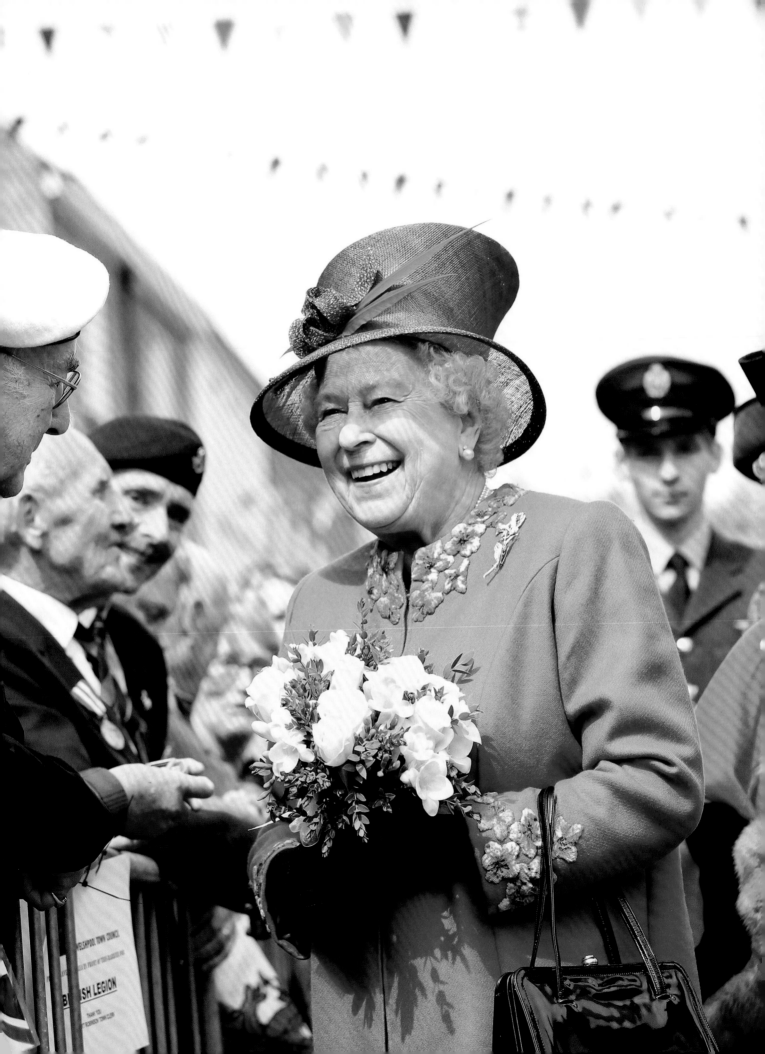

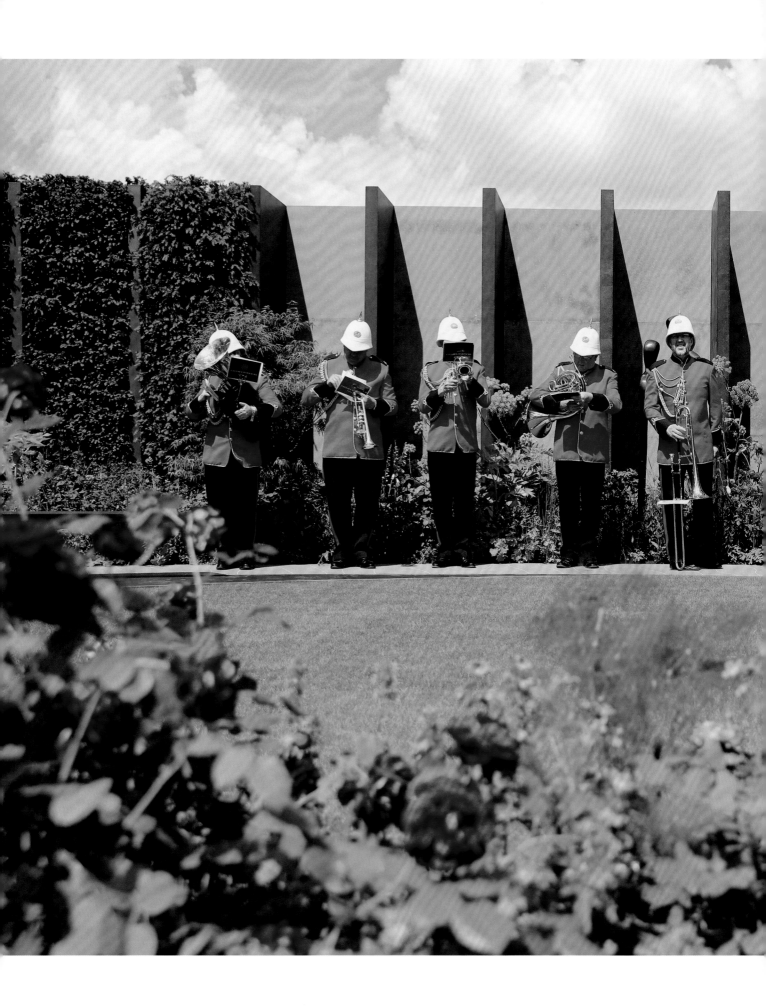

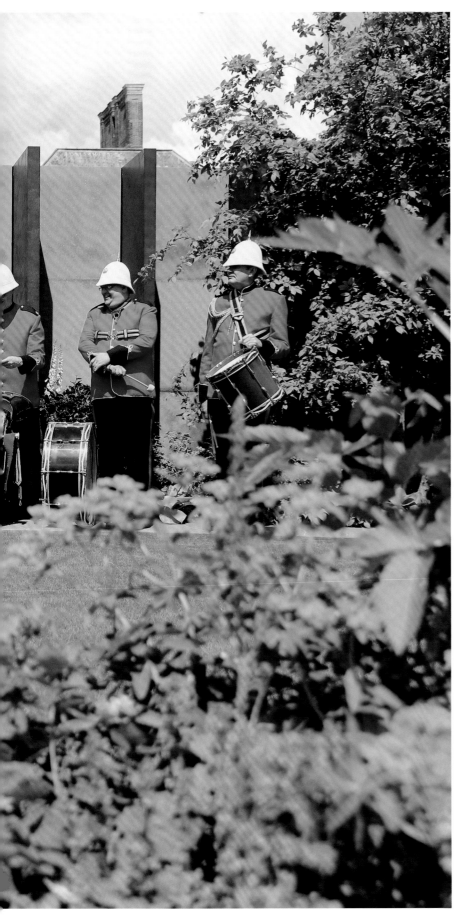

CHELSEA FLOWER SHOW

Every year, the Chelsea Flower Show lights up London. Vibrant displays captivate flower lovers and garden designers, who flock from around the world to attend the event. Traditionally, the royal family has an exclusive preview on the afternoon before the gates open to the public. The Queen was made patron of the Royal Horticultural Society in 1952 and has been visiting the flower show ever since.

On arrival, the royals generally split up to see as much of the show as possible. It is entirely chance that deems which member of the royal family I will be documenting. The Queen has long been an admirer of flowers, and her favourite bloom, Lily of the Valley, was included in her coronation bouquet. In 2016, she was honoured with a floral portrait by the designer Veevers Carter, titled *Behind Every Great Florist*. The dazzling display featured a profile representation of the monarch. In the photograph here, it can be seen framing a Chelsea Pensioner as he browses the show's designs. In 2020, during the coronavirus pandemic, the RHS Chelsea Flower Show went online for the first time.

A relaxed Queen Elizabeth in pastel pink visits the 2018 Royal Horticultural Society Chelsea Flower Show in London on a sunny spring day.

Overleaf
Children wait in the rain for the arrival of the Queen and the Duke of Edinburgh at the National Memorial to the Few at Capel-le-Ferne near Folkestone, Kent, in 2015.

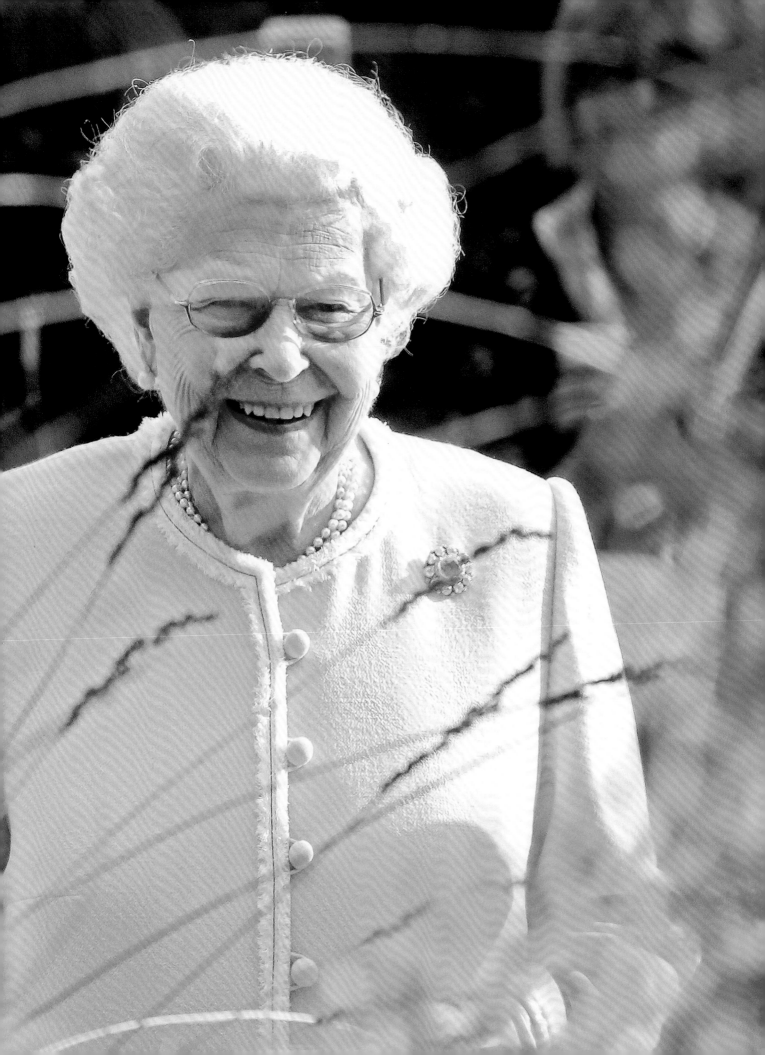

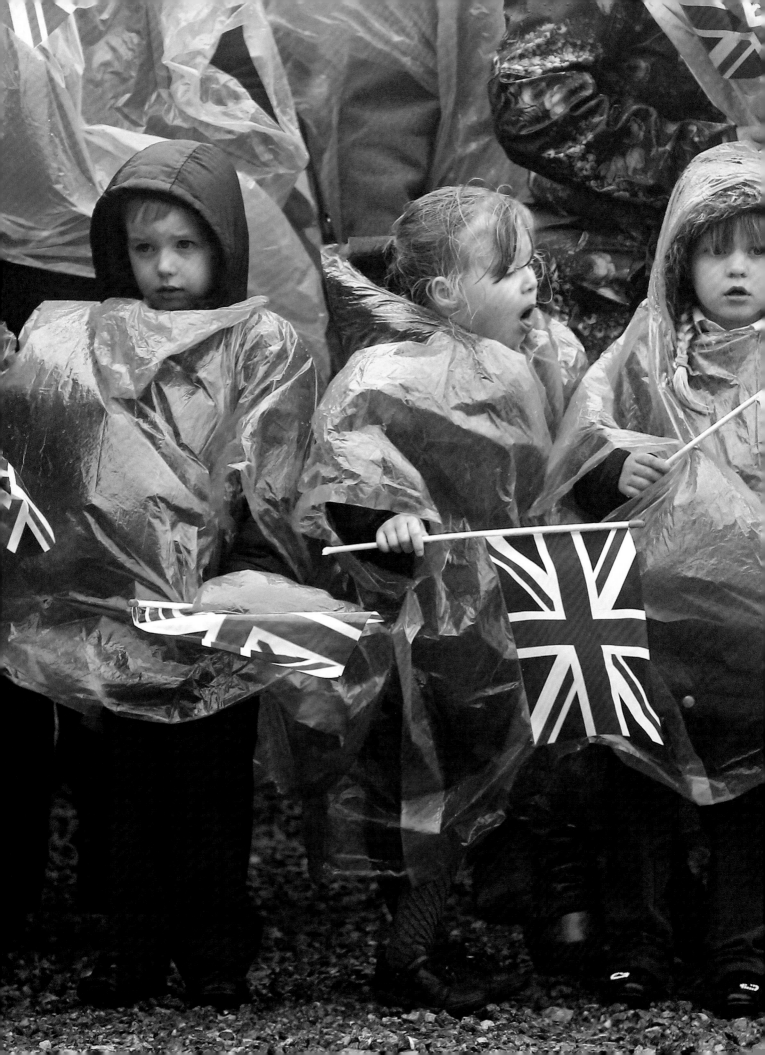

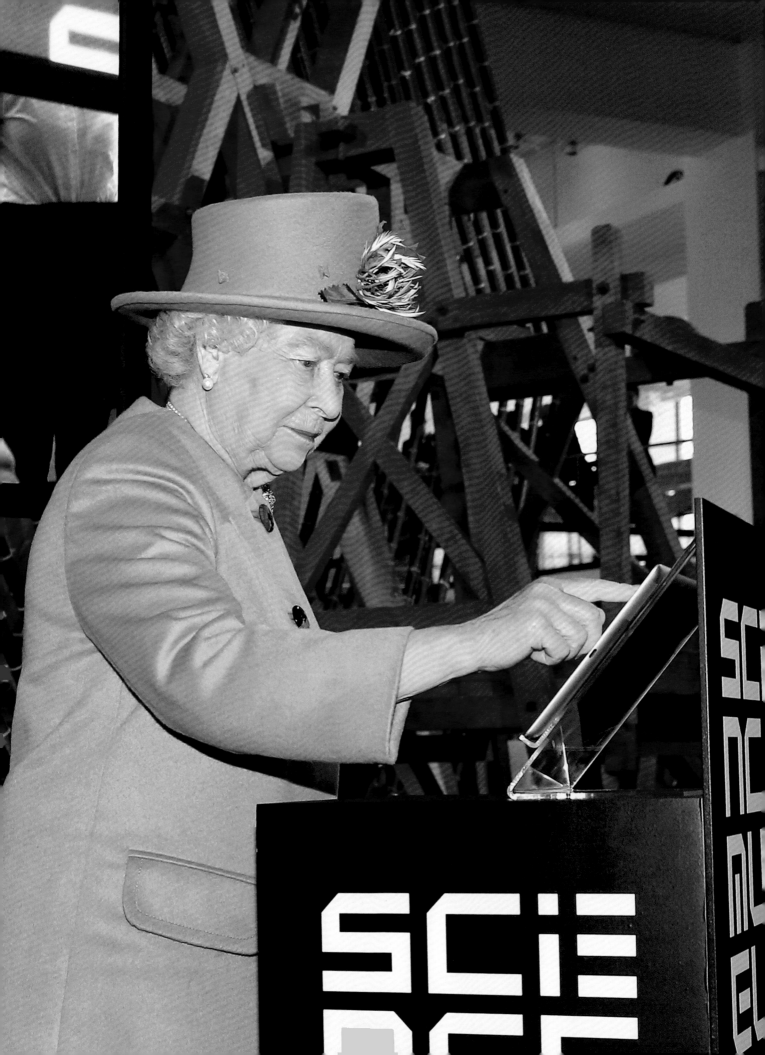

"It is a pleasure to open the Information Age exhibition today at the @ScienceMuseum and I hope people enjoy visiting. Elizabeth R" QUEEN ELIZABETH II

TWEETING QUEEN

Social media is a key part of the royal family's communications strategy in the modern age, with millions of followers on various accounts. Photographs, official portraits, and statements are released regularly via popular platforms such as Instagram and Twitter, which are an ideal way to engage directly with the public around the world. Bearing this in mind, it was a sign of things to come when, in 2014, the Queen sent her first tweet into the Twittersphere on a specially installed Apple iPad, while opening the *Information Age* exhibition at the Science Museum in London.

Keeping with the technology theme, the Queen was also presented with a "digital bouquet" made from copper, ticker tape, and computer punch cards designed by the museum's resident inventor, Mark Champkins.

UNVEILING OF
THE QUEEN'S STATUE

It is not often you unveil a statue
of yourself, but this was the case
for the Queen at the Honourable
Artillery Company's headquarters
in the City of London in 2016. The
bronze bust, by portrait sculptor
Antony Dufort, was commissioned
to mark the occasion of the Queen
becoming the longest-serving
Captain-General of the company.

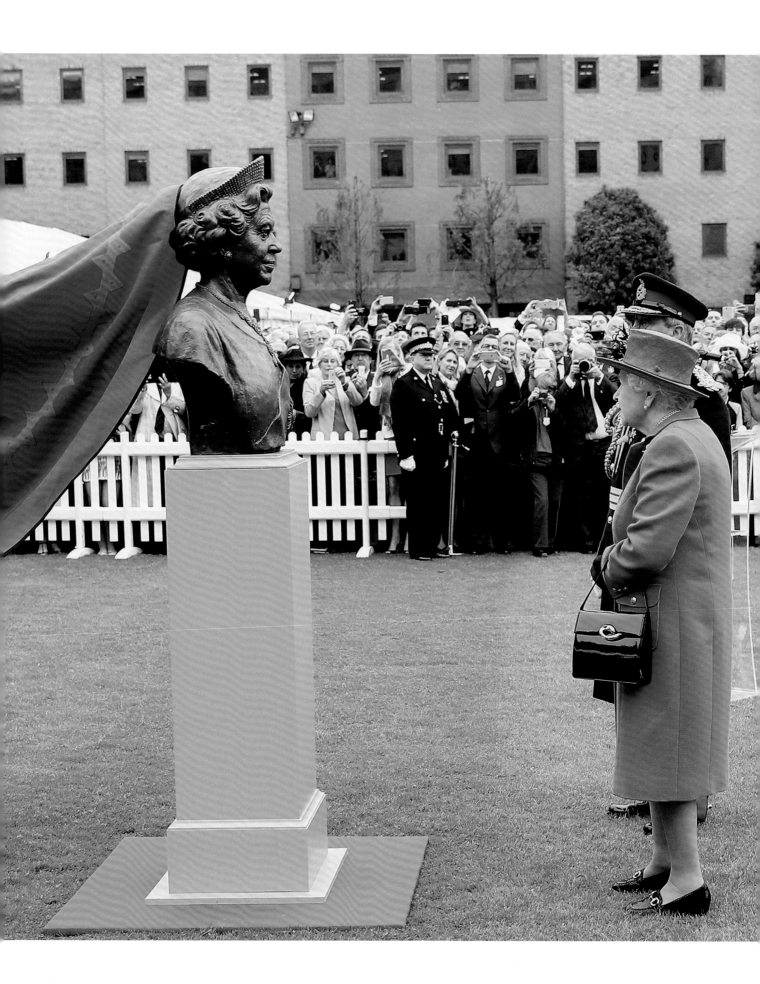

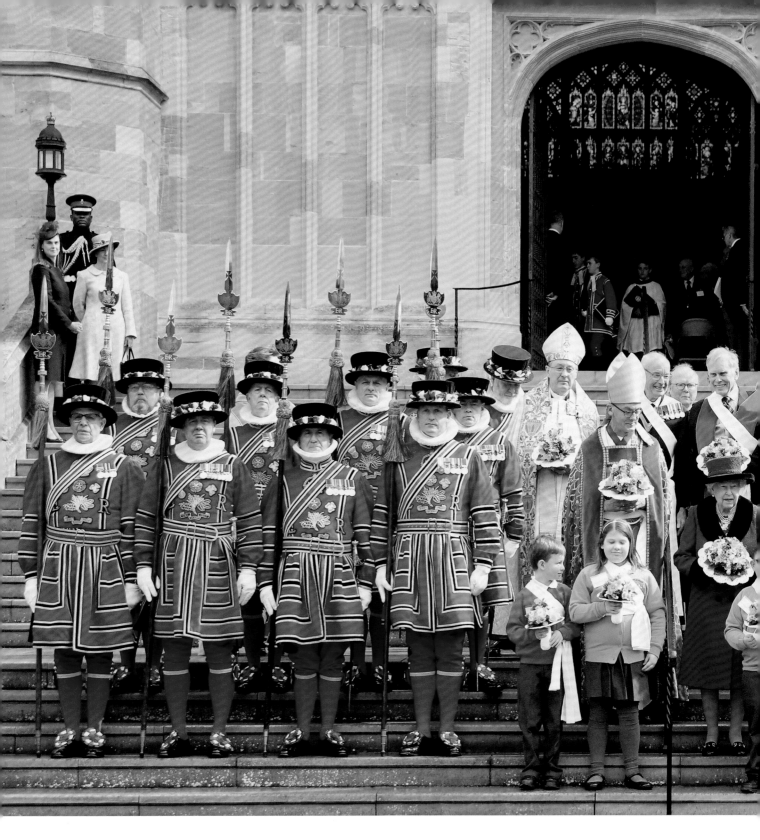

AN EASTER RETURN

Maundy Thursday—the Christian holy day that falls on the Thursday before Easter—is when the Queen gives "Maundy money" to local pensioners, in a service that commemorates Jesus washing the feet of the apostles at the Last Supper. The Queen traditionally distributes the

money to individuals in recognition of their contribution to the community and the Church. One man and one woman are chosen for each year the Queen has lived, and they receive Maundy money equivalent in pence to that number of years. The Queen decided from the

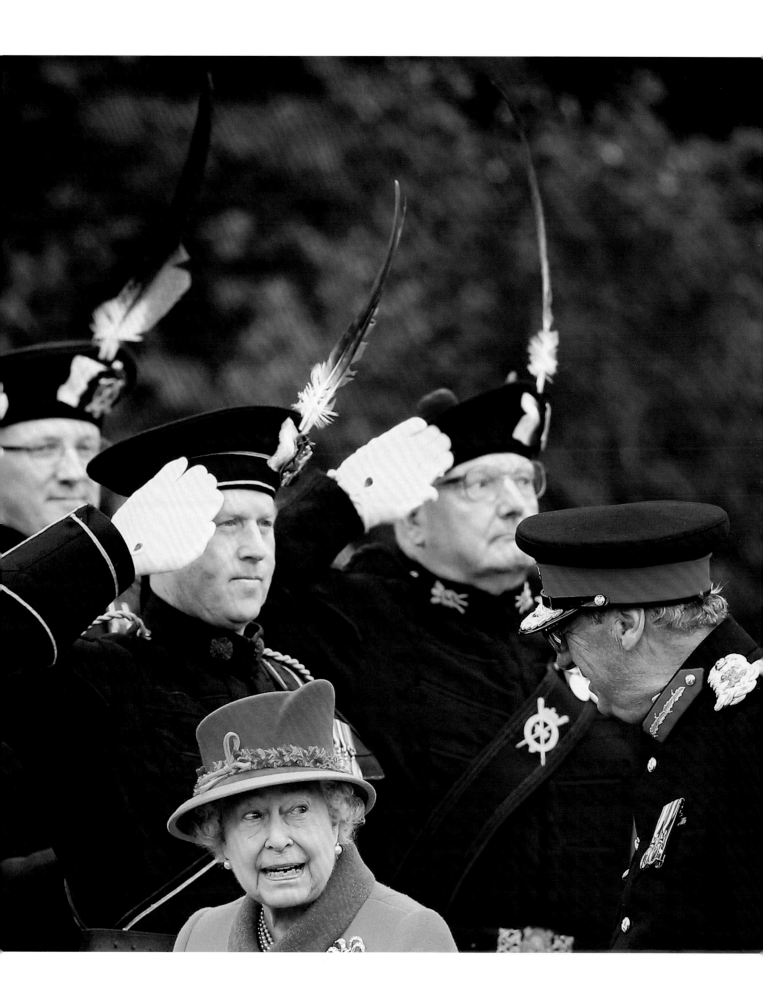

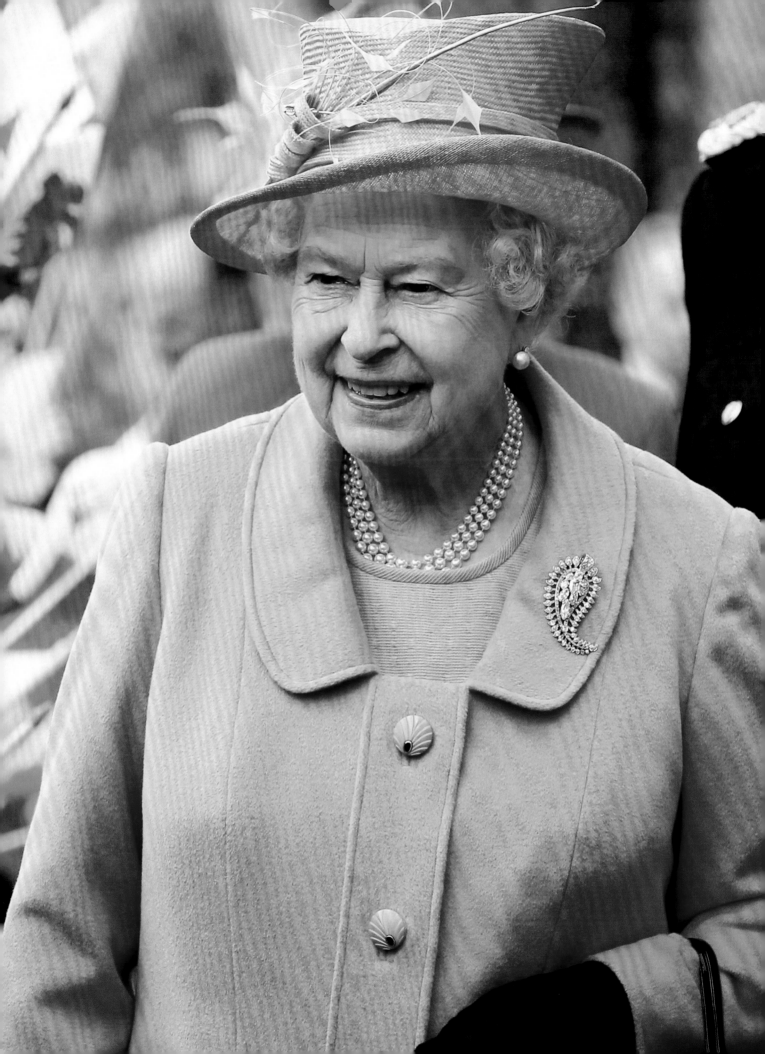

The Queen's ninetieth birthday on 21 April 2016 was a moment of celebration for the whole nation. The spring sun shone at Windsor Castle as huge crowds gathered outside.

Overleaf
A gardener works on the roses in the East Terrace Garden in the grounds of Windsor Castle. In 2020 the gardens were opened to the public for the first time in more than forty years.

Page 44
Iconic MG cars head out of Windsor Castle toward the Long Walk after taking part in a parade around the castle grounds on 25 April 2009.

Page 45
A member of staff finalises the table setting for a state banquet in St George's Hall at Windsor Castle, in honour of India's president, Pratibha Devisingh Patil, in 2009.

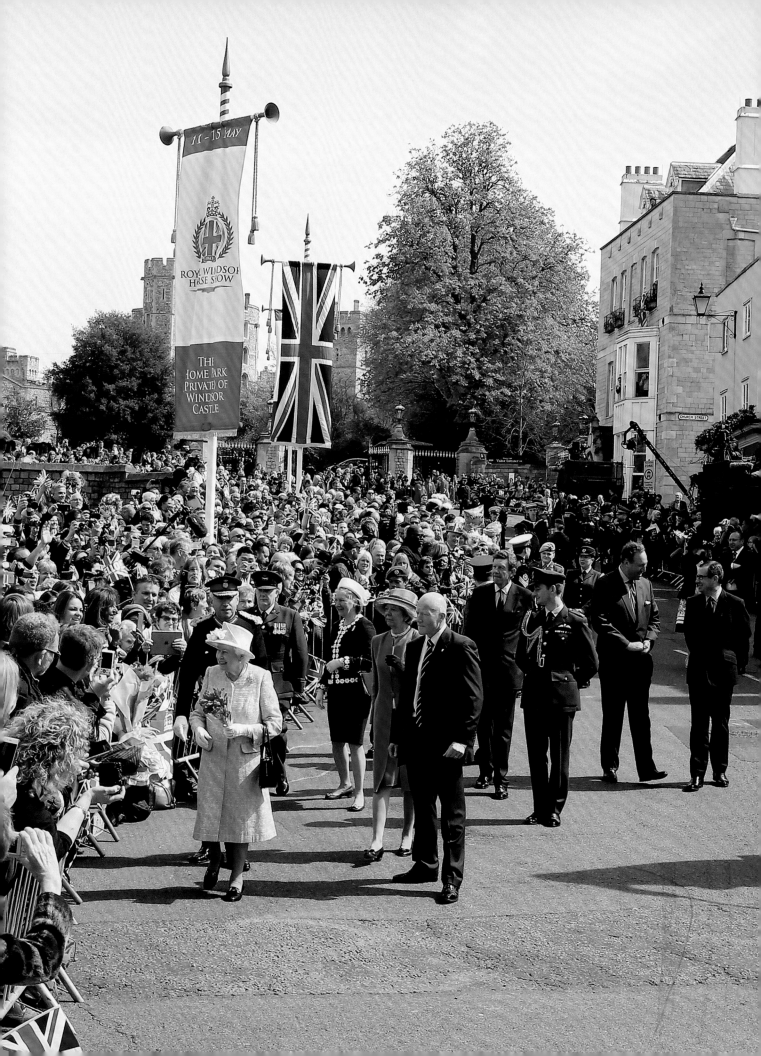

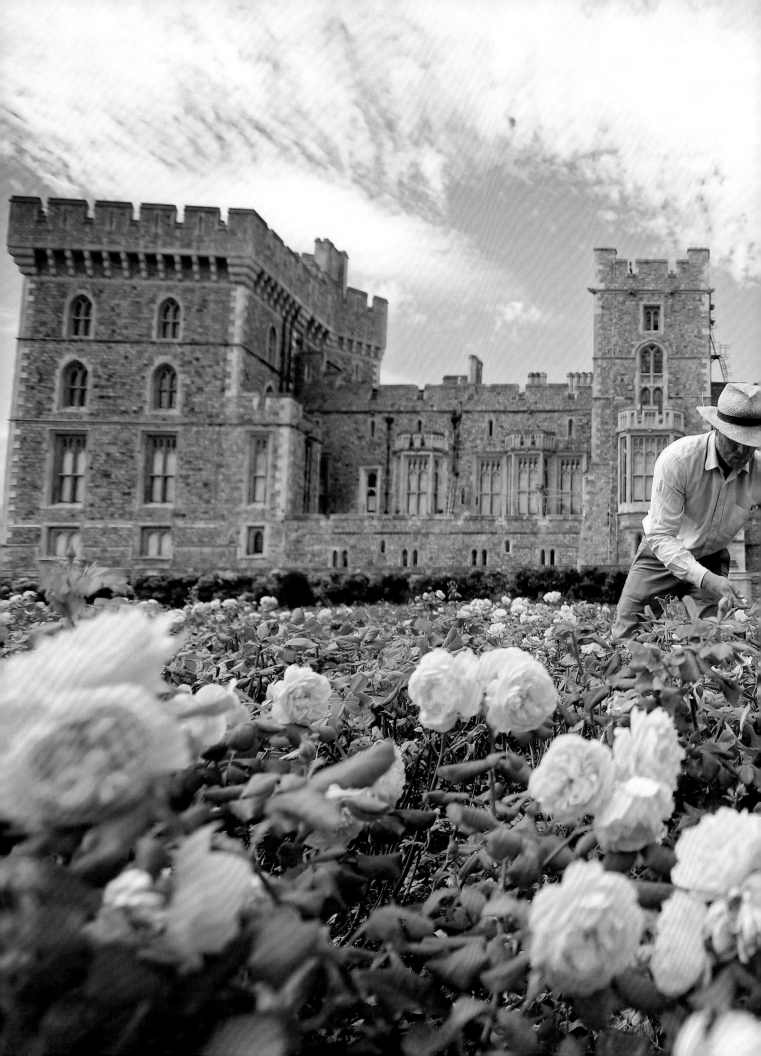

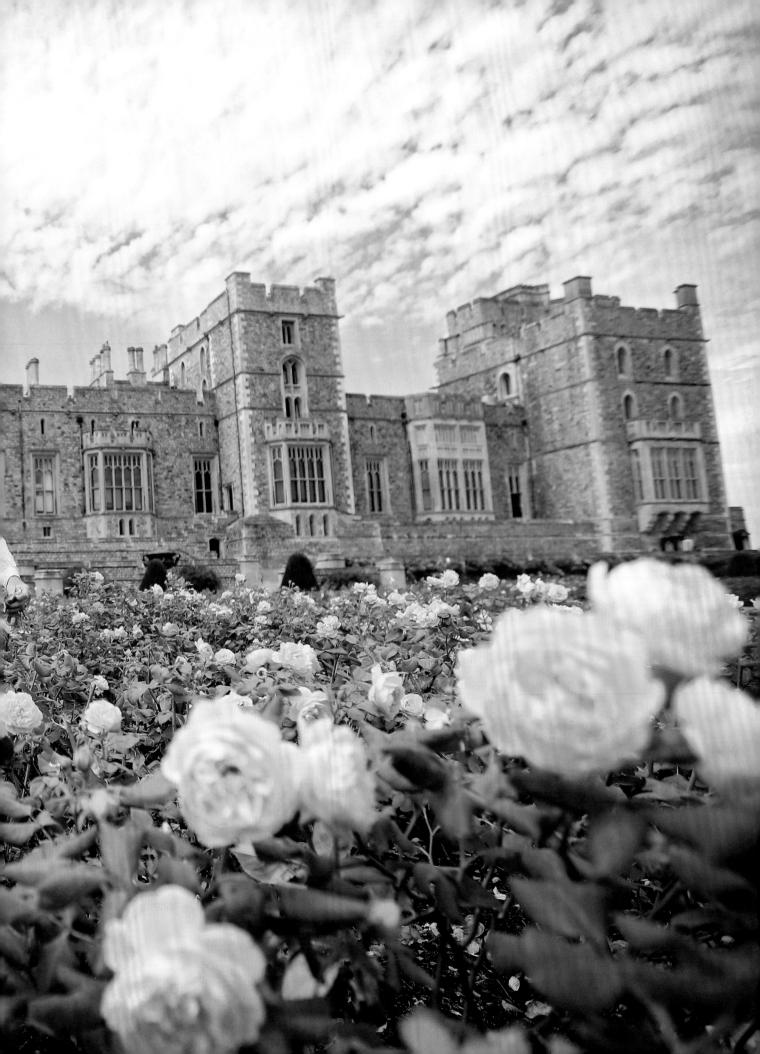

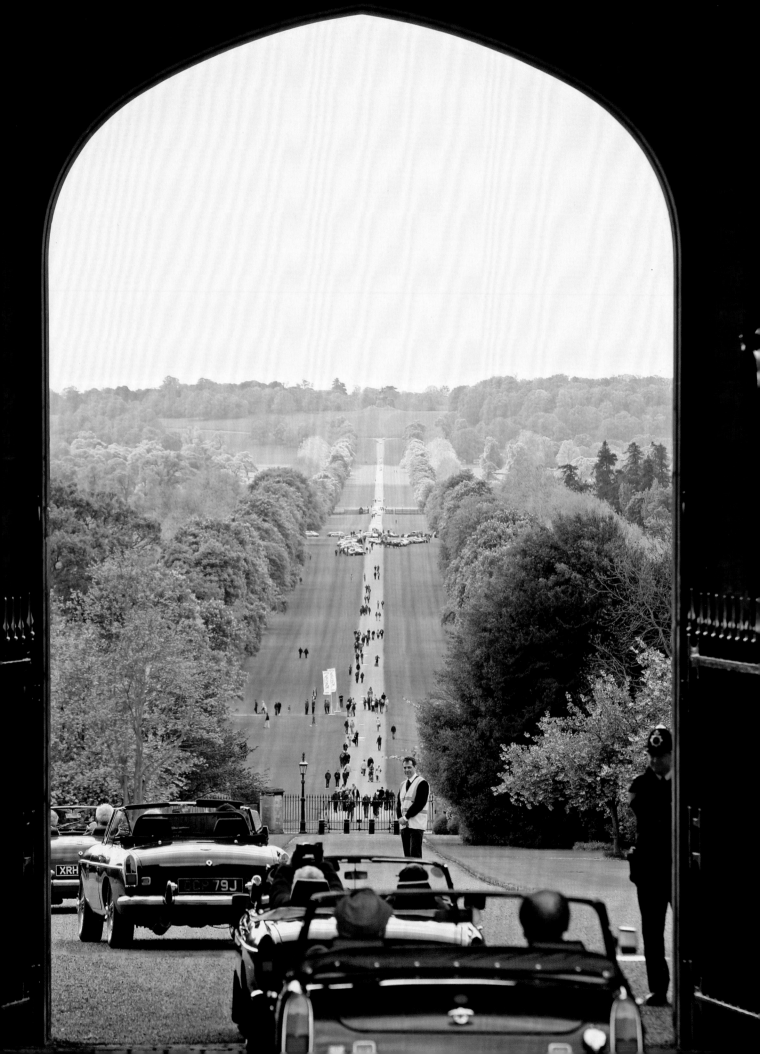

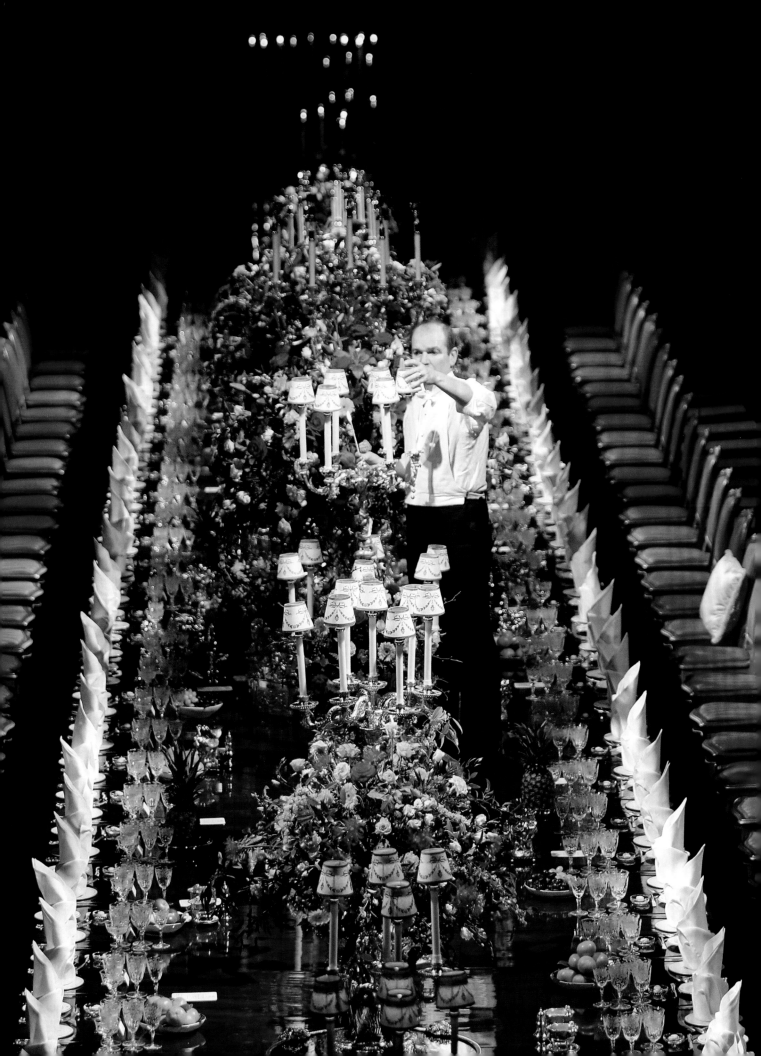

THE CHELSEA PENSIONERS—FOUNDER'S DAY

Sandwiched between the King's Road in London and
the River Thames, on a 66-acre site facing Battersea Park,
is the Royal Hospital, the impressive 362-year-old home
of the Chelsea Pensioners. Founder's Day celebrates King
Charles II founding the Royal Hospital, originally as an
almshouse. Chelsea Pensioners who are recognised by
their iconic red uniforms, are retired soldiers of the
British Army.

Founder's Day is traditionally attended by a member
of the royal family. On this hot June day in 2008, the
Queen took the salute from the veterans. The Queen's
visit was significant, as it marked twenty-four years since
the Queen and the Duke of Edinburgh had previously
attended. The Queen smiled as she reviewed the lines
of proud veterans, who were wearing oak leaves on their
lapels to commemorate King Charles's escape from the
Roundheads (Charles allegedly hid in an oak tree).
These interesting vignettes, which form an important
part of many everyday royal engagements, often
provide fascinating historical links to an earlier age.

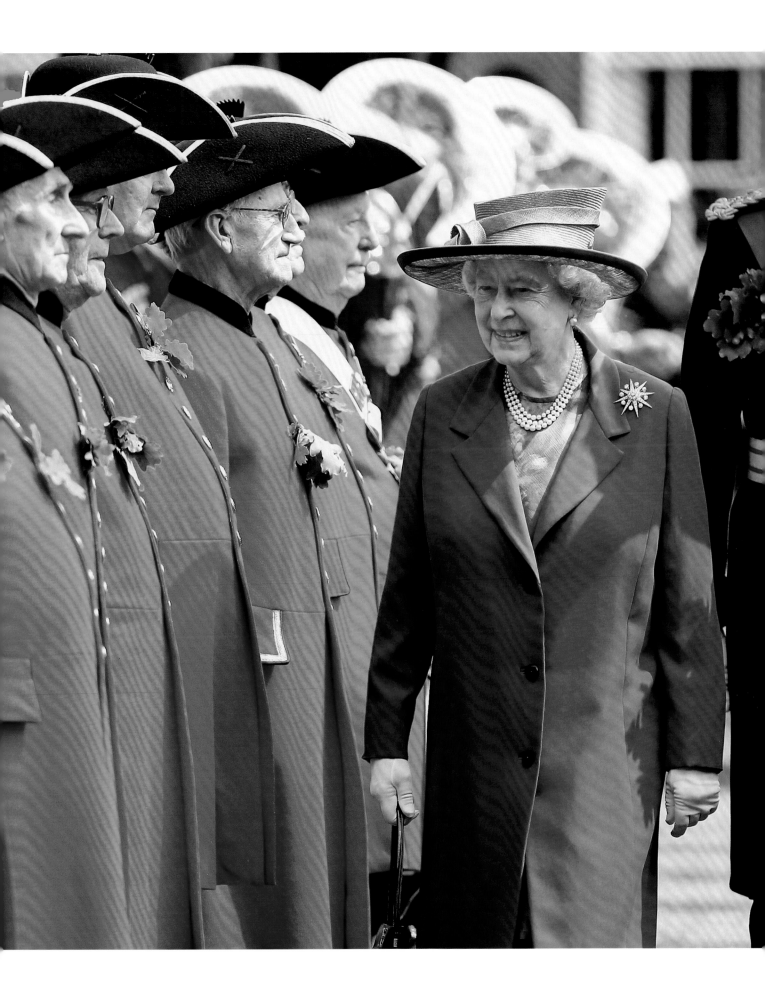

CHRISTMAS AT SANDRINGHAM

Christmas Day remains an important date in the royal photographer's diary. Tradition dictates that the royals attend the church of St. Mary Magdalene at Sandringham, Norfolk, for two services on the morning of 25 December. I have always enjoyed photographing this event, despite the annual protestations from my family. Spending times of celebration away from loved ones is one of the challenges of the job. I have often found myself driving across the country to my family home in Wales for a delayed Christmas lunch and a very welcome glass of champagne at 4 pm, breathing a huge sigh of relief after a day that began at 5 am.

Early on Christmas Day morning, members of the public gather at the gates of the Sandringham Estate, huddled in the dark along with the media and police, wishing each other a chilly "Happy Christmas" while sipping on steaming coffees. The festive atmosphere continues into the late morning as the royals appear in the distance chatting among themselves, before passing through the gates towards the crowds and

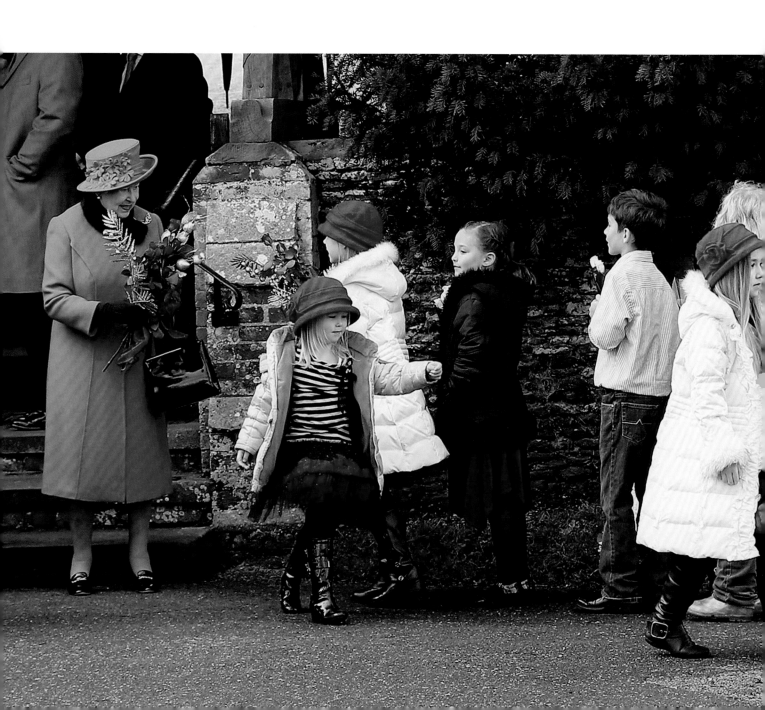

then walking up the road to the church. After the family have entered the church, the Queen arrives in a maroon Bentley State Limousine.

The most relaxed images happen when the Queen, often helped by Princess Beatrice or Princess Eugenie, accepts gifts and cards from children. It is always tricky to photograph the different members of the family as they emerge into the light from the dark arch of the church porch, waving and greeting the public, many of whom consider this part of *their* Christmas tradition.

Overleaf
Students and teachers take photographs and wave flags as the Queen and the Duke of Edinburgh arrive for a visit to Royal Holloway, University of London.

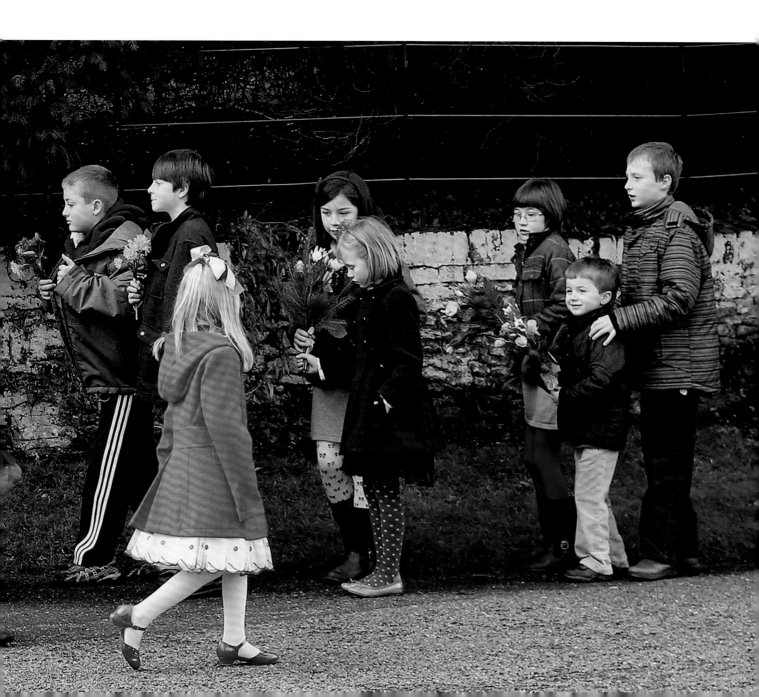

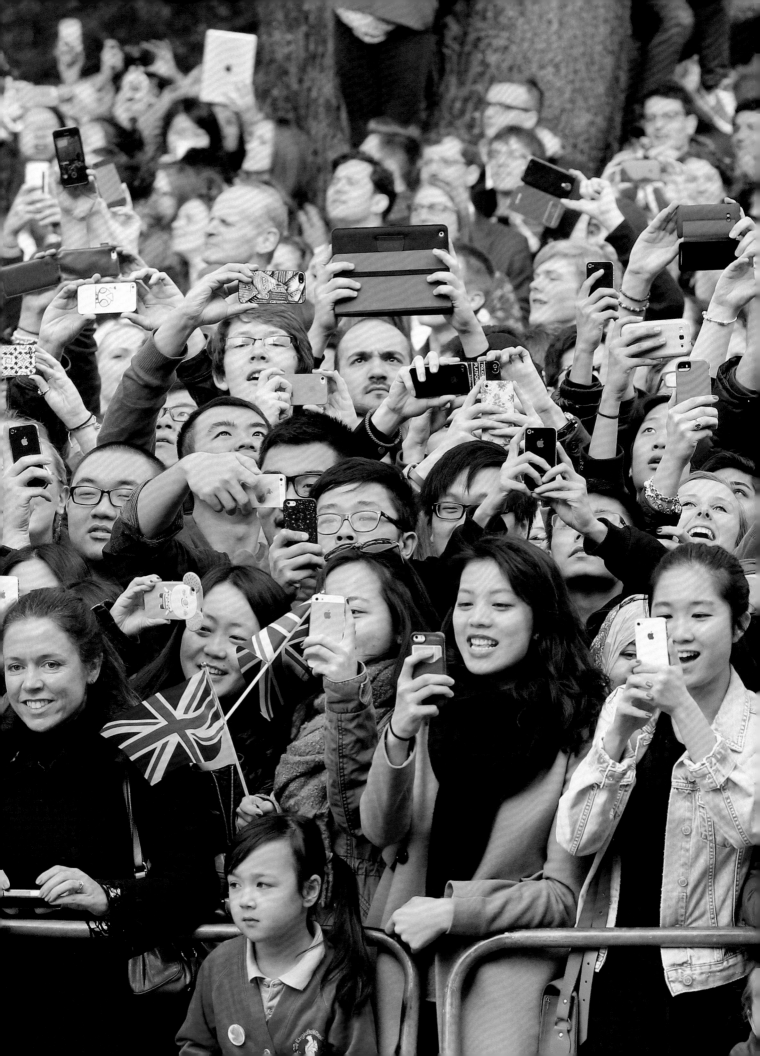

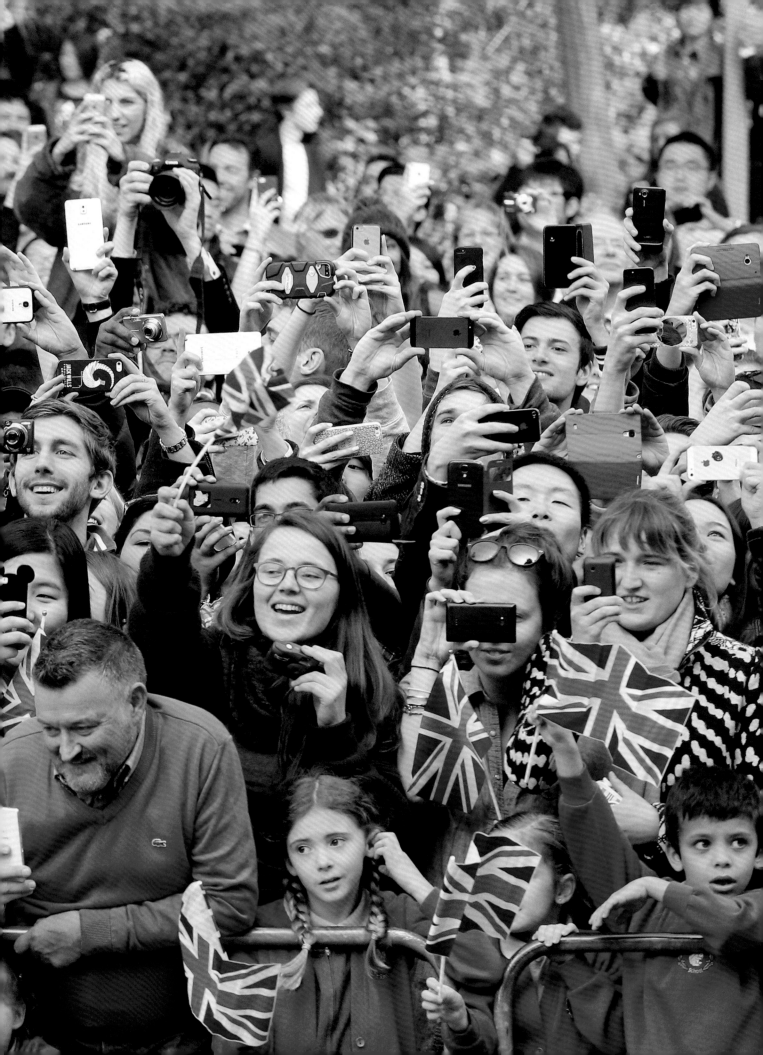

PLANTING TREES—IT'S WHAT WE DO!

During a visit to Cota, a small village on the edge of a rainforest outside São Paulo in Brazil, Prince Harry said, "Planting trees—it's what we do," as he filled in the earth around a sapling in 104°F heat with sweat drenching his shirt. He could not be more right. I have photographed the royal family planting thousands of trees around the world. It is always a lovely way to end an engagement, leaving something so positive, living, permanent, and good for the environment when the visit itself will long be consigned to the archive. The Prince of Wales often raises his spade aloft to cheers, before an affectionate touch on one of the newly planted tree's limbs is accompanied by a quiet "Good luck, tree." I have always found that incredibly endearing.

The venue for this photograph was the National Institute of Agricultural Botany (NIAB) near Cambridge on 9 July 2019. The Queen, wearing a stunning fuchsia ensemble, had already been taken on a tour of some of the specially grown wheat, when she was asked if she could plant a tree in the grounds of the agricultural research centre. When NIAB officials offered help, she firmly replied, "No, no. I'm still perfectly capable of planting a tree," before adding, "I don't think I've ever planted one of these before," which was amazing considering the significant part of her life spent planting trees around the world. The Queen then grinned broadly and joked, "Someone's going to have to plant it properly now!"

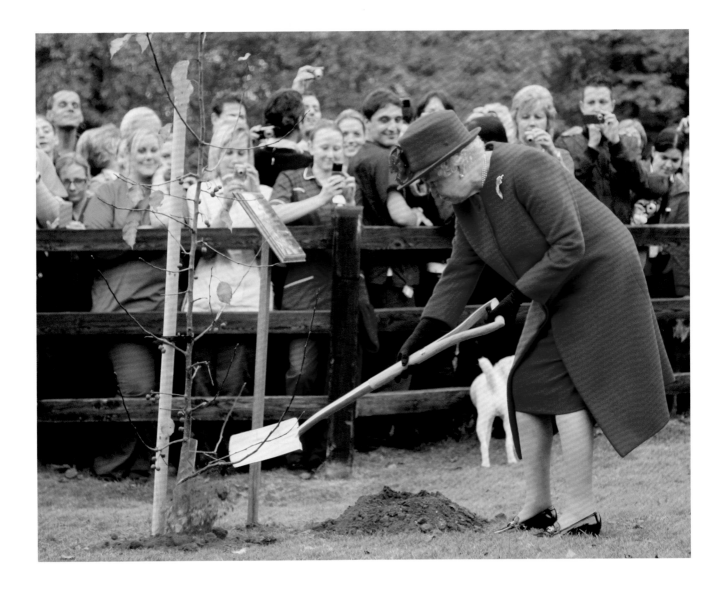

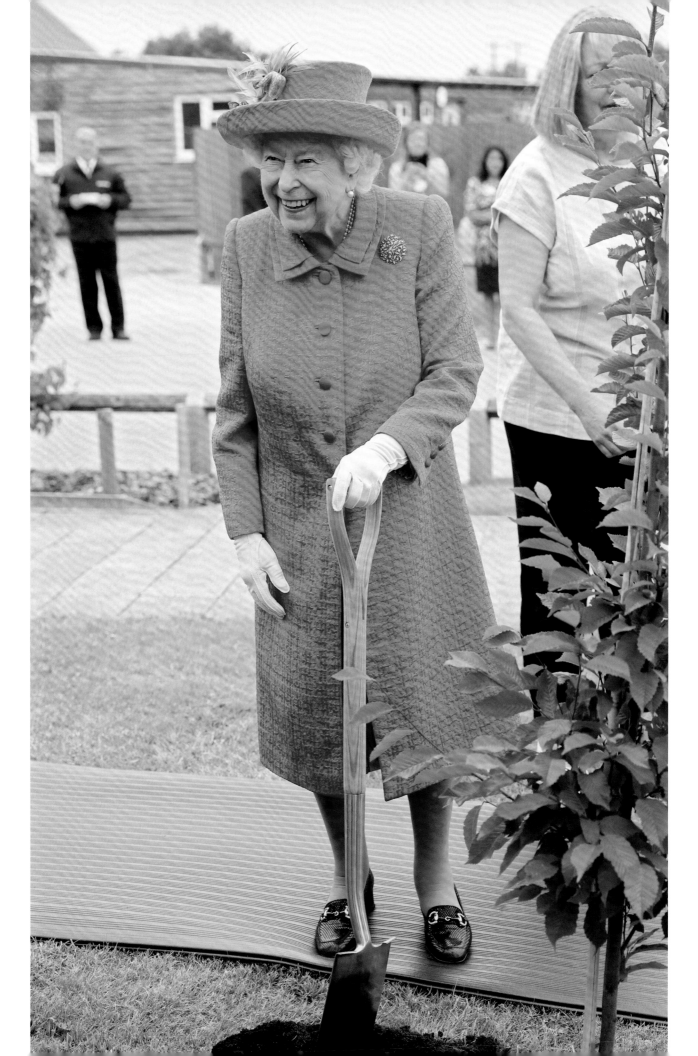

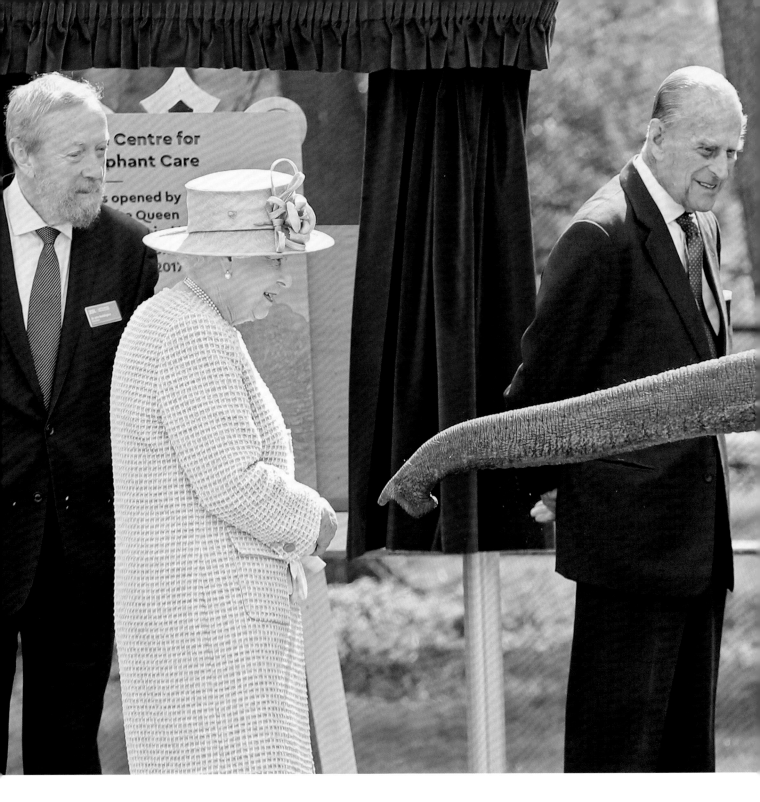

DONNA THE ASIAN ELEPHANT

The occasion was the opening of Whipsnade Zoo's Centre for Elephant Care in 2017, and it certainly provided me with one of my more unexpected images of the Queen and the Duke of Edinburgh. Normally, in these kinds of situations, you do not imagine the Queen will get as close as she did to such a large and potentially dangerous animal, so it was with surprise that I photographed the royal couple feeding the incredibly friendly Donna with a banana or two. It certainly amused the Duke, who had a broad grin on his face as Donna extended her trunk, full stretch, keen to snaffle another banana from the unsuspecting monarch's pocket, while some concerned-looking zookeepers kept watch, ready to restrain the huge animal at any sign of trouble.

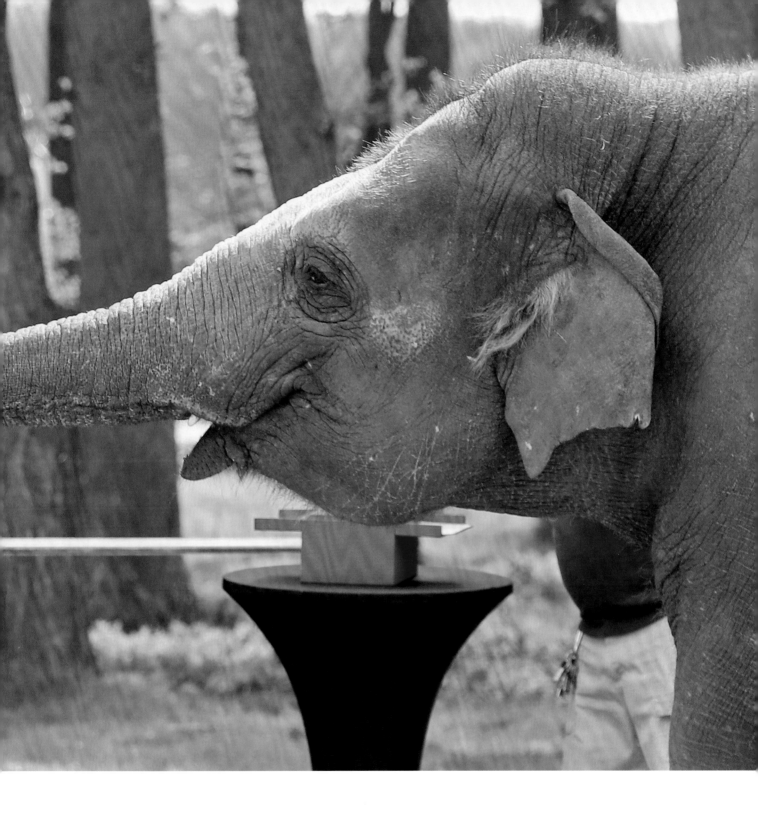

Overleaf
The Lord-Lieutenant of Derbyshire, William Tucker, gives a speech as the Queen looks on in the stunning Painted Hall of Chatsworth House, Derbyshire, on 10 April 2014.

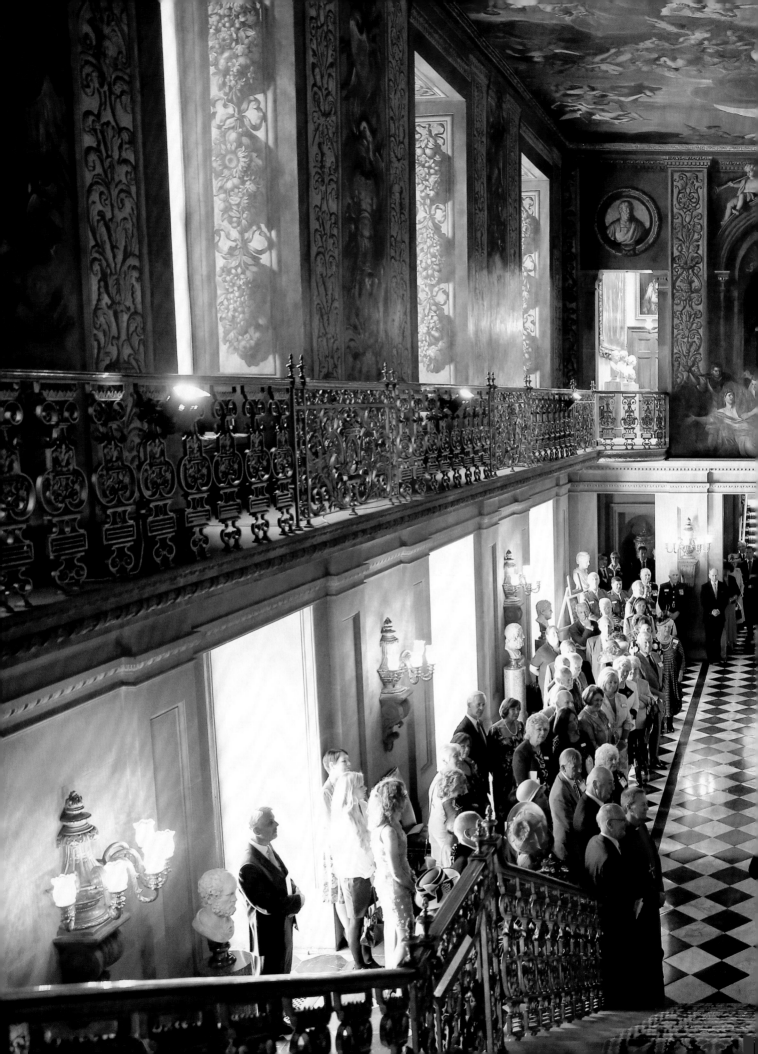

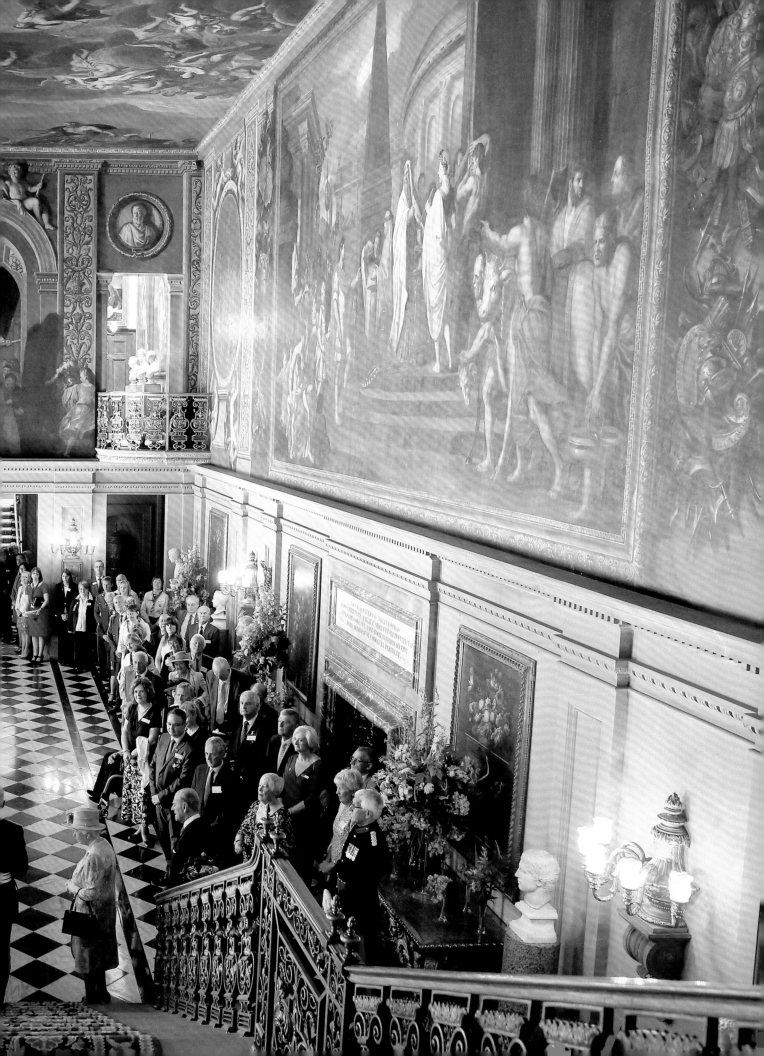

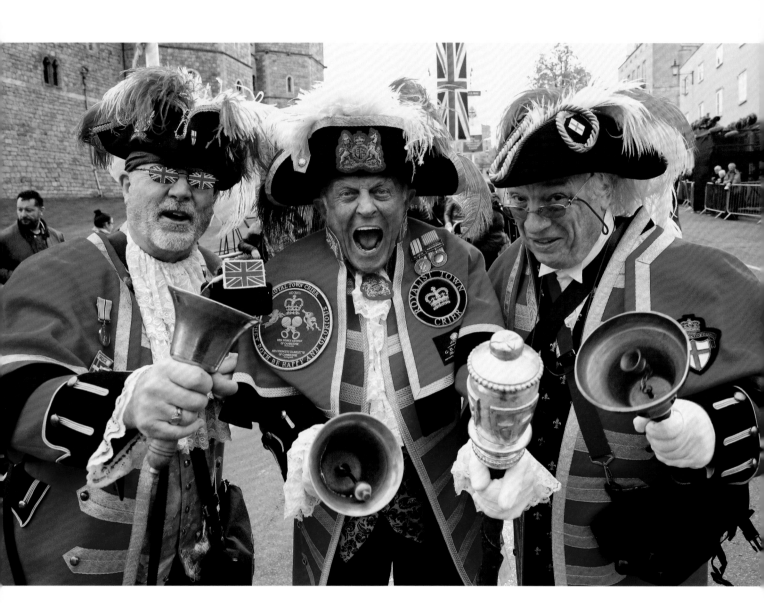

A YEAR OF CELEBRATION

The Diamond Jubilee year was one of the most memorable in my professional life as a royal photographer. The feel-good celebratory nature of the period combined with the heady national excitement of the London 2012 Olympic Games was reflective of everything that is so special about documenting these historical events. I spent much of the year touring around the world with the Prince of Wales and Duchess of Cornwall, as well as the Duke and Duchess of Cambridge and Prince Harry. The Queen and the Duke of Edinburgh criss-crossed the UK, meeting as many people as their impressive stamina allowed.

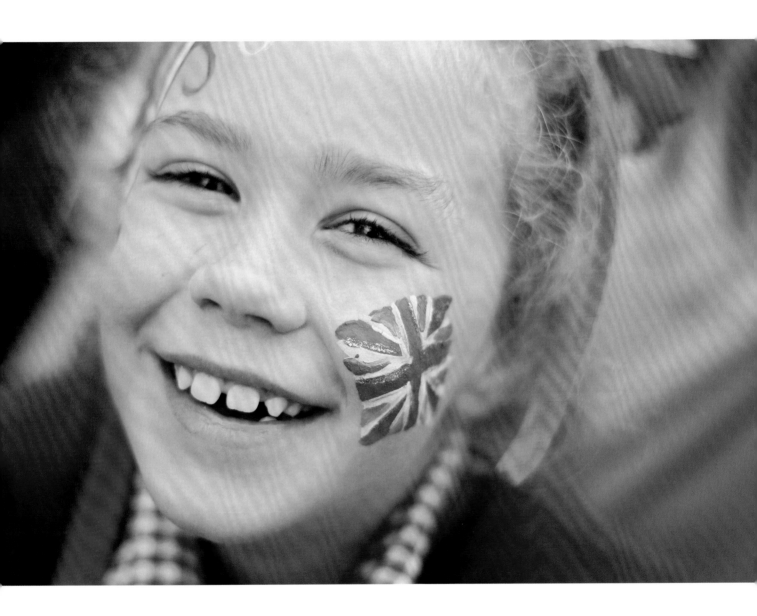

THE THREE CRIERS

Whenever there is something to celebrate, the Town Criers are on hand to let the public know. Here (above, left), are the famous Three Criers, Tony Appleton, Steve Clow, and Peter Baker, as they make sure everyone knows it's the Queen's ninetieth birthday. On the right, a young girl gets into the Jubilee spirit with some patriotic face painting.

Overleaf
Fireworks explode over Buckingham Palace on 4 June 2012 during the Diamond Jubilee concert. This was only the second time in history that the UK had celebrated the Diamond Jubilee of a monarch.

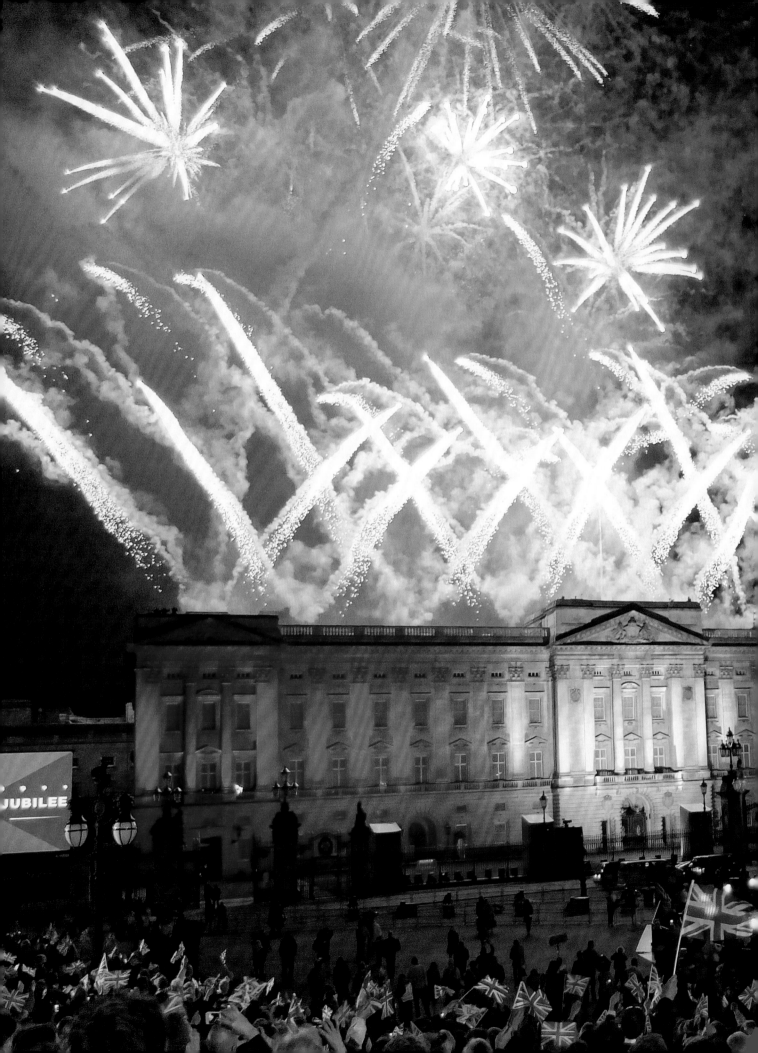

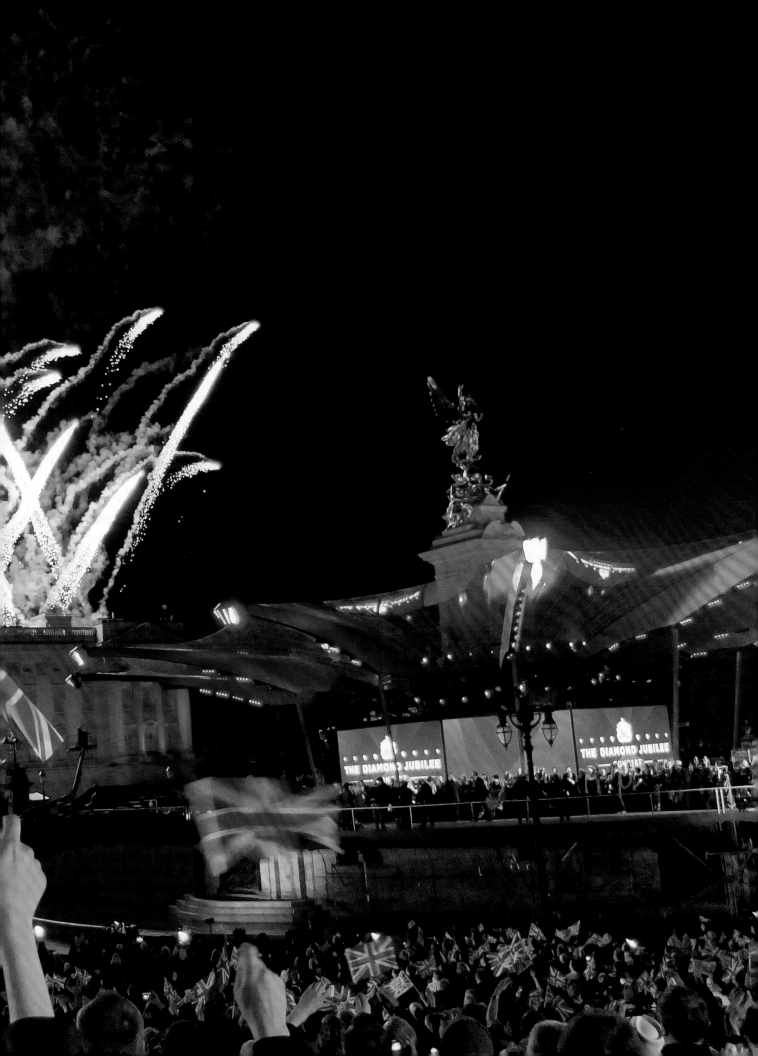

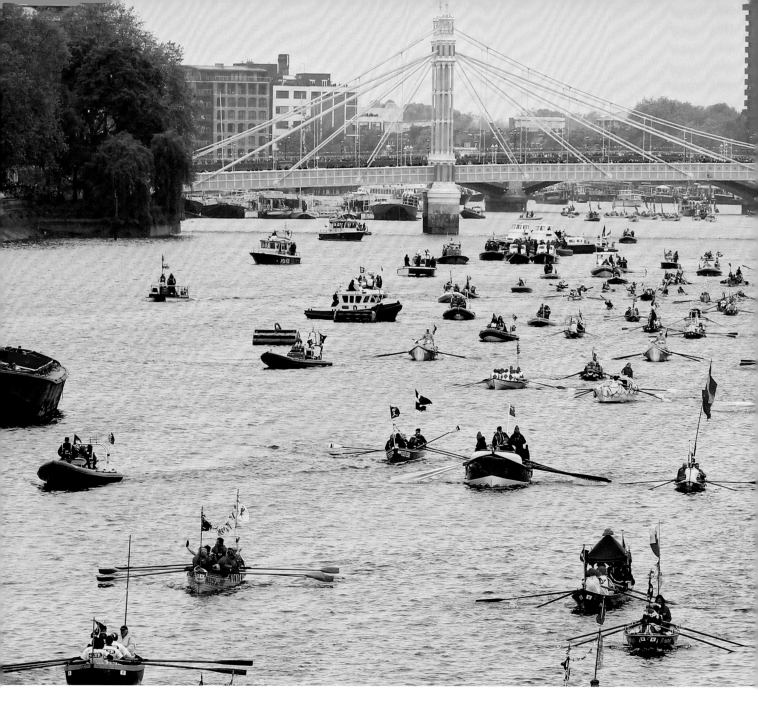

THE DIAMOND JUBILEE RIVER PAGEANT

On 3 June 2012, the skies were looking ominous before
the nautical extravaganza had even begun, but the
phrase "the rain did not dampen the British spirit" could
not have been more applicable. The nation was in the
midst of commemorating the Diamond Jubilee, the
sixtieth anniversary of the accession of Queen Elizabeth II
on 6 February 1952. The River Pageant was the much-
anticipated highlight of an extended weekend of
celebrations, in which 670 vessels of all shapes, sizes,
and purposes were due to make their way upstream
on the River Thames in a sight not seen for centuries.

The event had some personal significance for me.
Forming part of a team of photographers covering every
aspect of the pageant, I was tasked with photographing the
boats from Chelsea Bridge, a river crossing designed by my
great-grandfather, George Topham Forrest, who was chief
architect at London County Council. I wonder what he
would have made of this unique spectacle: an armada of
vessels travelling under his creation and up to Tower Bridge.

As the first boats appeared in the distance, grey clouds
seemed to fill the sky. In the end, I was incredibly lucky,
because those of us positioned on Chelsea Bridge

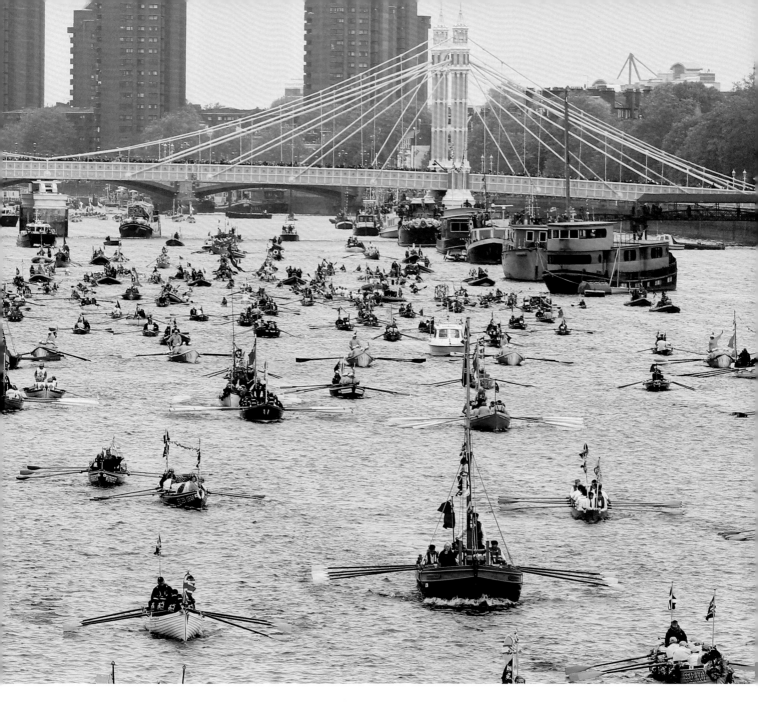

managed to escape the worst drenching. The pageant, which was made up of military, commercial, and pleasure craft, passed by us amid huge and enthusiastic cheers. It was watched by an estimated one million people on the riverbanks, at office windows, and in residential blocks—all waving flags and cheering. It was an amazing atmosphere.

At around quarter past two in the afternoon, the royal launch from HMY *Britannia* carried the Queen to the royal barge MV *Spirit of Chartwell*, which was moored at Cadogan Pier. There were a few showers after the boats passed. I headed back to my Battersea flat to file the images I had

taken. It was then, as I looked out of the window, that the heavens opened, and a biblical amount of rain hammered down. Some of my colleagues' cameras further up the river had simply stopped working in the deluge. I thanked my lucky stars that it had turned out the way it did for me.

Overleaf
A guard of honour formed of the Coldstream Guards waits in the quadrangle of Windsor Castle in front of the Round Tower before performing a welcome ceremony for US President Donald Trump and First Lady Melania Trump on 13 July 2018.

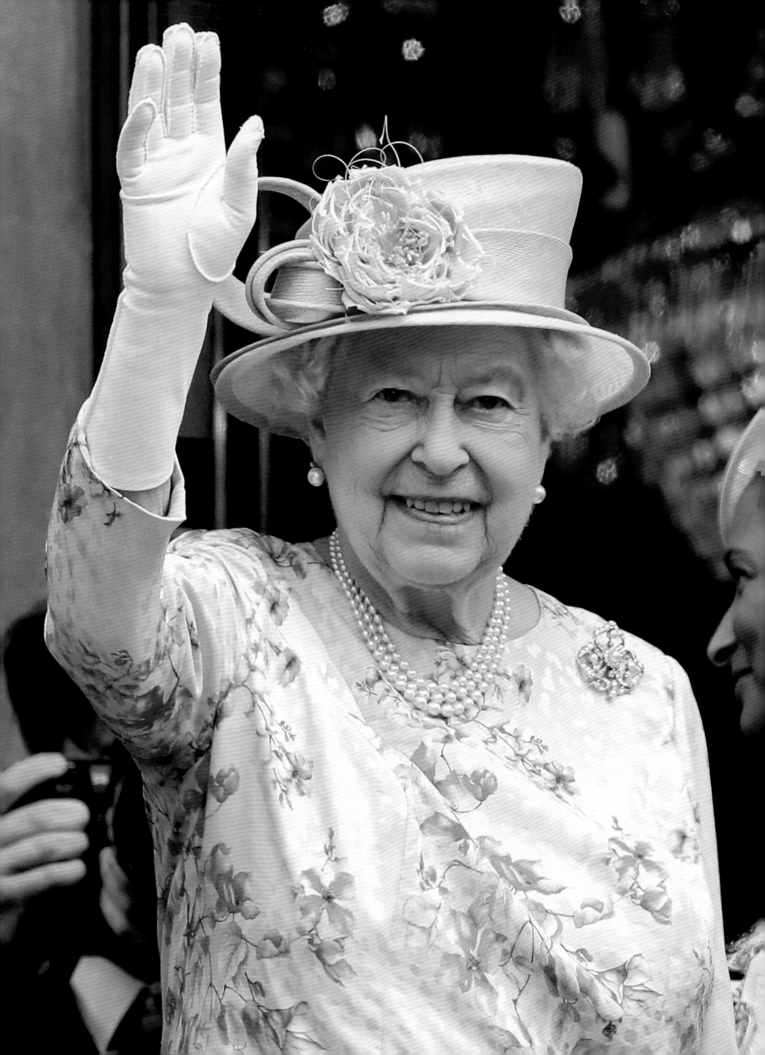

II

DUTY AND DIGNITY

Queen Elizabeth II's commitment to duty and her dedication to a position that she has held for over sixty-eight years, longer than any other monarch in the world, is unparalleled. From the moment the twenty-five-year-old Elizabeth heard of the death of her father while she was in Kenya (a trip she had undertaken on his behalf), her life was mapped out before her. She arrived back in London on 7 February to be formally proclaimed Queen the next day: "I shall always work, as my father did throughout his reign, to advance the happiness and prosperity of my peoples."

But what of the role of the monarch? What are the responsibilities and duties? Much has changed in recent years. Immediately following her coronation, the Queen and the Duke of Edinburgh embarked on a Commonwealth tour lasting five months. Although the Queen no longer travels beyond the UK, she continues to have numerous military and ceremonial responsibilities, and is also royal patron or president of over 600 charities, military associations, professional bodies, and public service organisations. This sheer weight of expectation and responsibility underpins the role of the monarch, and what it means to be someone who so many people look to for strength, inspiration, stability, and leadership. It is the very essence of duty.

REMEMBRANCE SUNDAY

The service on Remembrance Sunday in November is one of the most important royal engagements of the year, certainly the most poignant. Ever since 1920, when King George V mourned at the funeral of the First World War's unknown warrior, the monarch has, alongside politicians and military leaders, led the country in a National Act of Remembrance. Until 2017 the Queen laid a wreath at the base of the Cenotaph on behalf of the nation. The Prince of Wales then took on this role for the first time, in an example of the Queen passing duties to the next generation. The Prince delicately placed the Queen's wreath as she looked on from a balcony above. In a ceremony so laden with emotion and significance, even the camera shutters fall quiet during the two-minute silence, as we all remember those who have made the ultimate sacrifice.

Page 66
The Queen waves from the balcony of
Liverpool Town Hall during a visit to the
city on 22 June 2016.

BLOOD SWEPT LANDS AND SEAS OF RED

It was an art installation that captured the imagination of a nation. *Blood Swept Lands and Seas of Red*, situated in the moat of the Tower of London, was a striking visual representation of great loss and tragedy. Stage designer Tom Piper completed the conceptual design, and the work was created by ceramic artist Paul Cummins. In total, it consisted of 888,246 ceramic poppies, each representing a British military fatality during the First World War. The first poppy was "planted" on 17 July 2014, and the work was unveiled on 5 August. The Queen and the Duke of Edinburgh visited the installation on 16 October. As the solo pool photographer positioned among the poppies, I was able to take a shot from a low viewpoint with the poppies in the foreground, glistening as the morning dew clung on to the "petals" of the Etruria Marl–based Etruscan earthenware. Clearly a moving experience for the royal couple, they walked alone among the poppies, seemingly lost in their own thoughts. The Queen was touched enough to mention the installation in her annual Christmas message broadcast later that year.

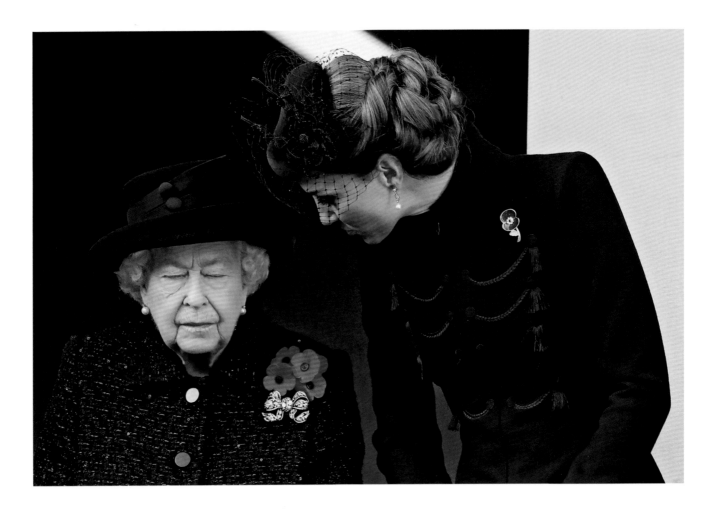

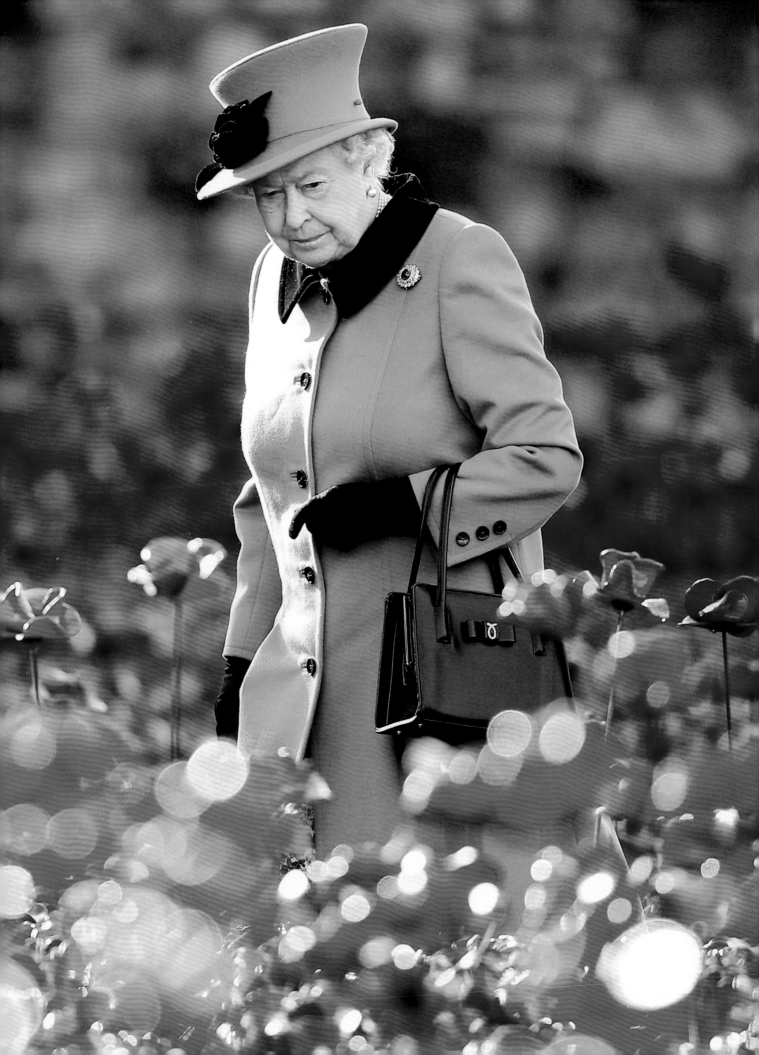

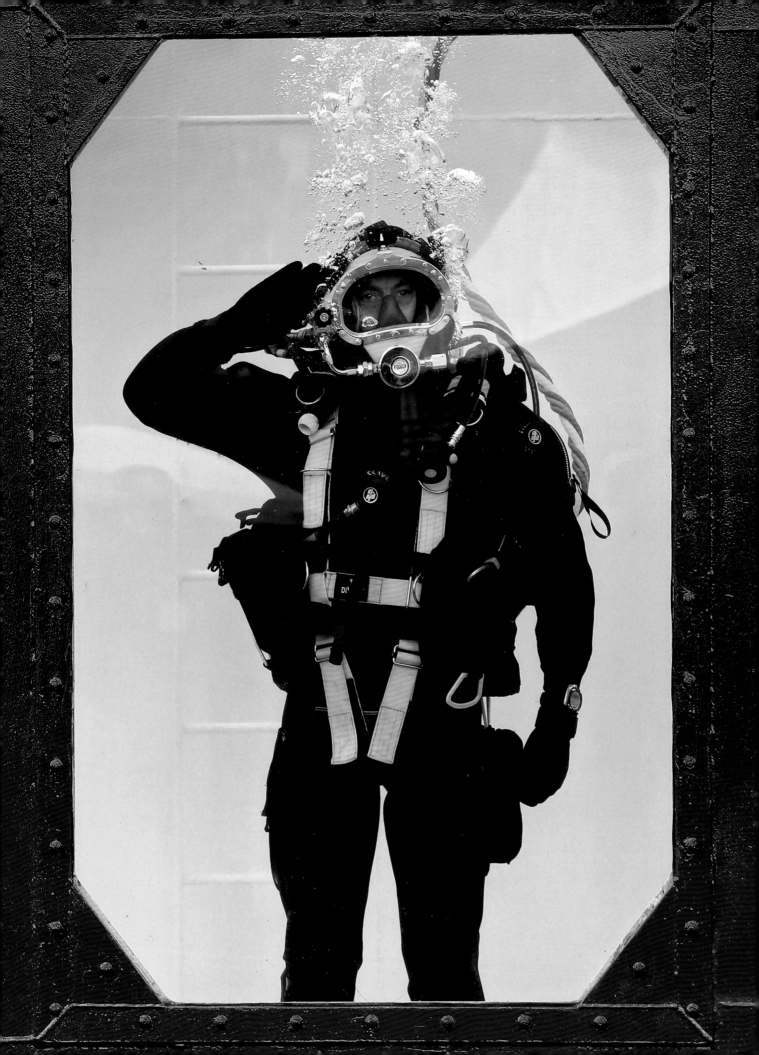

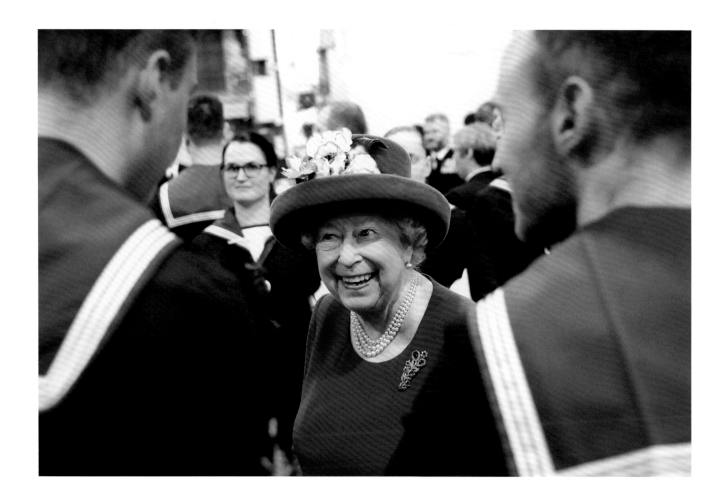

THE SALUTING DIVER

The Queen was visiting the Royal Engineers at their
Brompton Barracks base in 2016 when I spotted this
rather unusual salute from one of their divers. Positioned
in a reinforced-glass diving tank, the soldier saluted the
monarch as she was driven past in her Range Rover. The
unconventional greeting certainly seemed to amuse the
Queen, who was on top form as she travelled in between
military personnel, standing up in the specially
converted vehicle.

THE CAKE AT A SHIP'S LAUNCH

It was at the Portsmouth launch of the British Royal Navy's
aircraft carrier, the HMS *Queen Elizabeth*, that I noticed
this comical "commissioning cake." Made by David
Duncan specially for the ceremony, I am not sure if the
Queen saw the sugar-icing representation of herself,
but the humour would certainly not be lost on her!

(Above) The Queen attends the Commissioning
Ceremony for the Royal Navy aircraft carrier
HMS *Queen Elizabeth*, the largest warship ever
built for the Royal Navy.

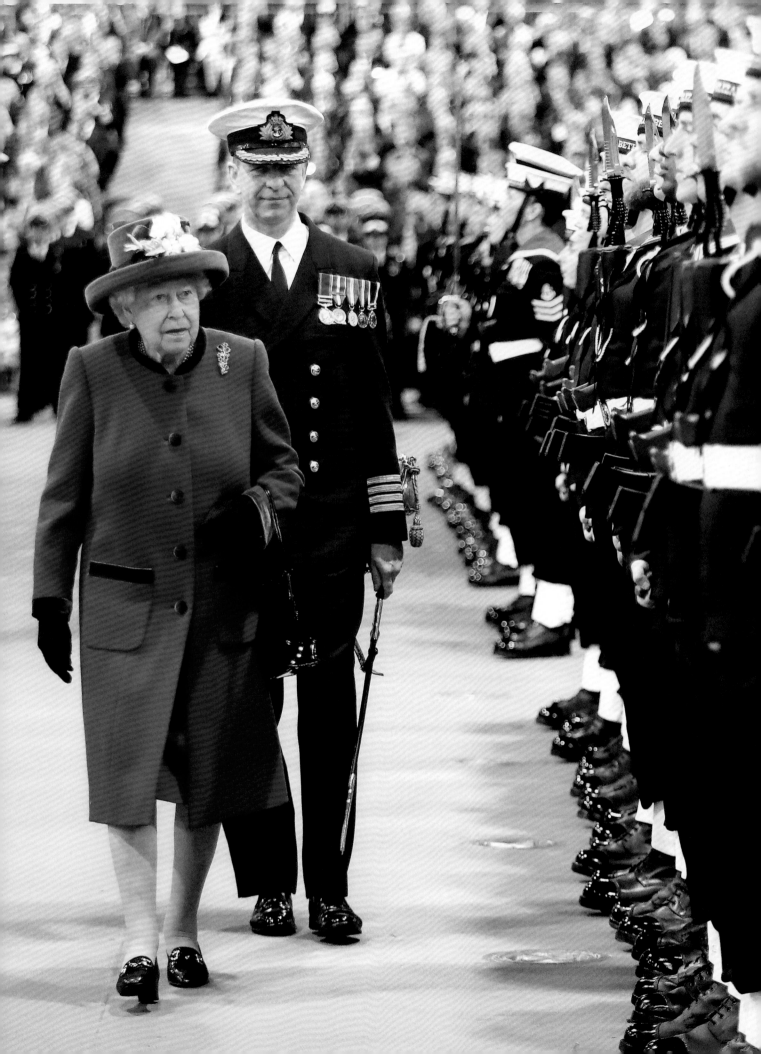

REVIEWING THE ROYAL NAVY

The Queen walks along the lines of navy troops paraded on the four-acre flight deck of the 65,000-tonne HMS *Queen Elizabeth* (the largest and most powerful vessel ever constructed for the Royal Navy), inspecting each intently. The Queen was attending the commissioning ceremony in Portsmouth, on the south coast of England, for the Royal Navy's aircraft carrier along with her daughter, the Princess Royal. Designed to launch the new F35 Joint Strike Fighter, the state-of-the-art vessel not only features high-tech weaponry and the latest technology but also five gyms, a medical centre, and a chapel. The ship's propellers weigh 33 tonnes each, and the engines push out enough power to run a thousand family cars. The whole thing felt like a floating city. It was probably one of the more unusual locations for a royal reception.

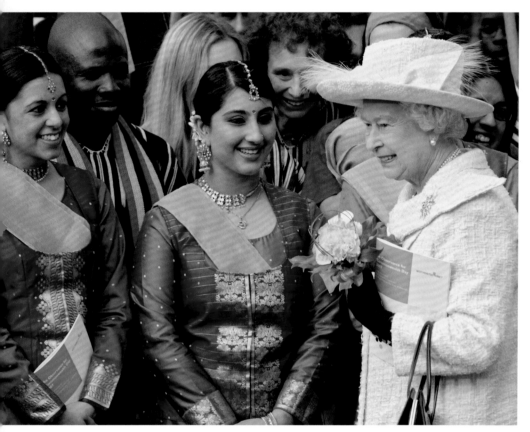

COMMONWEALTH DAY

The Commonwealth comprises a vast array of cultures, people, and countries. Even after its seventy years of existence, it remains an incredibly important facet of the identity of its fifty-four members. The Queen traditionally addresses the Commonwealth on Commonwealth Day, an important annual celebration of this unique association.

TROOPING THE COLOUR

While the Queen's actual birthday falls on 21 April, the nation celebrates with her during the Official Birthday festivities known as "Trooping the Colour." This incredible spectacular showcasing all the best of British pomp and ceremony takes place on Horse Guards Parade next to St James's Park in London. It is famous for the moment when all the members of the royal family appear on the balcony at Buckingham Palace. Trooping the Colour is not exclusive to Queen Elizabeth. It has marked the Official Birthday of the sovereign for more than 260 years. For the British public, it is a familiar and reassuring sight. For a photographer, it is certainly a highlight in the royal diary and a happy memory of the height of summer, as I watch the sun rise over the palace while securing my position for the forthcoming events.

An intimate knowledge of the choreography of the occasion enables me to capture all the aspects of a day that not only features the soldiers and the ceremony but also a rare opportunity to see all the senior royals in one place. More than 1,400 parading soldiers, 200 horses, and 400 musicians take part in this dazzling show of Britishness, which is watched by thousands of members of the public lining The Mall. The enduring image of the event will always be the Queen travelling down The Mall, surrounded by the horses and riders of the Sovereign Escort of the Household Cavalry and framed by Union Jacks.

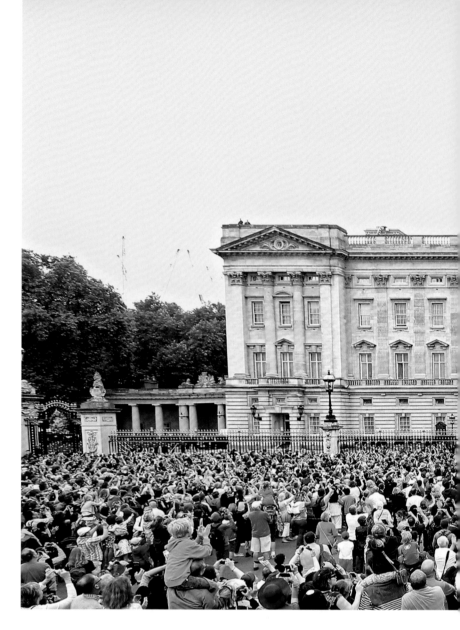

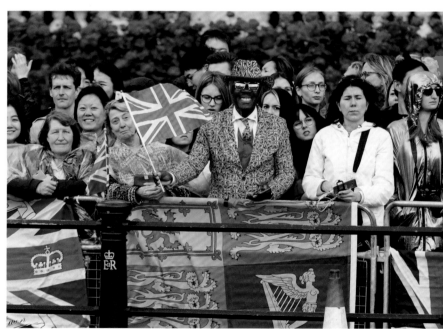

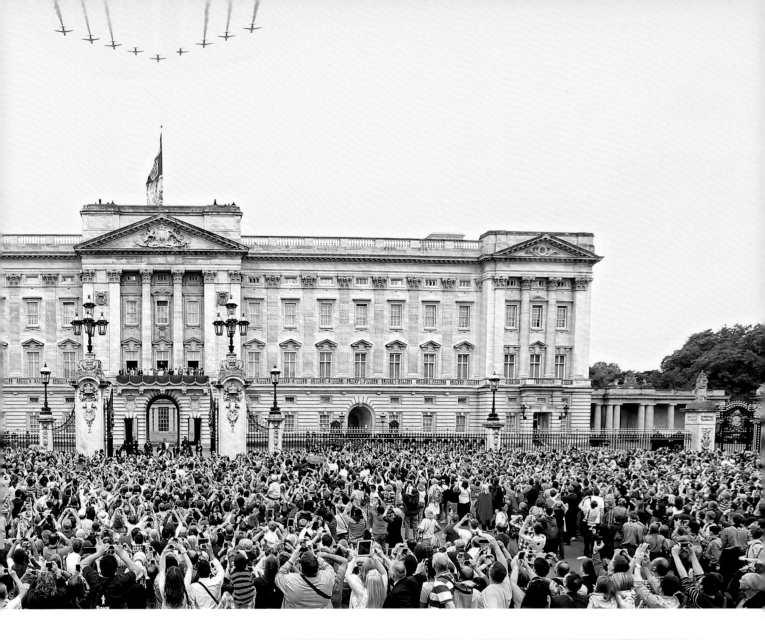

(Left) A man, dressed in a very patriotic Union Jack suit, waves a flag among the crowds lining The Mall.

(Right) Prince George peeks between the curtains at Buckingham Palace before appearing on the balcony with his family on 8 June 2019.

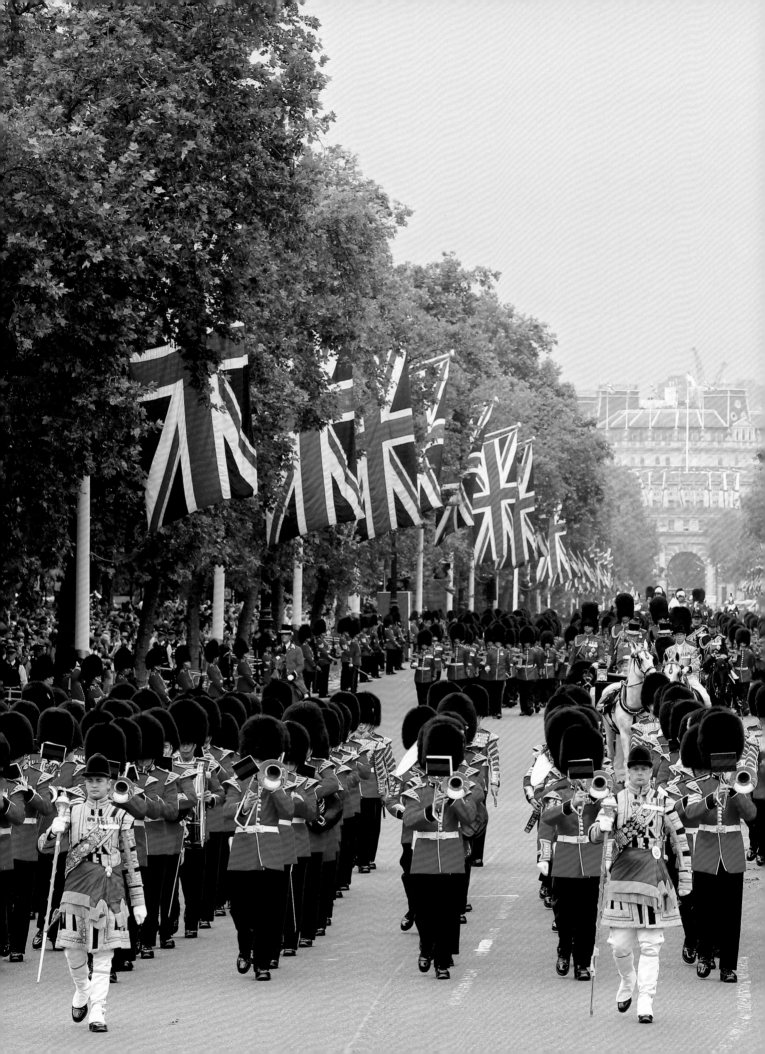

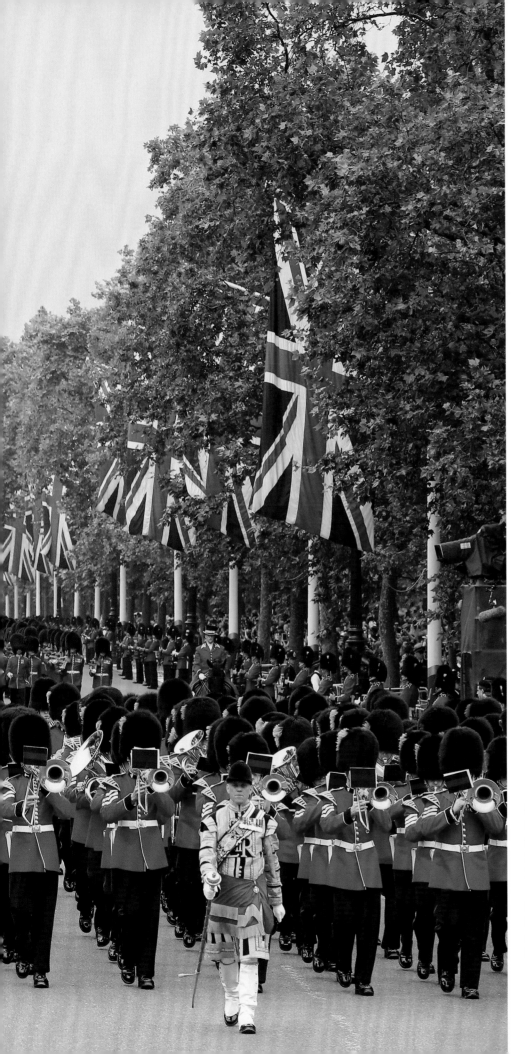

Overleaf
Members of the royal family watch the Royal Air Force fly-past from the balcony of Buckingham Palace on 17 June 2017.

Planes from the Royal Air Force fly over Buckingham Palace on 14 June 2008 during Trooping the Colour, the Queen's Official Birthday celebrations.

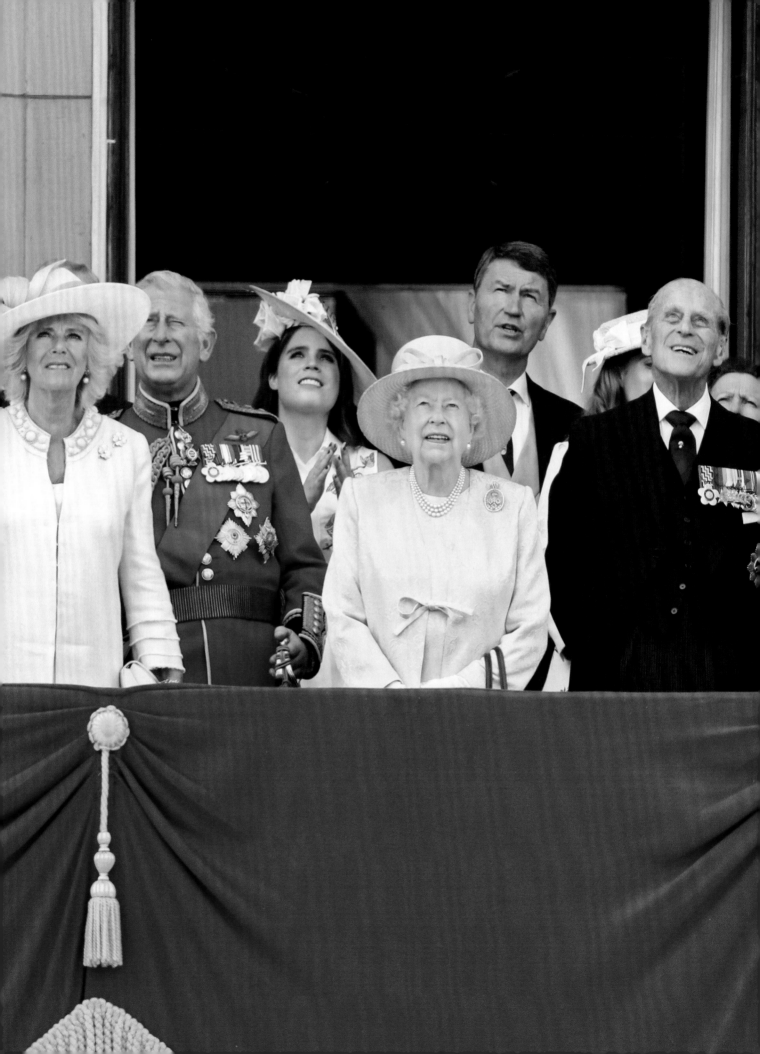

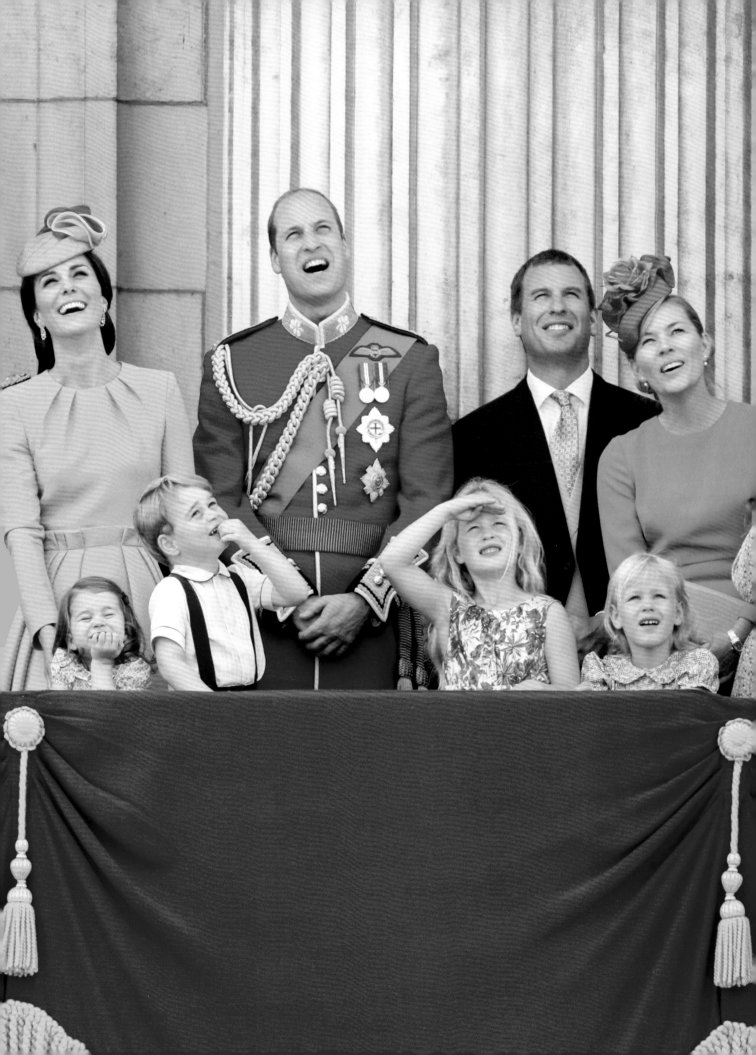

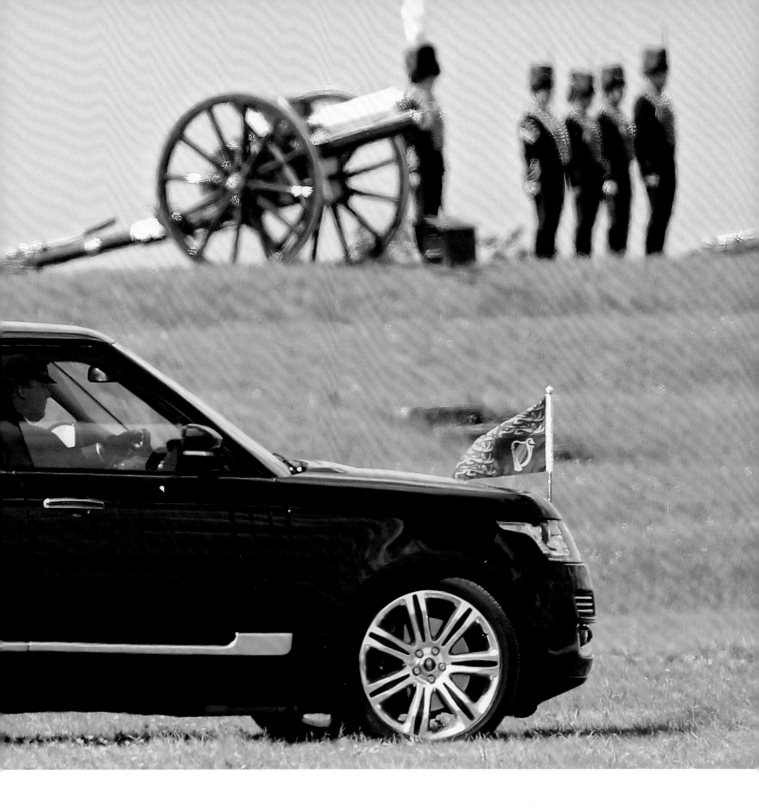

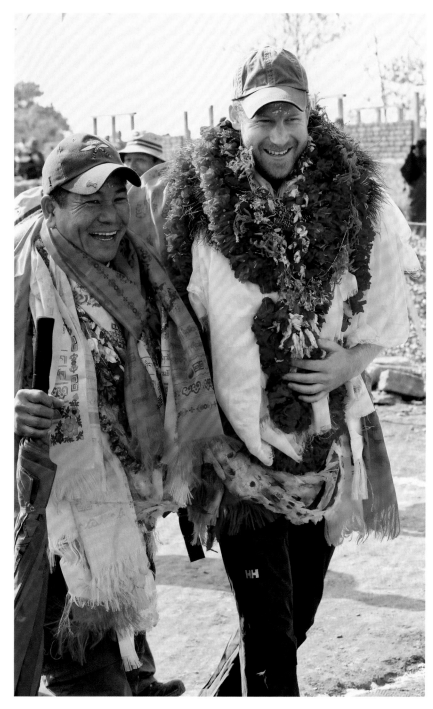

The Gurkhas are soldiers of Nepalese nationality recruited for the British Army, Nepalese Army, Indian Army, and Gurkha Reserve Unit in Brunei, as well as for UN peacekeeping forces around the world. Gurkhas have been part of the British Army for more than 200 years. "Better to die than be a coward" is their motto. The soldiers are well known for not only their fearlessness in battle but also their kindness of heart. I learnt this firsthand during a visit with Prince Harry to the Himalayan mountain village of Leorani in 2016. After a three-hour trek up to the remote village, the sense of humour and warmth displayed by the Gurkhas who looked after me will stay with me for years to come. On the left is an image of Prince Harry with Major Prakash Gurung MVO after they had completed an expedition through the foothills of the Himalayas. The two had first met in Afghanistan in 2007, and Major Prakash also served as the Queen's Gurkha Orderly Officer in recent years.

In 2015, the Queen, the Duke of Edinburgh, the Prince of Wales, and Prince Harry attended the Gurkha 200 Pageant at the Royal Hospital in Chelsea (right) to commemorate two centuries of service by Gurkha soldiers to the Crown. The Gurkhas have served in every major conflict involving British forces since 1815, gaining a reputation for bravery and loyalty. During the Second World War, there were more than 40,000 Gurkha casualties. Thirteen Victoria Crosses—the highest British military decoration for valour—have been awarded to Gurkha soldiers. At the pageant, the royals were entertained by the Band of the Brigade of Gurkhas and dazzled by the colours of the traditional Magar dress worn by Nepalese dancers, before meeting some of the soldiers.

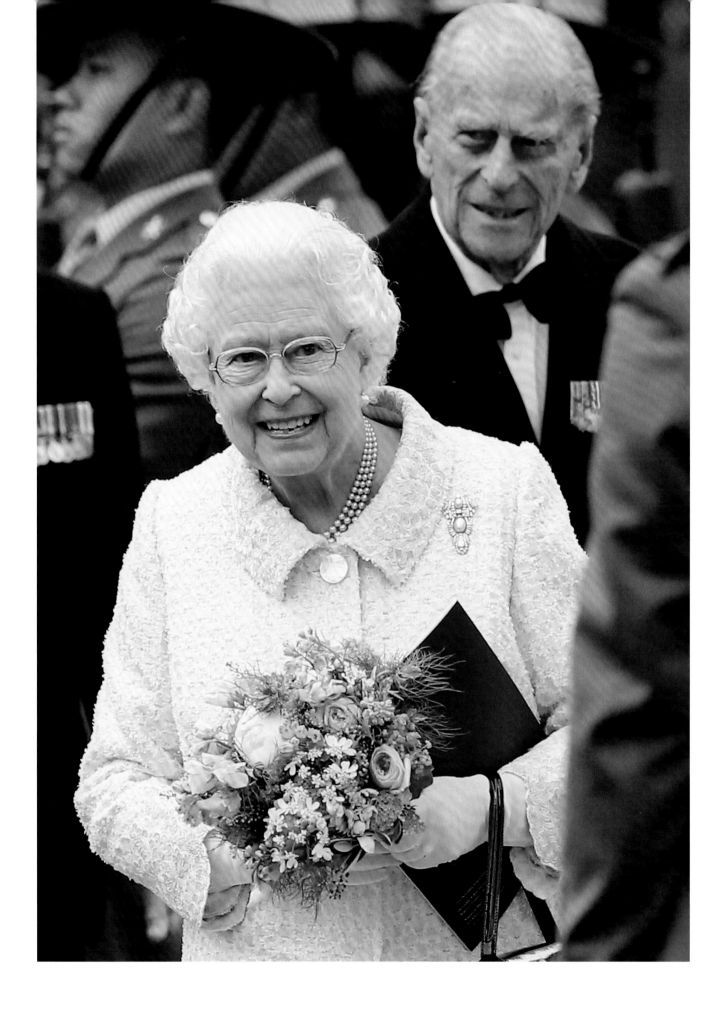

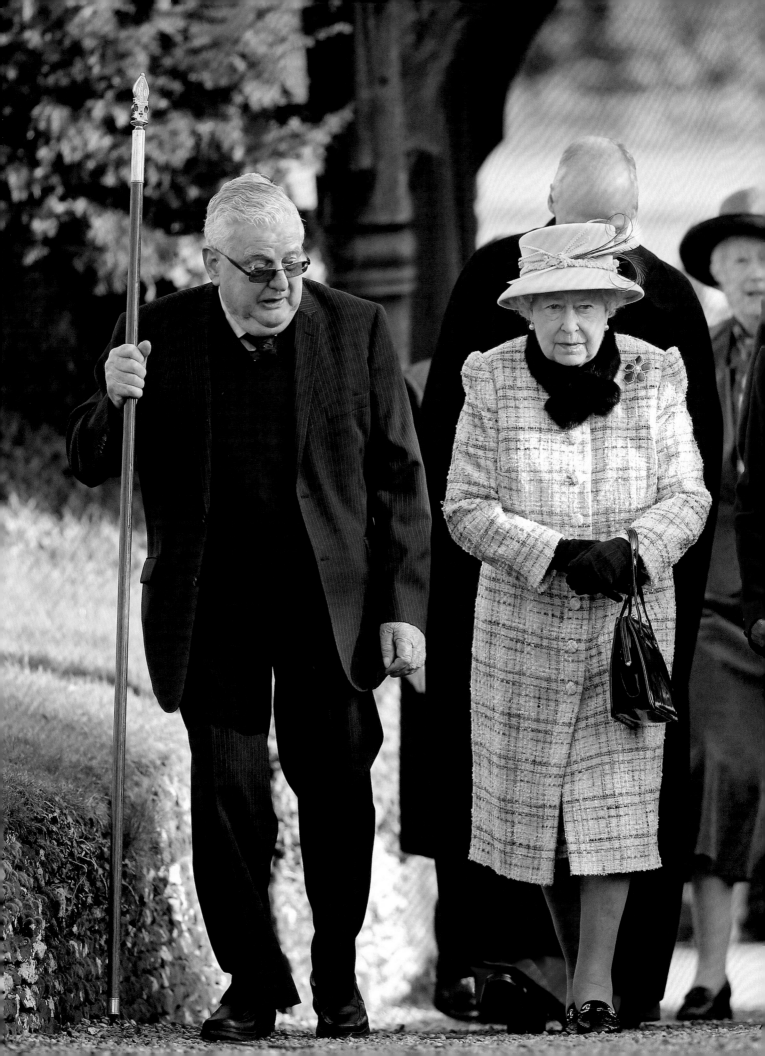

A VERY PERSONAL DUTY

As sovereign, the Queen holds the title "Defender of the Faith and Supreme Governor of the Church of England." She is a deeply religious person and clearly feels a huge responsibility to uphold and represent the values of the Church in everything she does. This relationship to the Church was symbolised during the Queen's coronation in 1953, when she was anointed by the Archbishop of Canterbury and took an oath to "maintain and preserve inviolably the settlement of the Church of England, and the doctrine, worship, discipline, and government thereof, as by law established in England."

In 2014, the Queen described her own faith as "the anchor in my life". She attends church privately every Sunday. It is during the early part of the year that we can witness this deep personal commitment to religion when she attends "open church" services in Norfolk, whatever the weather is. The public may also see her at church during some of the bigger festivals, such as Christmas and Easter. The Queen acknowledges and celebrates other faiths and recognises significant spiritual periods. Interfaith harmony and tolerance remain important to her. They are something I have seen promoted and practised by the Prince of Wales around the world.

LAUNCHING THE CRUISE SHIP *BRITANNIA*

Launching ships, like planting trees, is all part of the job for members of the royal family. There is nothing more prestigious than having the Queen launch a bottle of champagne into the bow of your new vessel. It was on a glorious day that I found myself capturing that exact moment, as the Queen, in an apricot ensemble, watched the bottle crash into the letters B-R-I-T of *Britannia*, an impressive P&O cruise ship designed to carry more than 3,600 passengers. As the band played, the champagne burst onto the ship's side. It is always a relief when it breaks properly, as superstition dictates that a ship will have bad luck if it does not smash.

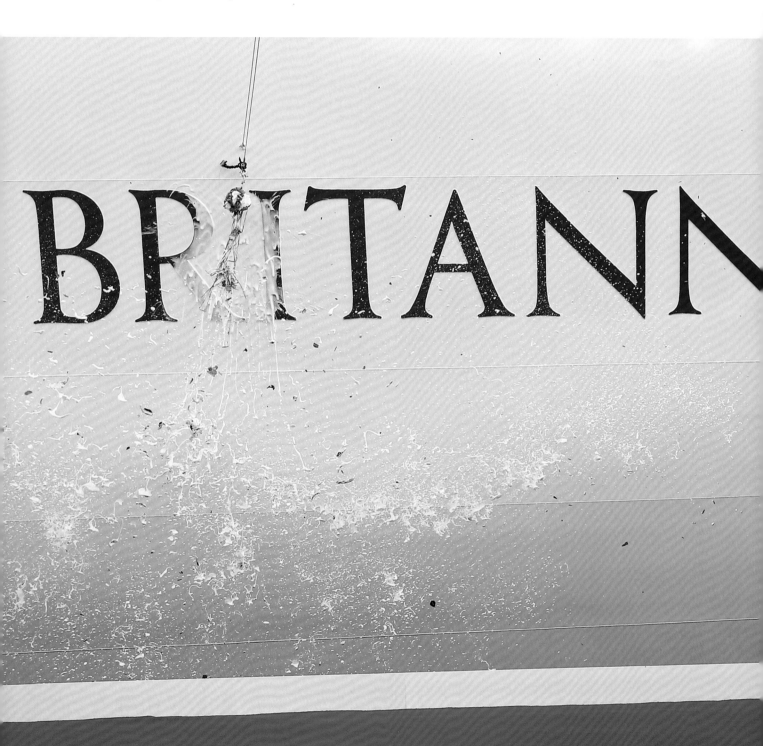

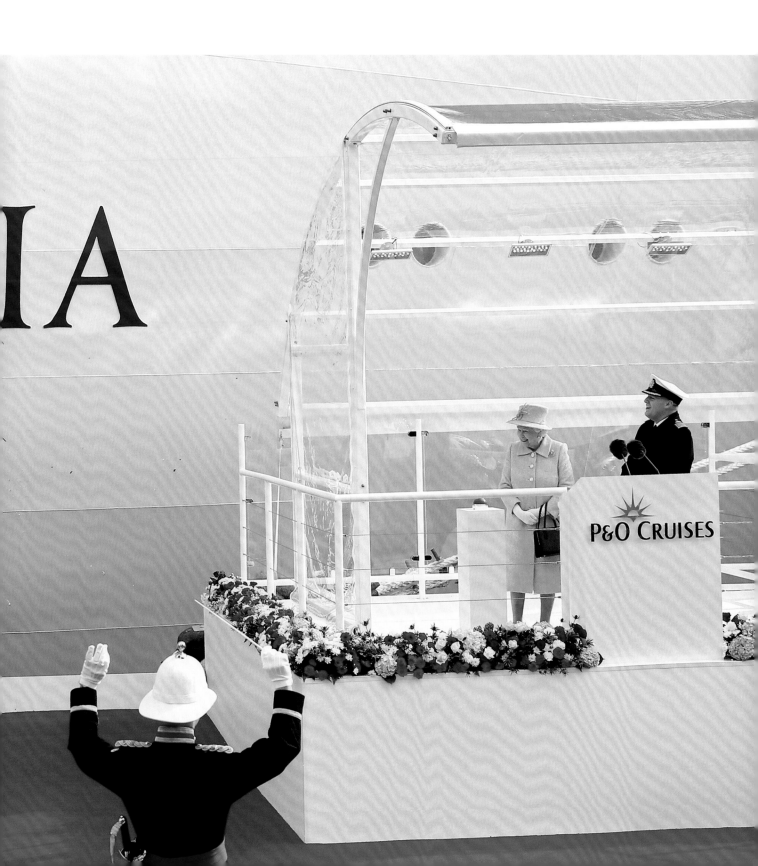

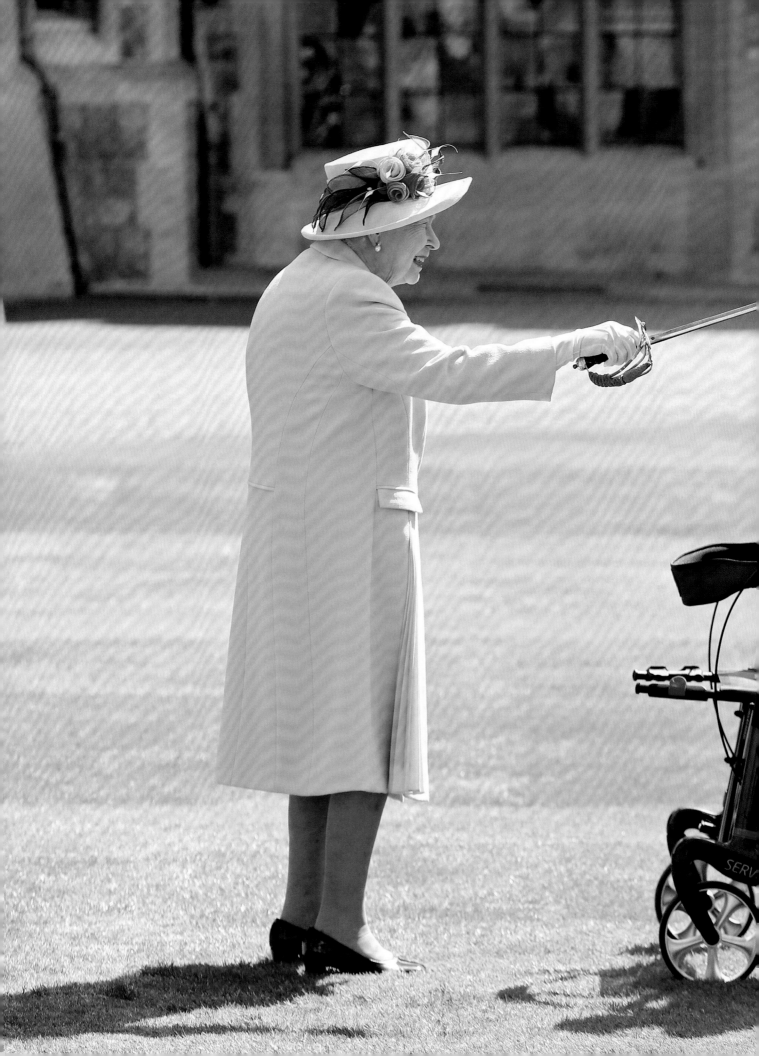

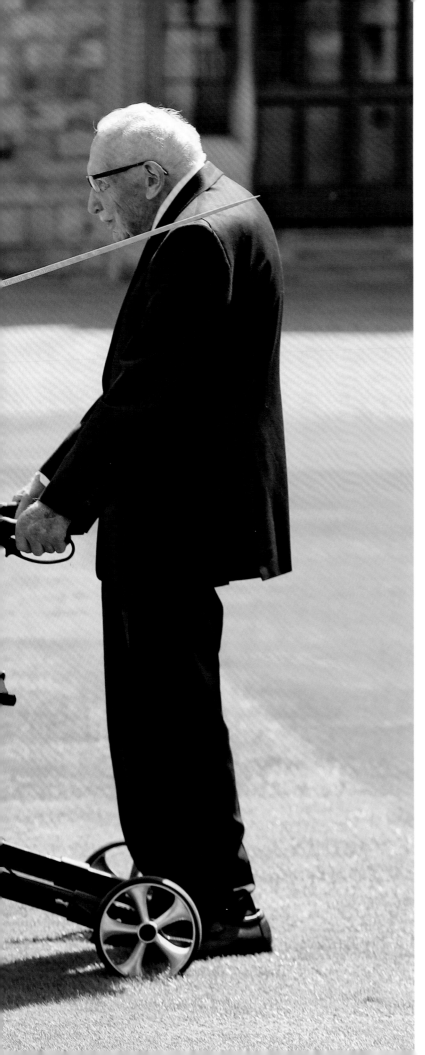

CAPTAIN TOM

It was one of the hottest days of the year when Captain Tom Moore wheeled his now-famous walking frame onto the perfectly manicured grass of the quadrangle of Windsor Castle. A British pensioner, Captain Thomas Moore, known as "Captain Tom," became a national hero when he set out to raise nearly $1,500 ahead of his hundredth birthday by walking a hundred laps of his garden. He captured the imagination of the UK and went on to raise more than $46 million for National Health Service charities. The former military officer served in India during the Burma campaign and later became an instructor in armoured warfare, but it was his achievements in 2020 that made him a household name. The occasion was Captain Tom becoming a Knight Bachelor at Windsor Castle.

The Queen smiled as she looked across to Captain Tom, touching him on both shoulders with the sword that she inherited from her father, George VI, when he was Duke of York and Colonel of the Scots Guards. This event was the Queen's first since the start of the Covid-19 pandemic and the national lockdown. I had been itching to photograph something over this quieter period, and this engagement was the first in a while. It could not have been more moving. Captain Tom's sense of humour became a feature of his humble and light-hearted approach. Asked if he would kneel (as tradition dictates for the investiture), he joked that he "would never be able to get up again." His patience with all the photographs on the day was admirable. It was an honour for me to capture a feel-good event in such difficult times. This particular image became one of my most liked photographs on social media, highlighting how the story became a much-needed beacon of light and inspiration. It is a great example of how the Queen can reward this kind of awe-inspiring achievement and bring a nation together. In February 2021, Sir Captain Tom Moore sadly passed away. Tributes poured in from around the world as Britain celebrated the achievements of this "shining light." It was clear that he captured the heart of the nation and will leave an enduring and inspiring legacy.

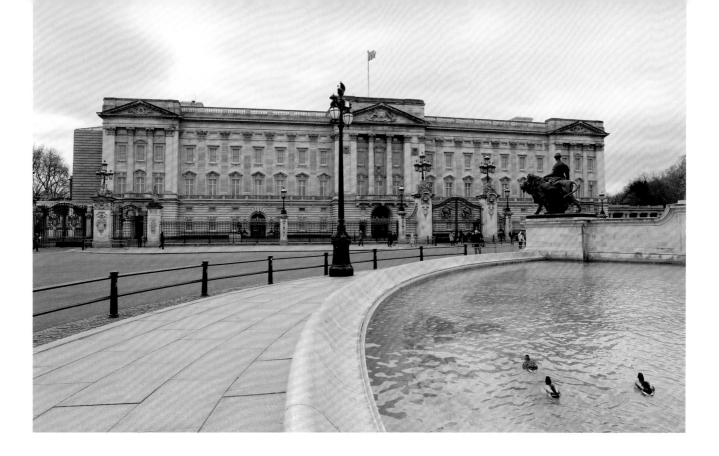

LONDON IN LOCKDOWN

During the first lockdown in 2020, there was a sense of fear of the virus and foreboding for what the future held. I documented many of the deserted streets in the capital, and saw Covid-19's crippling impact on our life and economy in this normally bustling city. It was with sadness that I visited sites that would usually be thronging with tourists and shoppers, but it was Buckingham Palace that most struck a chord. As a rule, the forecourt and the area around the Queen Victoria Memorial would be buzzing with tourists, but all I found were a few ducks, totally unaware of the global disaster unfolding around them.

A DEBUT ON ZOOM

As lockdowns were imposed during the Covid-19 pandemic, the royal family faced a dilemma: how to keep in touch with the public. Workers around the world flocked to the remote conferencing system Zoom. This was embraced by many of the younger members of the family. Despite this, it was a surprise to see the Queen appear from the Oak Room (her sitting room at Windsor Castle) on a Zoom call on 11 June 2020 to mark Carers Week and pay her respects to all the nurses, doctors, and care-home staff who had been battling on our behalf throughout the pandemic.

by what you have achieved already.
I'm very glad to have been able to join you today.

A QUEEN'S SPEECH

The Queen delivered a Covid-19 speech at exactly the right moment—when many people were searching for answers and feeling lonely while confined in their own homes. It showed the monarch doing what she does best. She struck a chord with the British public, broadcasting into our locked-down sitting rooms and kitchens when anxiety about the virus was at its peak. Her words summed up the worries and sadness of families who could not see their loved ones, workers who feared for their jobs, and people struggling on the front line, battling a virus that at that time we knew so little about and that had taken the lives of so many around the world. Her words touched the heart of the nation and will remain in our minds, symbolic of her ability to inspire and give hope.

"We should take comfort that while we may have more still to endure, better days will return: we will be with our friends again; we will meet again." QUEEN ELIZABETH II

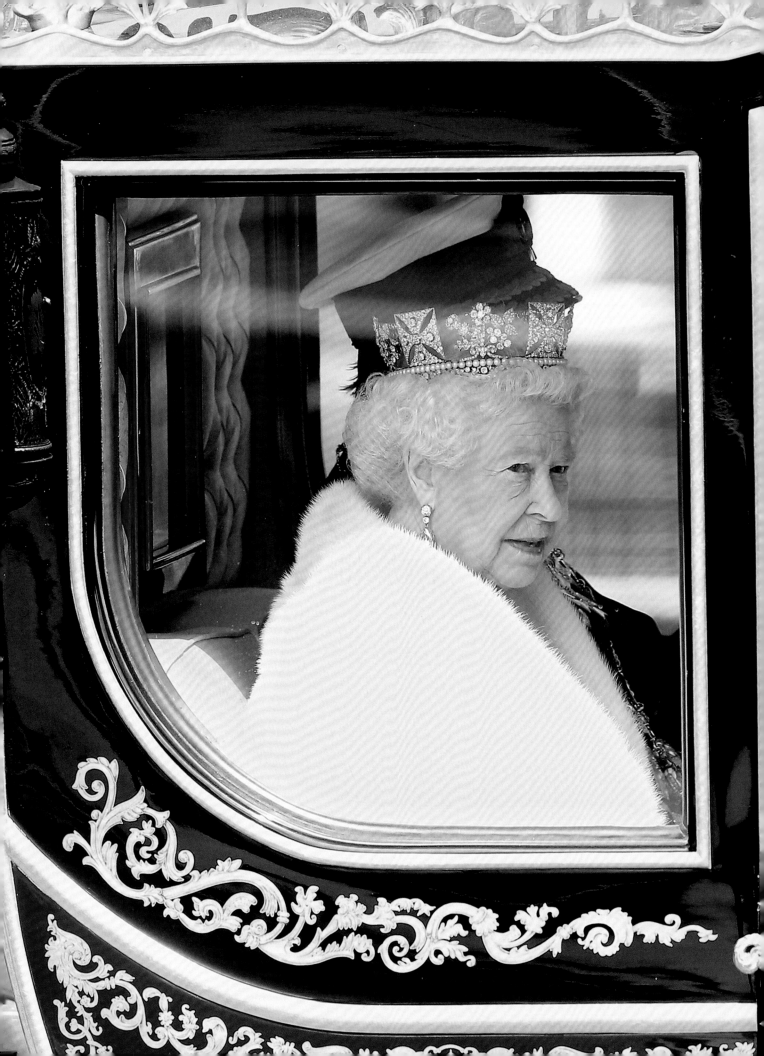

THE STATE OPENING OF PARLIAMENT

The State Opening of Parliament is one of the more important ceremonial engagements in the Queen's working year. It is accompanied by all the pomp you would expect of such an event. A photographer has a number of different aspects to cover, from the carriage procession out of Buckingham Palace (normally photographed from the Queen Victoria Memorial), to the Houses of Parliament, to capture the ceremony itself (on this occasion, I was positioned within the central lobby).

Pages 102–3
Here in 2016, the Queen and the Duke of Edinburgh look on as peers gather in the House of Lords ahead of the Queen's Speech, which formally marks the start of the parliamentary year. The State Opening of Parliament is now a solo engagement for the Queen, since the Duke retired from public service. I was right on my tiptoes to take this shot, trying to see above the robe-clad peers. This image has significant historical value, as it is one of the last times that the Queen wore the Imperial State Crown. The crown features more than 2,868 diamonds, 17 emeralds, and 17 sapphires. It was made for the coronation of King George VI in 1937. In recent years the Queen has swapped this impressive and incredibly heavy crown for the lighter George IV State Diadem.

Overleaf
The Yeoman of the Guard walk through the Peers' Lobby after carrying out the ceremonial search ahead of the State Opening of Parliament in the Houses of Parliament on 18 May 2016.

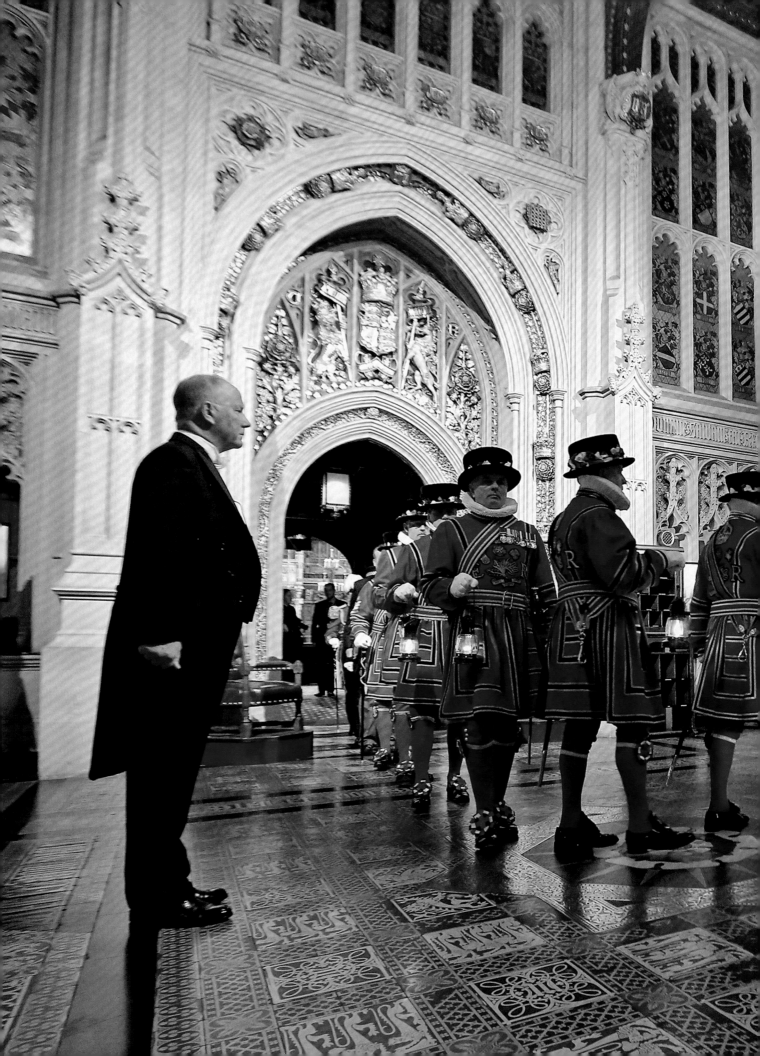

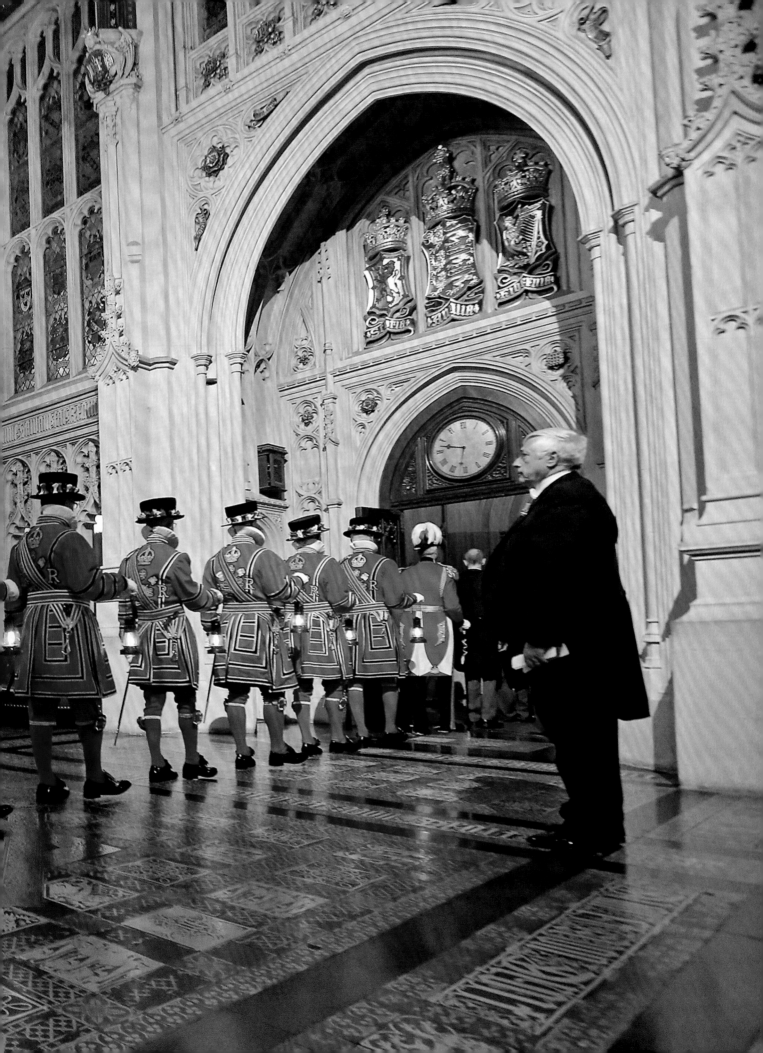

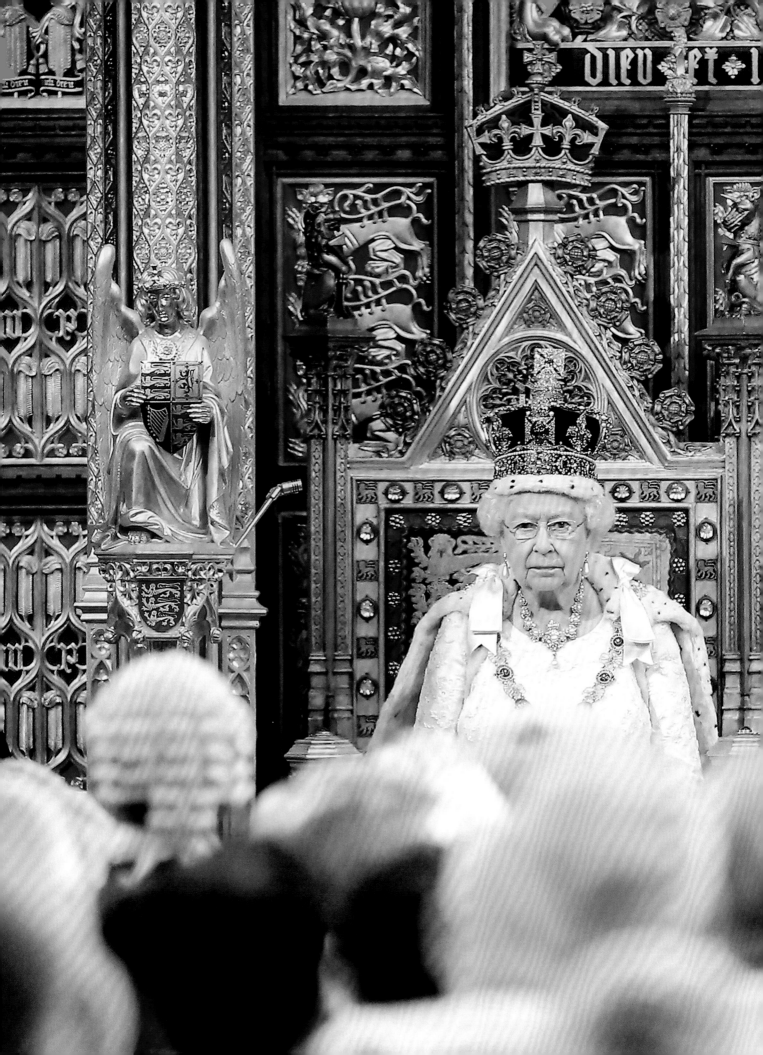

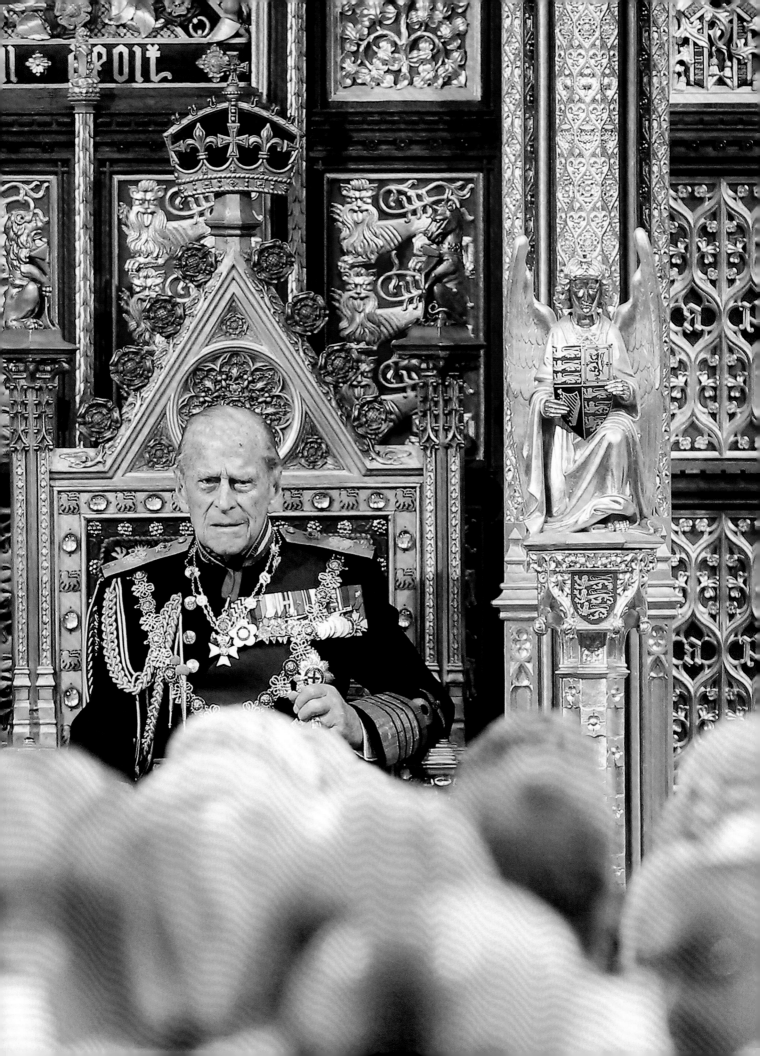

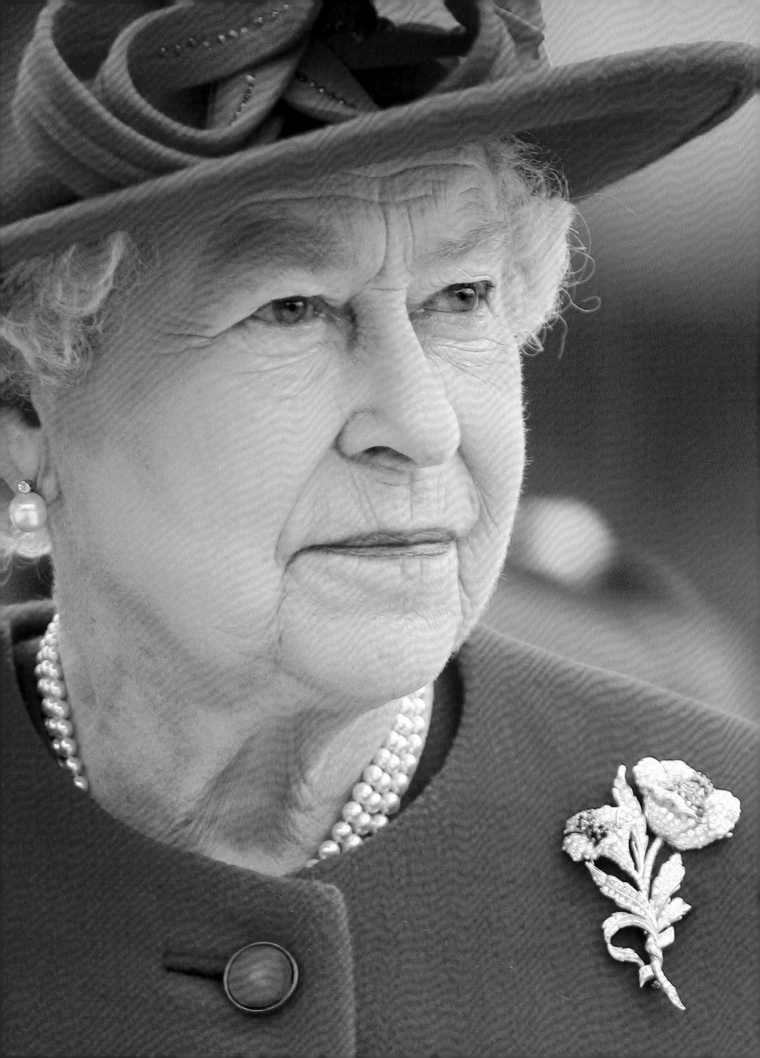

III

GLOBAL ICON

Queen Elizabeth II has reigned for longer than any other living monarch and is an iconic representation of everything British. She has spent much of her life travelling, but she has recently stepped back from this aspect of her role. As Head of the Commonwealth and an ambassador and statesperson, she remains a revered figure globally.

I would have loved to have been around during the times of the royal yacht, which was in service from 1954 until 1997, and clocked up more than a million nautical miles. These days, members of the royal family travel predominantly by aircraft. It is the romanticism of the slow pace of a yacht that appeals to me. It must have enabled the Queen all those decades ago to be the perfect host to visitors while aboard this slice of Britain in another land.

Although the Queen does not travel, she remains the most powerful domestic "selling point" for the UK. To be invited to London on a State Visit is a huge honour for a visiting dignitary. The Queen and royal family are an institution that continues to have influence far beyond the shores of the country.

The Commonwealth is among the most important facets of the Queen's role and one for which she feels a huge amount of pride. Almost unrecognisable from the association she inherited when she became Queen in 1952, the Commonwealth now comprises fifty-four countries working together for prosperity, democracy, and peace around the world.

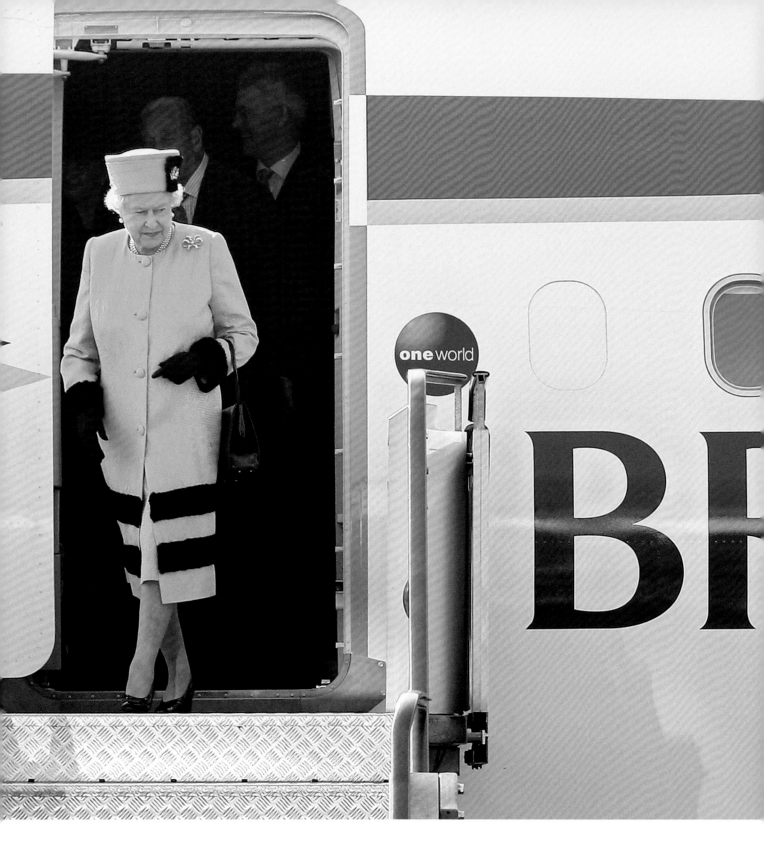

The Queens steps off a British Airways plane at Ljubljana Jože Pučnik Airport at the start of a two-day visit to Slovenia. This was the monarch's first visit to the former Communist country.

Page 104
The Queen looks on at the presidential Grassalkovich Palace in Bratislava on 23 October 2008. The Queen and the Duke of Edinburgh were on a two-day tour of Slovakia at the invitation of President Ivan Gašparovič.

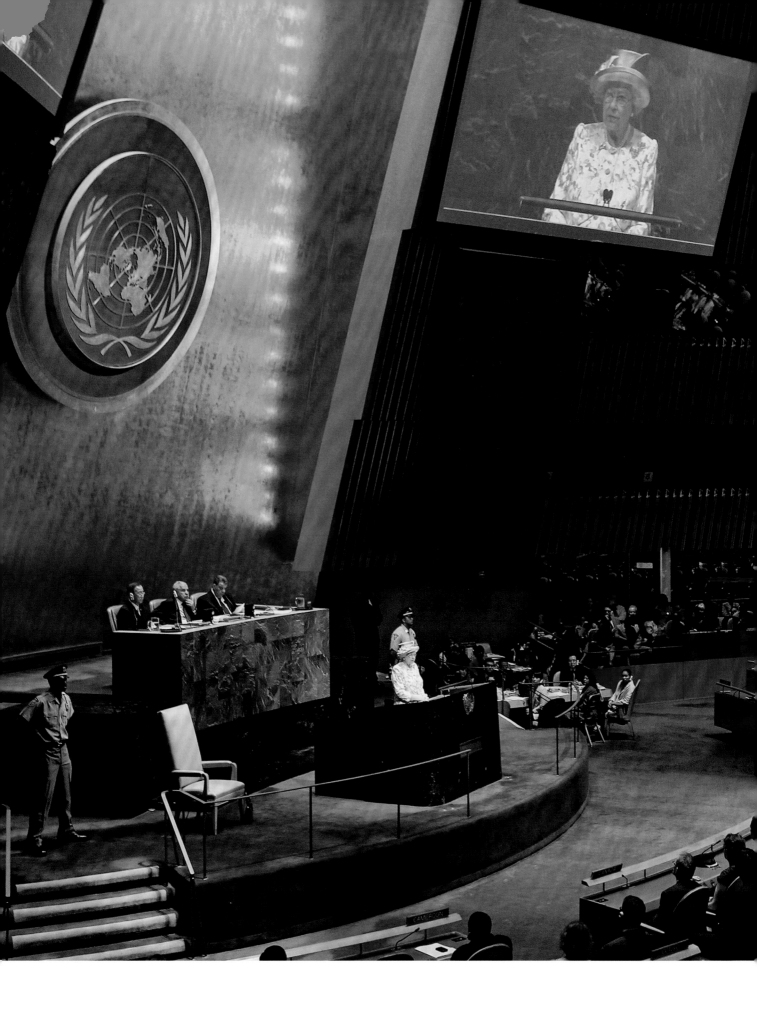

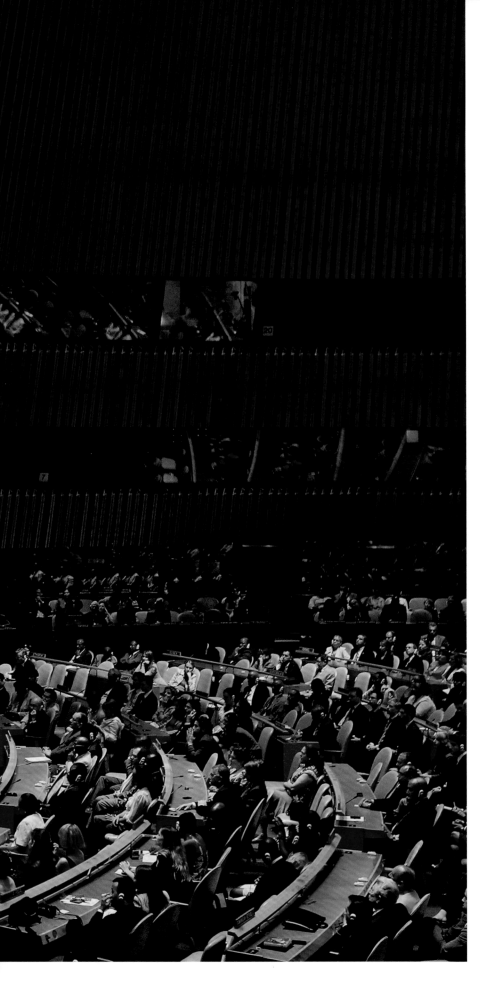

"In my lifetime, the United Nations has moved from being a high-minded aspiration to being a real force for common good."

QUEEN ELIZABETH II

SPEAKING AT THE UNITED NATIONS

The United Nations represents the ultimate in global diplomacy and conversation. The UN's iconic headquarters in Midtown Manhattan are a beacon of neutrality and stability, so it was with great excitement that I captured the Queen speaking from that famous lectern in 2010. Afterwards, I photographed the Queen with Ban Ki-Moon, the then Secretary-General of the UN, as she was given a tour of the building.

THREE PRESIDENTS

The visit of a US president is an exciting thing to be a part of. You get to see "The Beast" Cadillac limousine, Marine One, earnest-looking security in dark glasses speaking into hidden microphones, and so on.

(Pages 114–15) This image of Marine One landing in the Queen's "back garden" at Buckingham Palace, as the downdraft blows the journalists' hair as they frantically try to capture the historic moment on video, was one that certainly stood out during President Donald Trump's trip to the UK.

(Overleaf) I was also tasked with photographing the State Banquet for President Barack Obama's visit in 2011. The photograph was to be taken as the Queen, the Duke of Edinburgh, and President Obama and First Lady Michelle Obama headed through to the banquet hall. As the doors opened, they emerged and posed for this shot. With only moments to capture a group picture, as well as a close-up of the Queen and President Obama, there was a lot to achieve in a short amount of time.

(Right) I was a young photographer when I first went to the White House in Washington, DC. Getting to visit these iconic and historic locations, while being at the centre of an evolving and globally relevant royal tour, was hugely exciting. The platform that had been erected in the garden from which to photograph President George H.W. Bush and the Queen on the balcony was the perfect spot to capture all the pomp and ceremony that unfolded in front of the famous White House. The Queen, the Duke of Edinburgh, President Bush, and First Lady Barbara Bush waved to the crowd on the South Lawn.

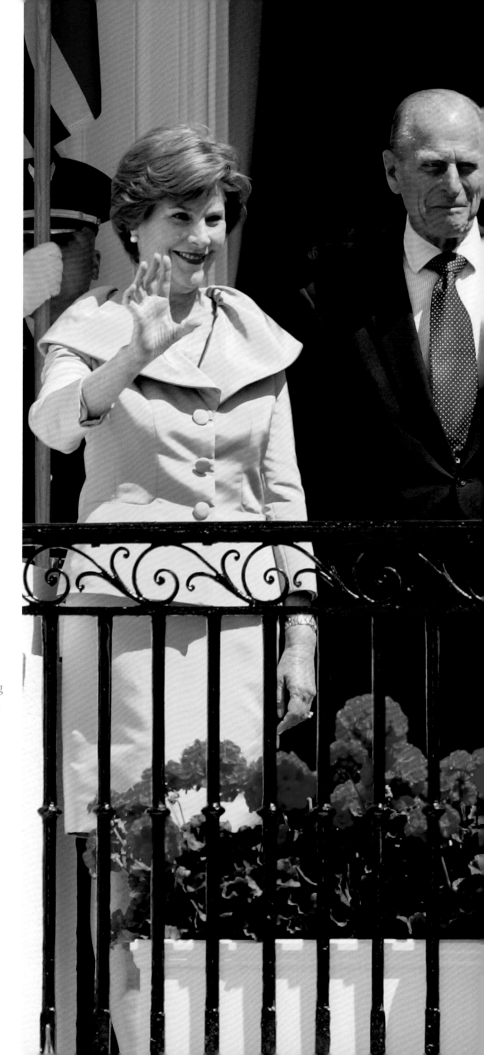

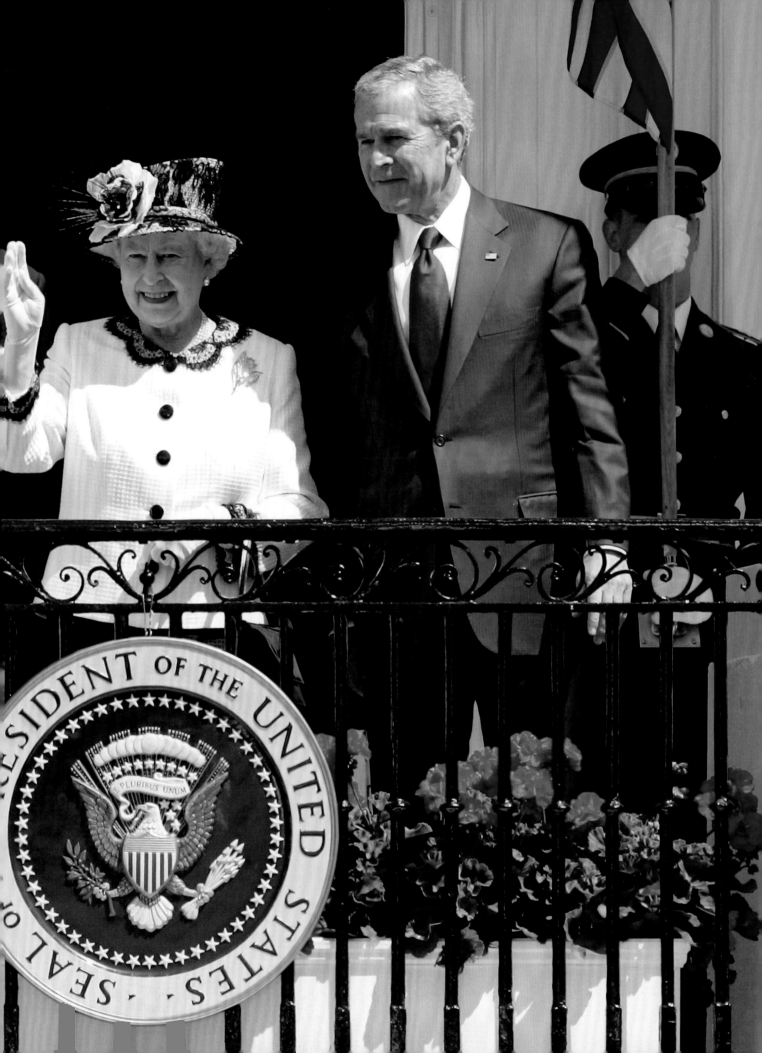

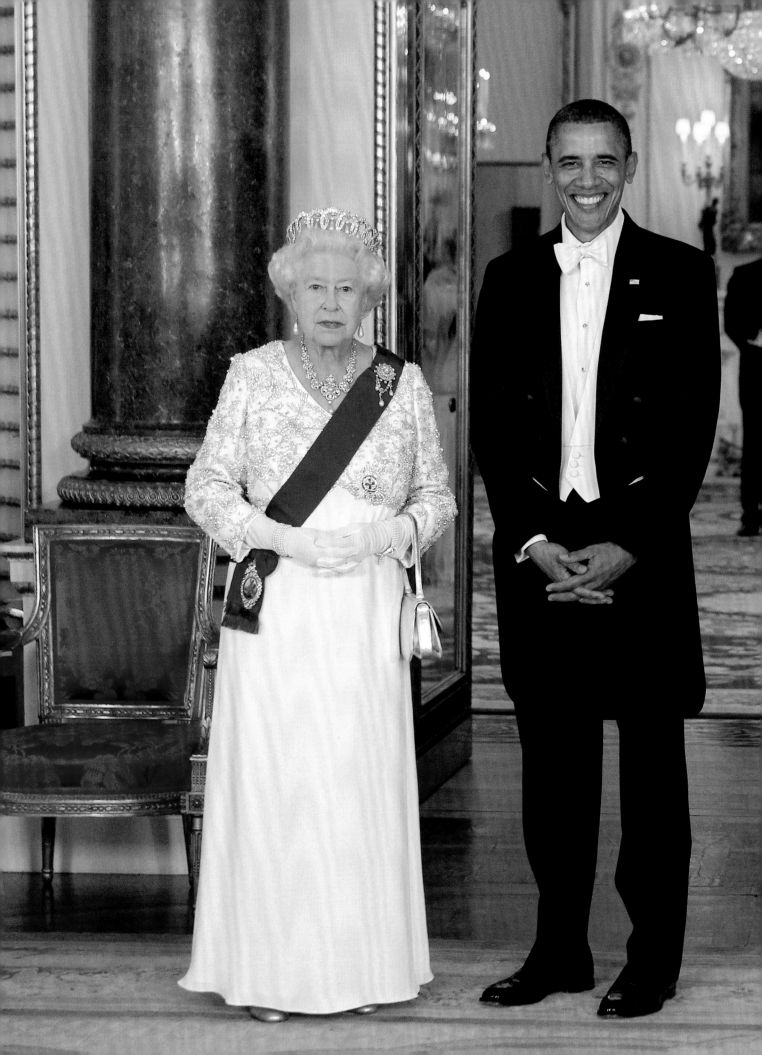

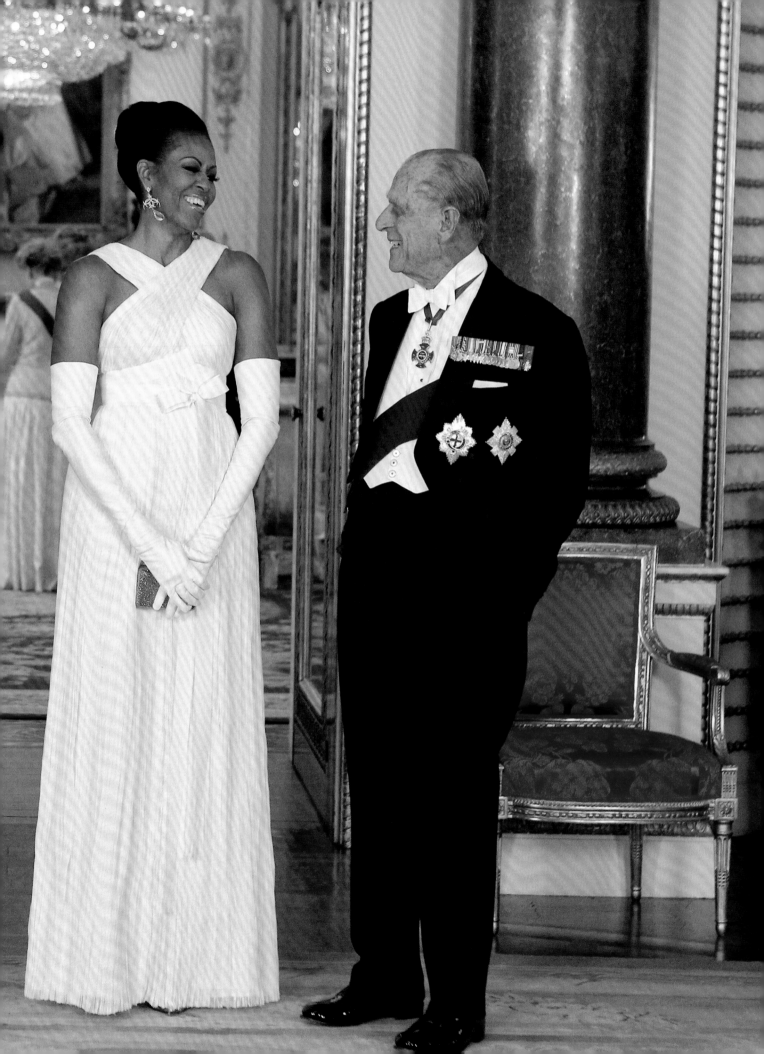

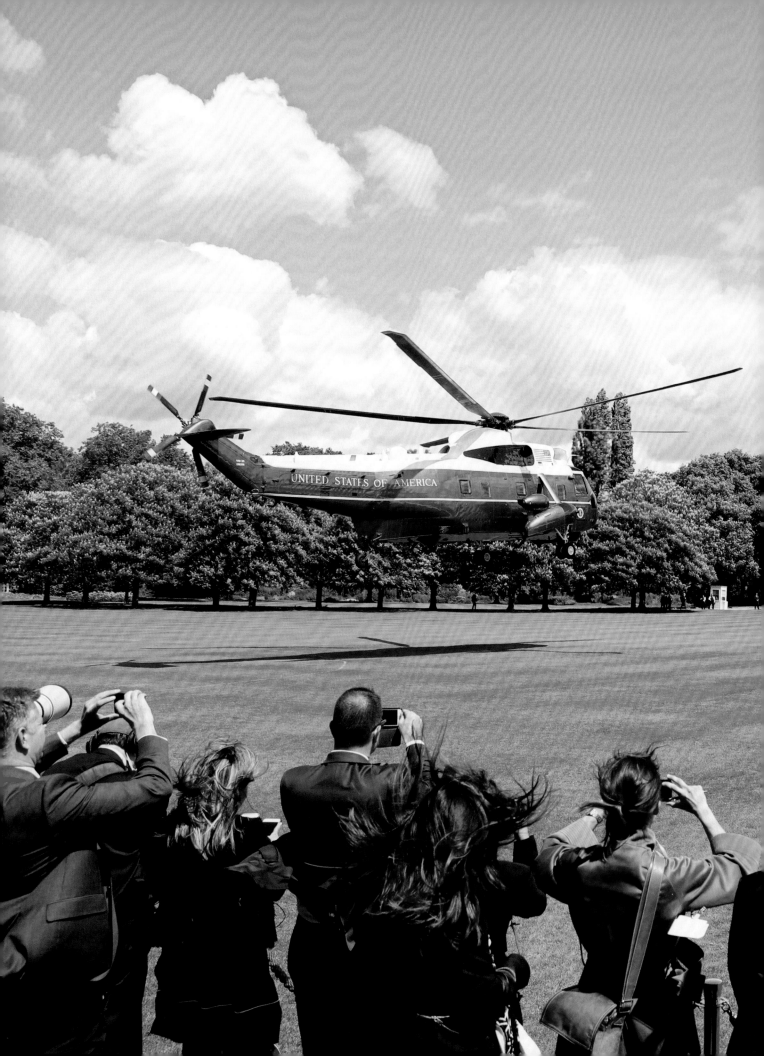

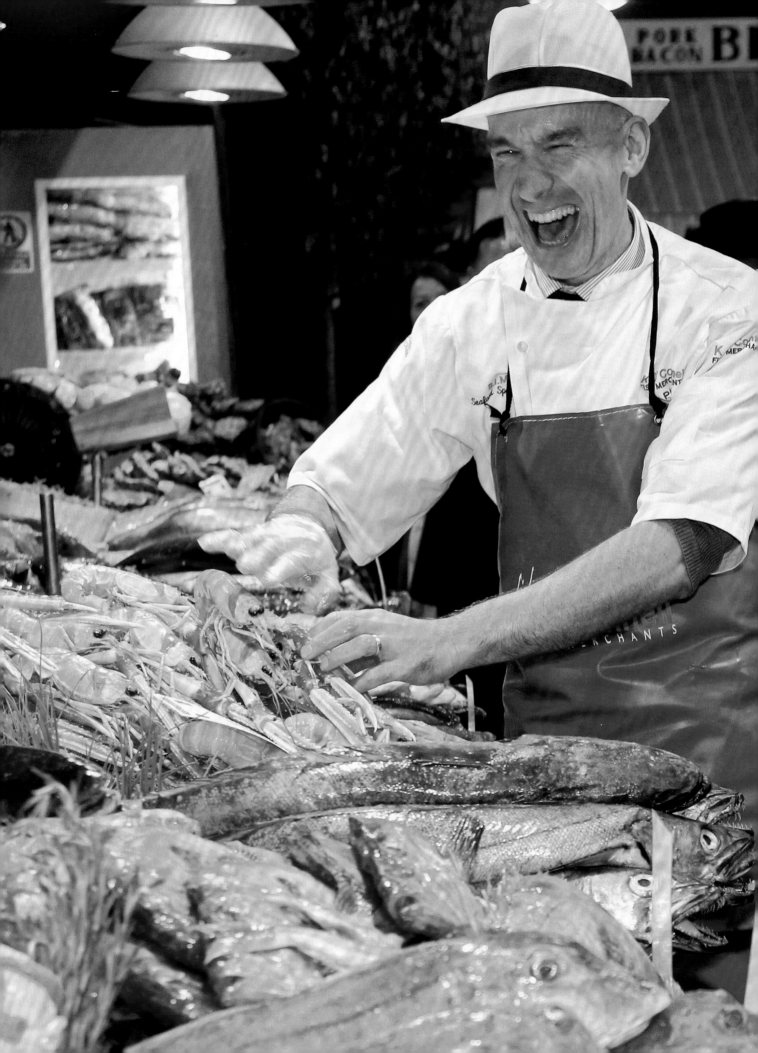

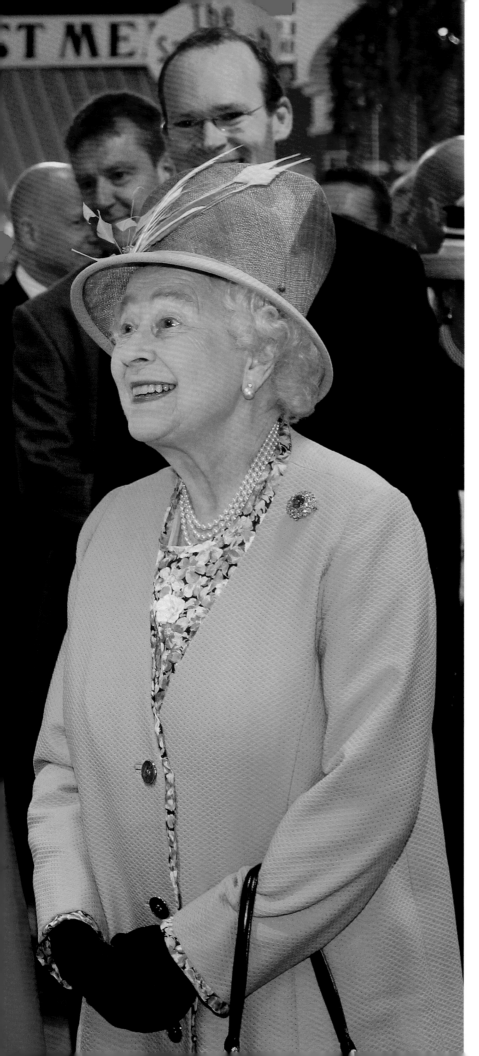

THE QUEEN'S HISTORIC TRIP TO IRELAND

In 2011, the Queen became the first British monarch to visit Ireland since 1911. It is a privilege to record these kinds of landmark trips. I can feel the weight of history and the importance of the photographs I take. The excitement of being involved eclipses the pressure of getting it right. An unprecedented security operation put the Queen's safety at the forefront. I remember the helicopters circling overhead and snipers looking on from the rooftops of nearby buildings, while she laid a wreath in the Dublin Memorial Garden, one of her most poignant tasks.

As the visit moved on from Dublin, one of the standout moments for me was when the Queen took a walk in the famous English Market in Cork and met a rather exuberant fishmonger, Pat O'Connell. I just love the expressions on both their faces! As we left the market and the gathered crowds cheered, I can remember as if it were yesterday the buzz of documenting such a significant historic occasion: a British monarch meeting and shaking hands with members of the Irish public for the first time in a hundred years.

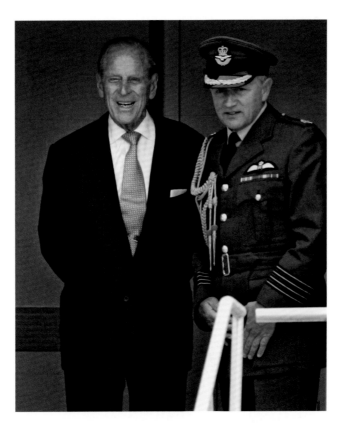

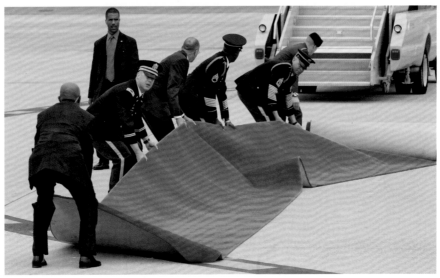

A RED-CARPET DEBACLE

The year was 2007, and the Queen and the Duke of Edinburgh were paying a State Visit to America. The six-day trip commemorated 400 years of the Jamestown Settlement. I could not have been more excited about this high-profile event and was excited for it to kick off. The Queen and the Duke were due to arrive at Richmond International Airport on a British Airways charter flight. As the plane touched down, everything seemed to be going smoothly. However, officials struggled, almost comically, with the arrangement of the red carpet, which should have run up to the steps at the base of the plane. At one point, the Duke appeared at the plane's door and chuckled as he looked down on the unfurling chaos below. Eventually, after a 25-minute delay, the carpet was laid in a more-or-less straight line and the Queen and the Duke stepped off the aircraft to begin a memorable US visit.

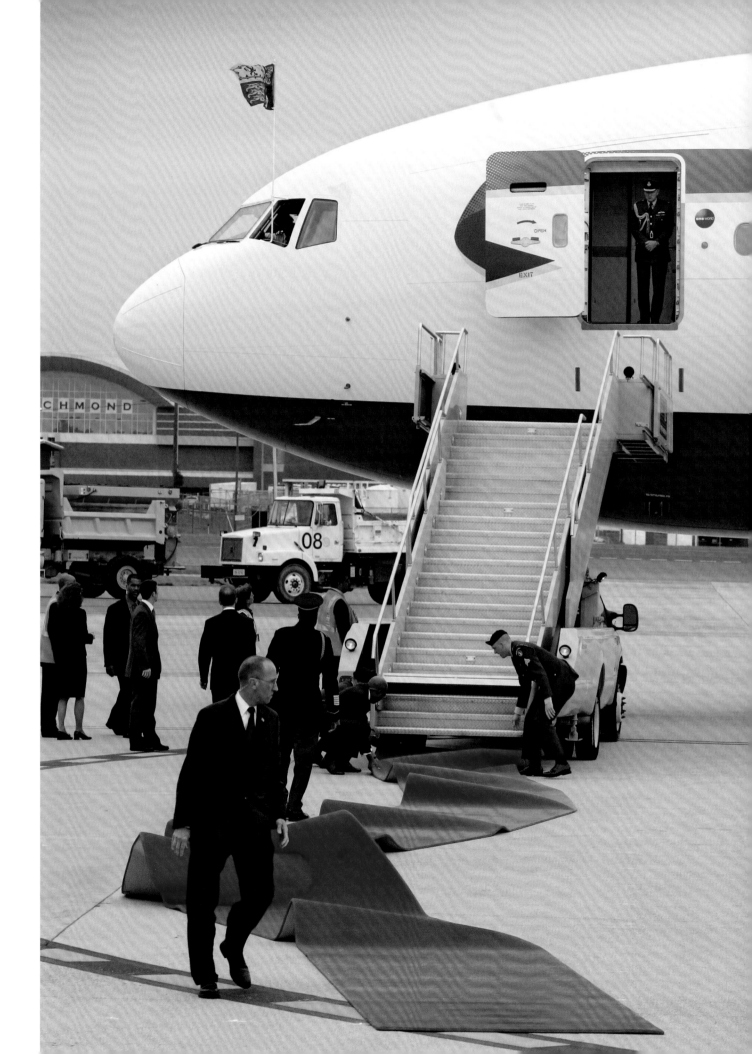

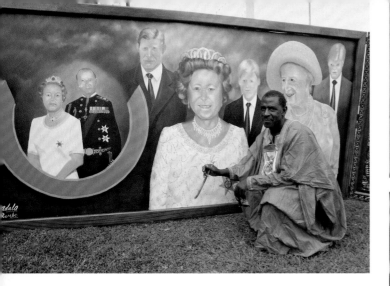

ARRIVING IN UGANDA

In 2007, I travelled overseas to cover the Commonwealth Heads of Government Meeting in Kampala, Uganda. The African capital had frantically prepared for this event to happen, and there seemed to be a strong sense of pride among the locals that it was taking place in their country. The fact that it had been made a public holiday further heightened the party atmosphere and there were jubilant scenes when the Queen arrived on her first visit since 1954. I travelled in the Queen's convoy as the parade of cars snaked into Kampala. Some of my most vivid memories are of the streets from the airport to the city centre, lined with cheering and waving with a level of excitement and enthusiasm I have not seen on any arrival since. It was exhilarating to be a part of it.

Many of the rooms in the media hotel in Kampala had not been completed in the run-up to the event. My own booking had fallen through, so I ended up sleeping on the floor of a fellow photographer's room—not the ideal preparation for the next day's work! After documenting some portraits of the royal family by a local artist, we visited the Mildmay Pediatric Care Centre where the Queen opened their new Elizabeth wing. I captured the Queen and the Duke of Edinburgh as they were greeted by a sea of flags before watching performances from the young children.

Overleaf
Ugandans enthusiastically greet the Queen's convoy as she makes her way from the airport into the centre of Kampala during the Commonwealth Heads of Government Meeting in November 2007.

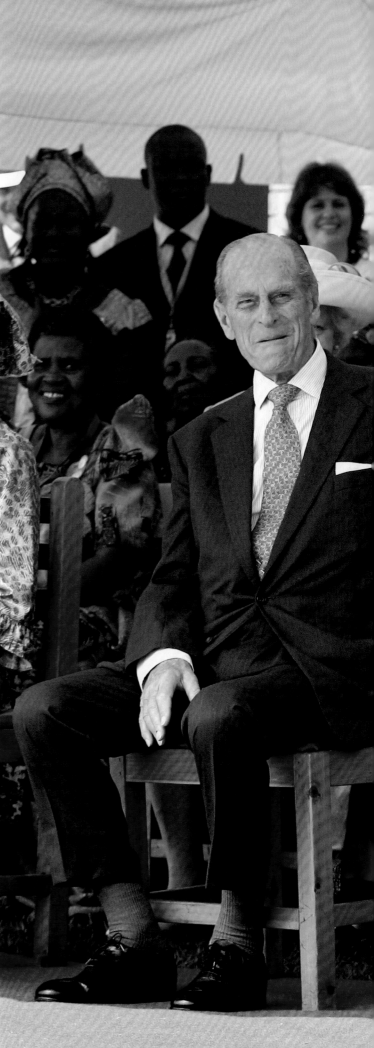

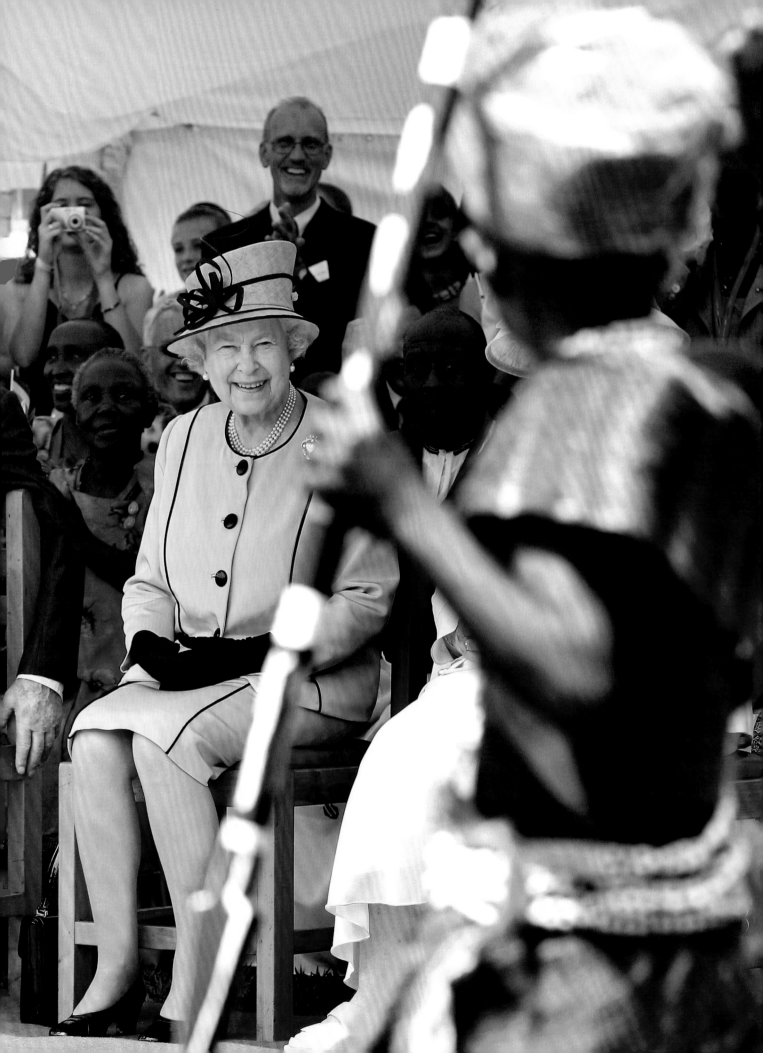

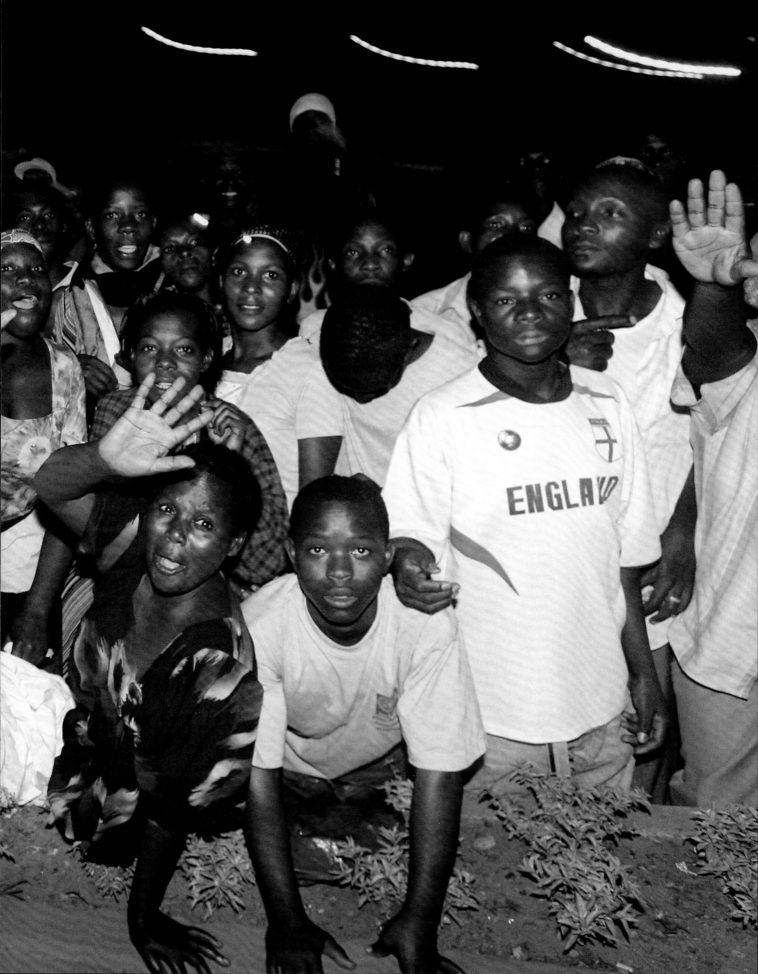

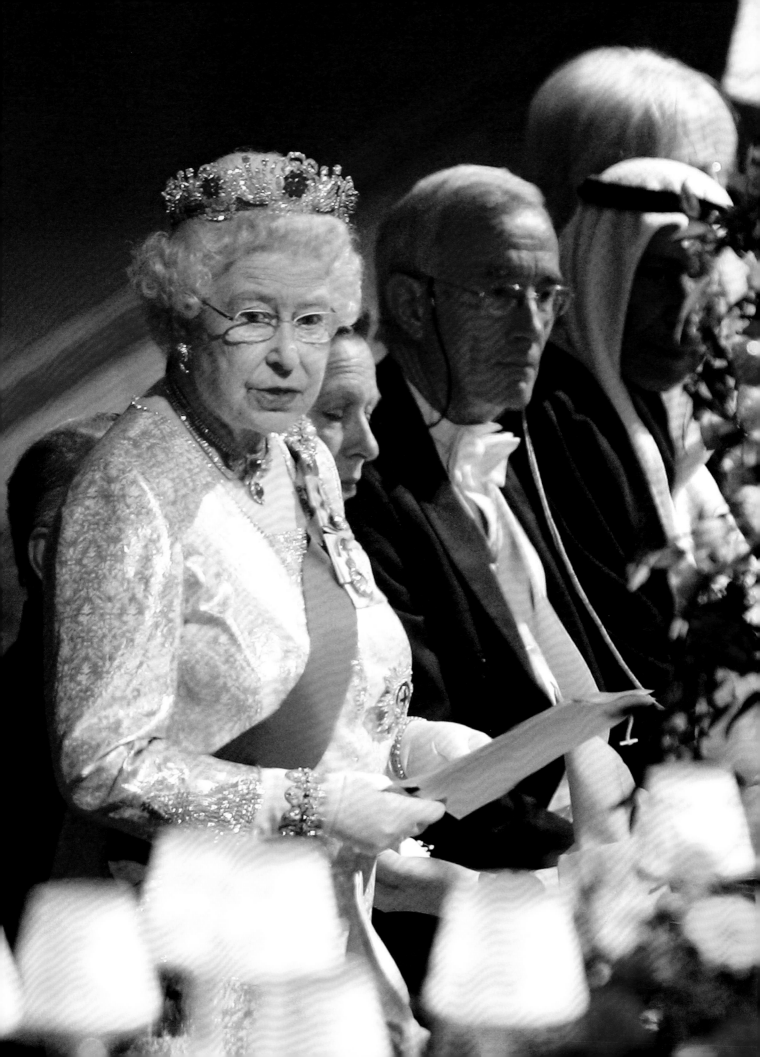

THE STATE BANQUET

Any State Visit is an opportunity to impress the invited dignitaries, be they prime ministers, kings, queens, or presidents. British pomp and ceremony are unique and unbeatable in their ability to strengthen relationships with allies around the world. This particular State Banquet for the President of the Republic of India, Pratibha Devisingh Patil, took place in St George's Hall at Windsor Castle in 2009.

Overleaf
Meticulous organisation goes into the planning of a State Banquet in the historic 180-foot St George's Hall at the Queen's residence of Windsor Castle.

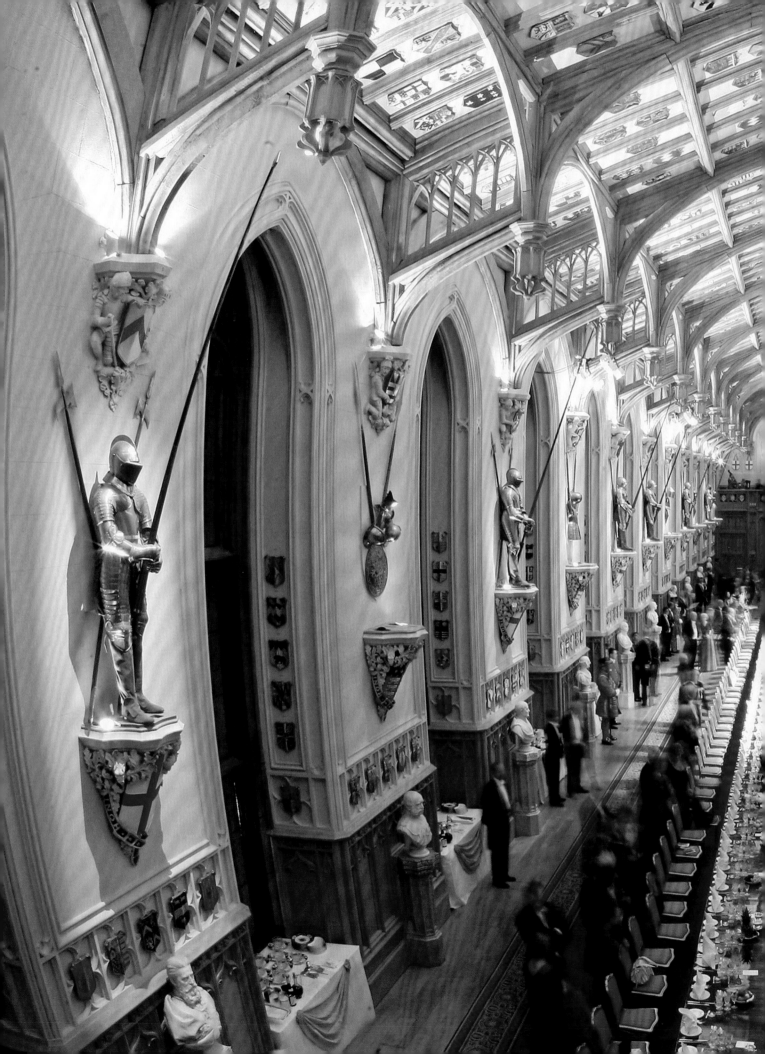

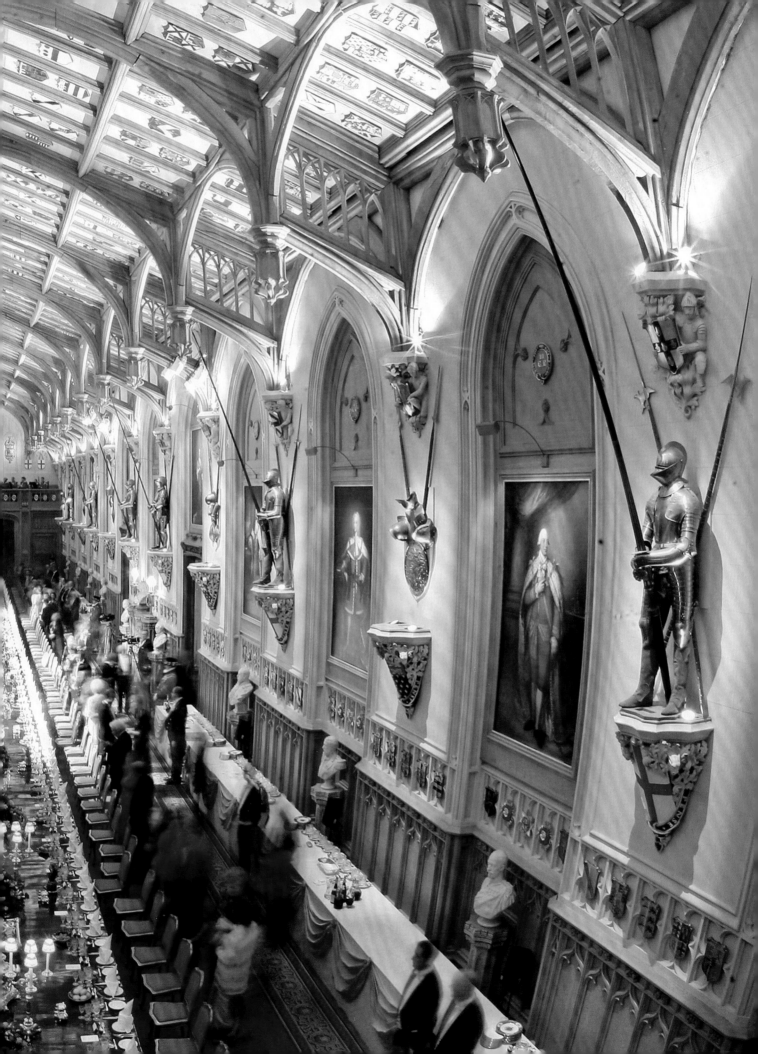

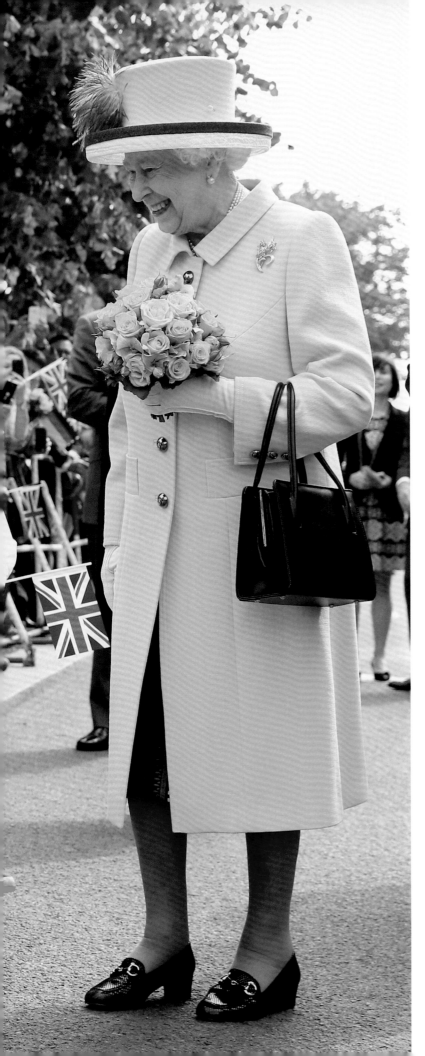

THE QUEEN MEETS THE "GERMAN KING"

It was during a sunny and good-humoured walkabout in June at the end of a four-day State Visit to Germany that the Queen, in a striking pale yellow ensemble, met five-year-old Konrad Thelen. As she left the Adlon Hotel in Berlin, she was greeted by a group of excited well-wishers. Clearly tickled by the young boy's regal outfit, the Queen smiled broadly, before going on to travel by car under the Brandenburg Gate. I was hoping to photograph her next to the iconic German landmark, but as is so often the case with the choreography of these events, it was out of my control. However, I was positioned at the side of the gate that enabled me to capture the interactions between the Queen and the crowd, which resulted in a lovely set of uplifting images.

Overleaf
The Queen's Bentley State Limousine passes under the iconic Brandenburg Gate after departing the Adlon Hotel with the Duke of Edinburgh to conclude a four-day State Visit to Germany in June 2015.

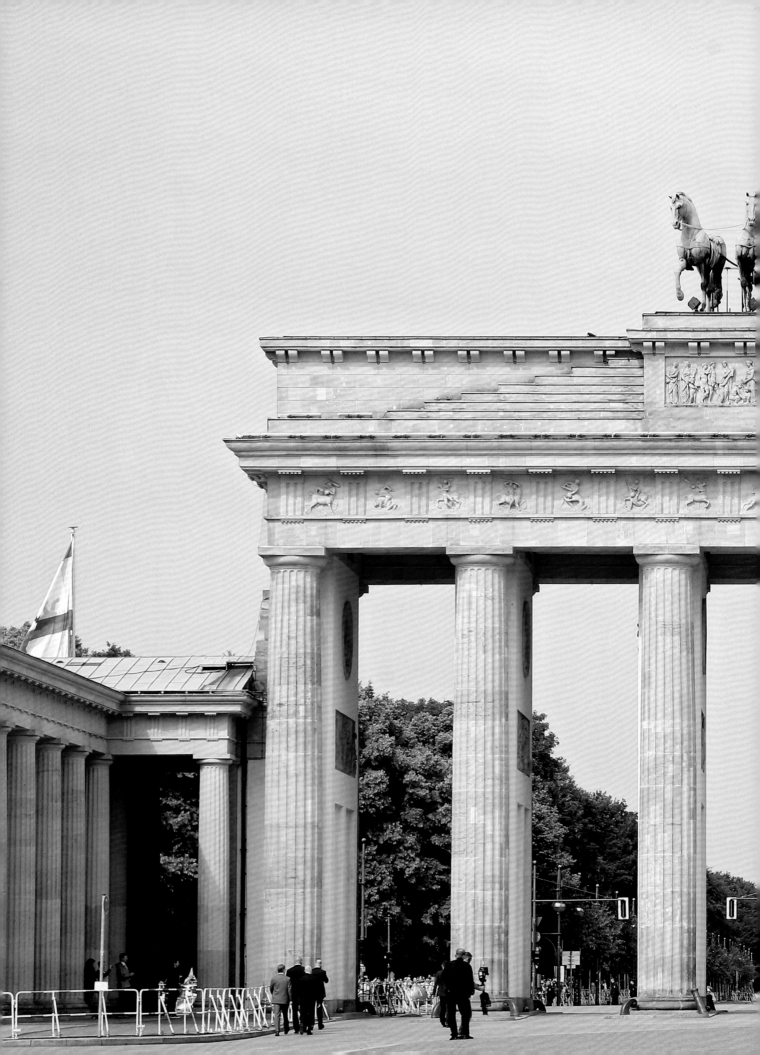

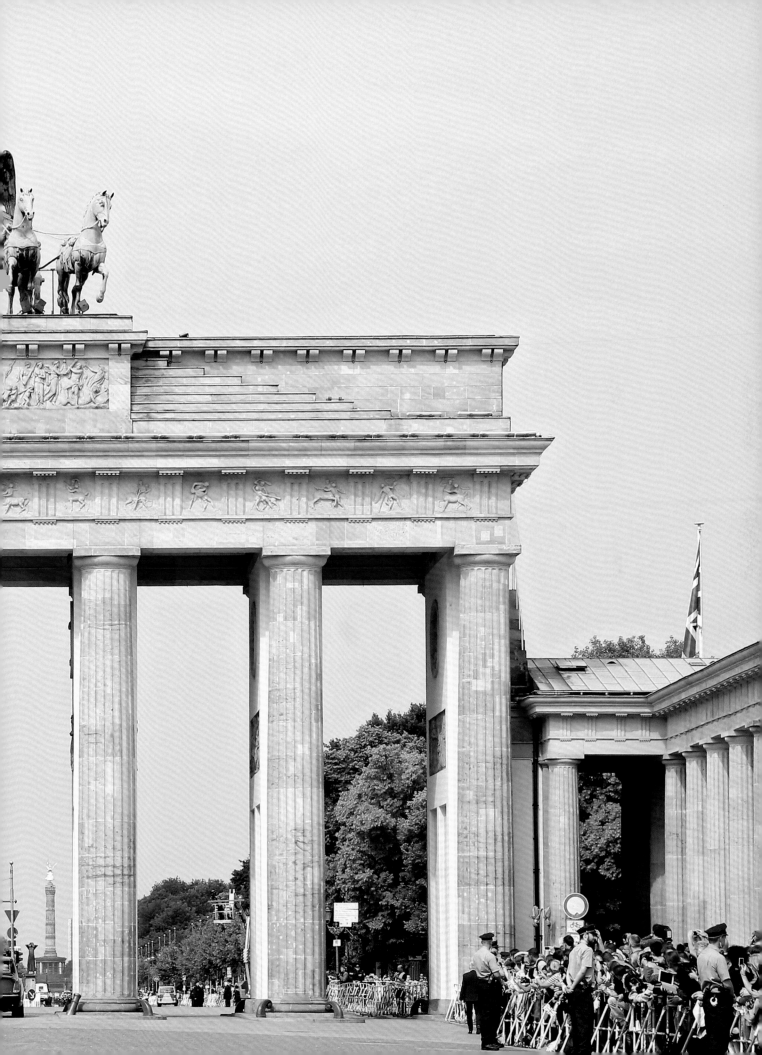

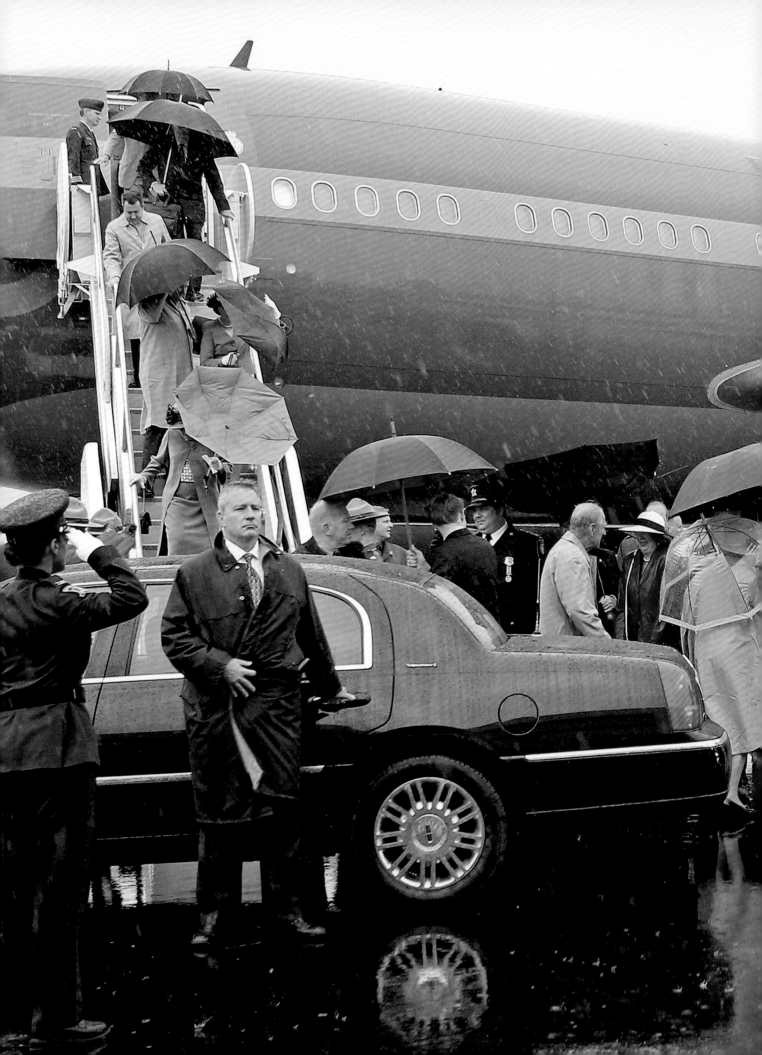

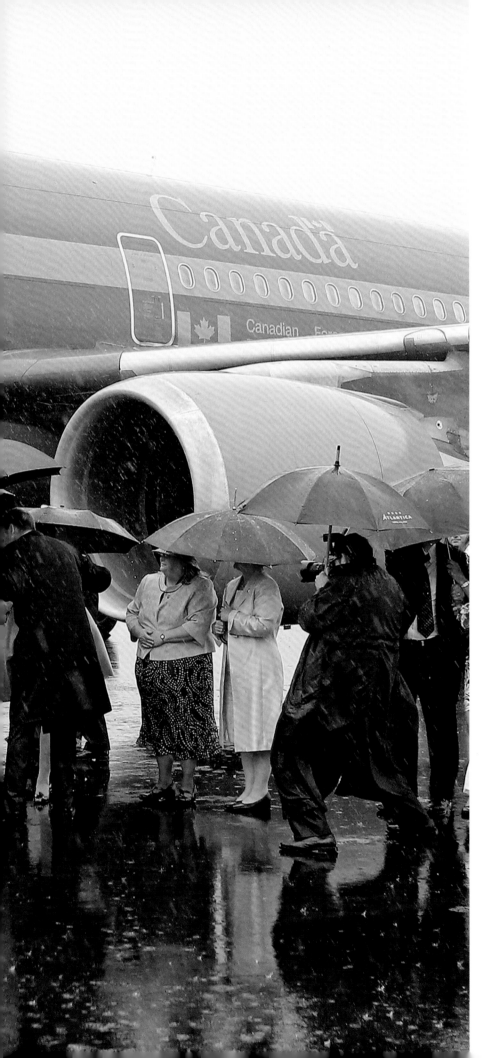

A RATHER DAMP ARRIVAL INTO CANADA

In July 210, the rain was torrential before the Queen and the Duke of Edinburgh had even stepped off the grey Royal Canadian Airforce jet onto the tarmac at Halifax Stanfield International Airport, which was reflective with the accumulated rainfall.

I often find that weather like this makes for the most memorable images. I love the chaos of the moment— umbrellas turned inside out by the wind and the entourage gingerly negotiating the steps of the aircraft. Here we see the Queen with her distinctive transparent umbrella edged in yellow, and the Duke of Edinburgh foregoing the use of an umbrella, instead braving the elements, cracking on with the duty in hand.

Overleaf
The sky was moody as the Queen visited the Canadian Museum of Human Rights, in Winnipeg in July 2010. The Queen and the Duke of Edinburgh were on an eight-day tour of Canada that started in Halifax and finished in Toronto.

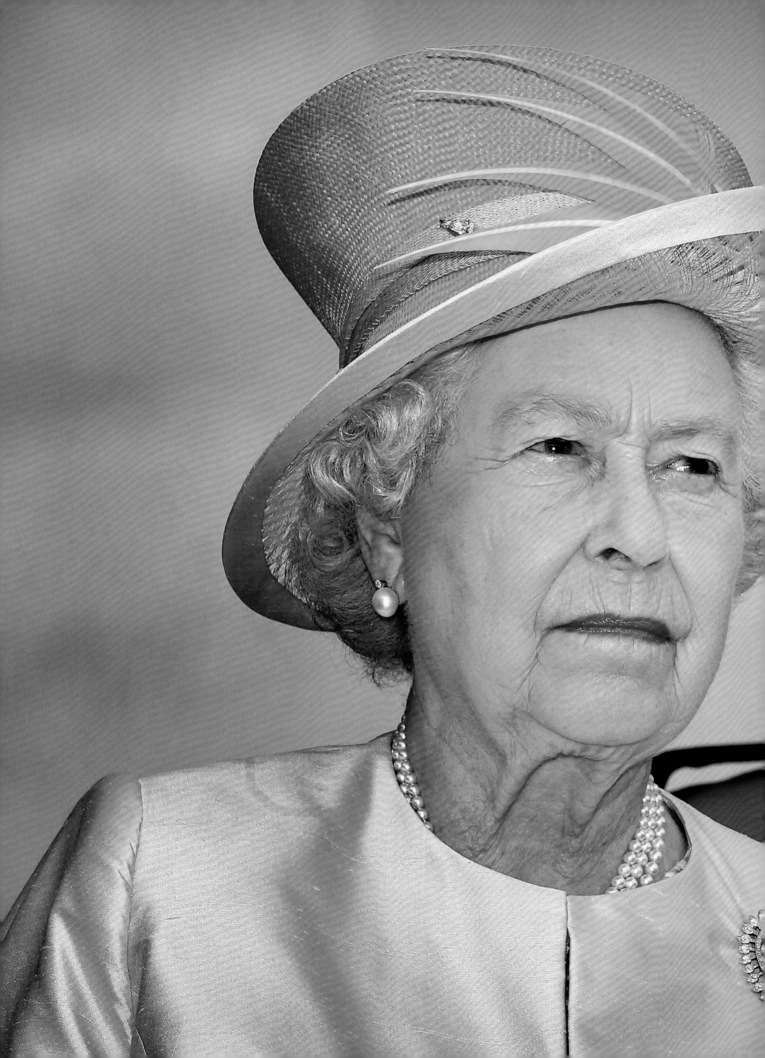

INTERNATIONAL FLEET REVIEW

The Queen sailed out of St. John's on a Canadian frigate, looking across the harbour at a fleet of frigates, destroyers, and an aircraft carrier, as the sailors cheered "hip hip hooray!" The event in July 2010 in Halifax marked a hundred years of the Canadian Navy. As Queen of Canada, the monarch was reviewing ships from around the world, including Denmark, Germany, France, and the UK. This was the Queen's twenty-second visit to Canada, and no doubt the review was a highlight of the eight-day trip.

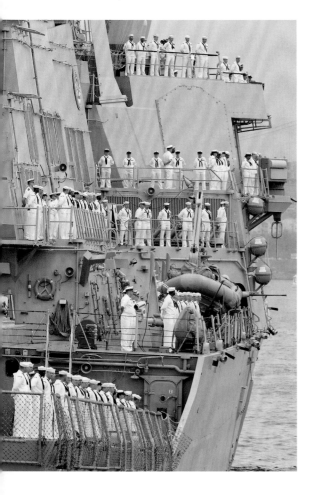

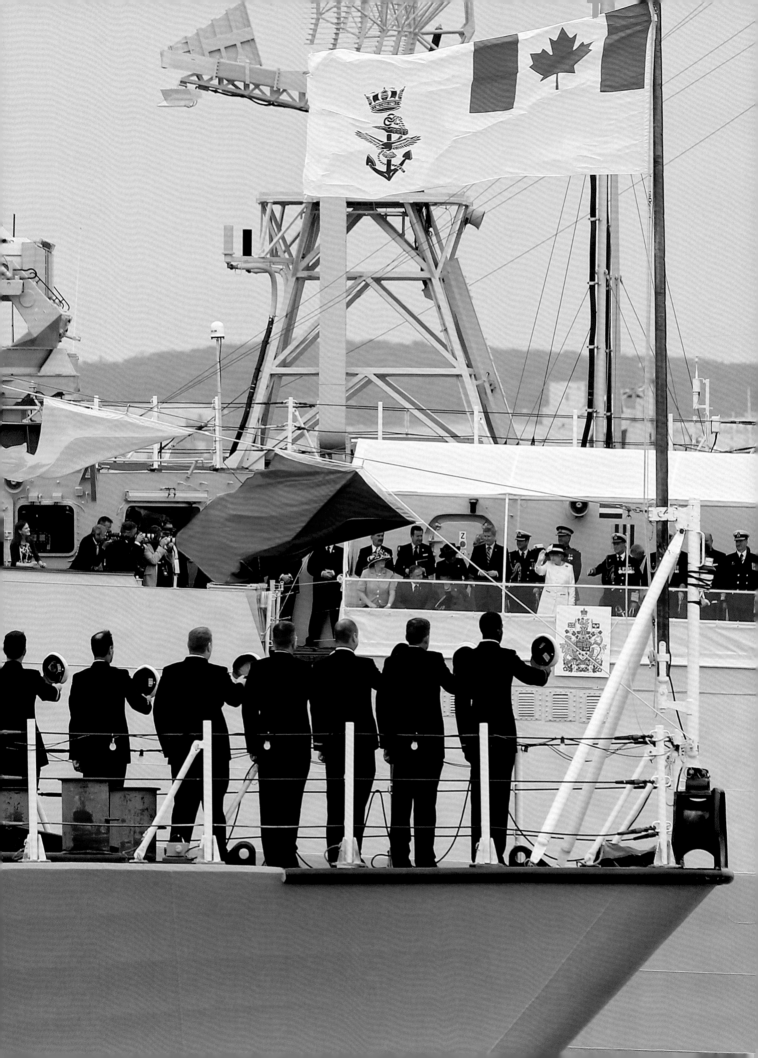

AUSTRALIA AND NEW ZEALAND

I have often travelled with the Prince of Wales and Duchess of Cornwall or the Duke and Duchess of Cambridge as they jet to Commonwealth realms such as Australia and New Zealand on behalf of the Queen. She is the most well-travelled monarch in the world, but now these duties lie with the younger members of the royal family. In this photograph schoolchildren wave flags as the Prince of Wales visits Kilkenny Primary School in Adelaide, Australia, on 7 November 2012.

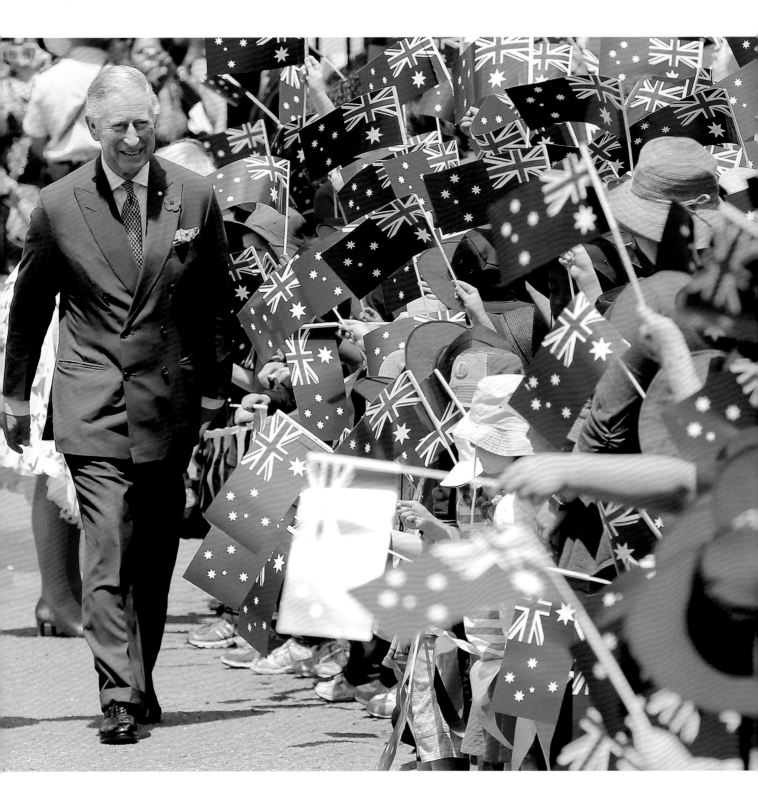

(Top) The Prince of Wales and the Duchess of Cornwall wear traditional korowai cloaks as they attend a reception at the Waitangi Treaty Grounds in New Zealand in November 2019.

(Bottom) The Duchess of Cambridge takes part in a "hongi," a traditional Māori greeting, as she visits Christchurch, New Zealand, in April 2014

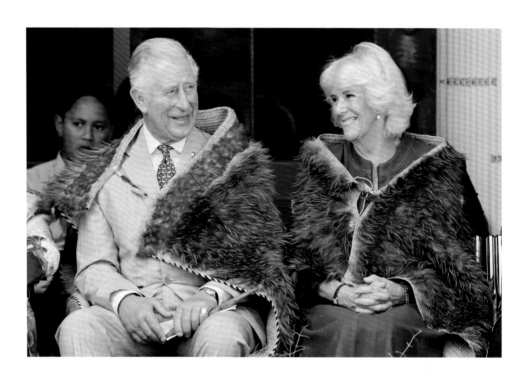

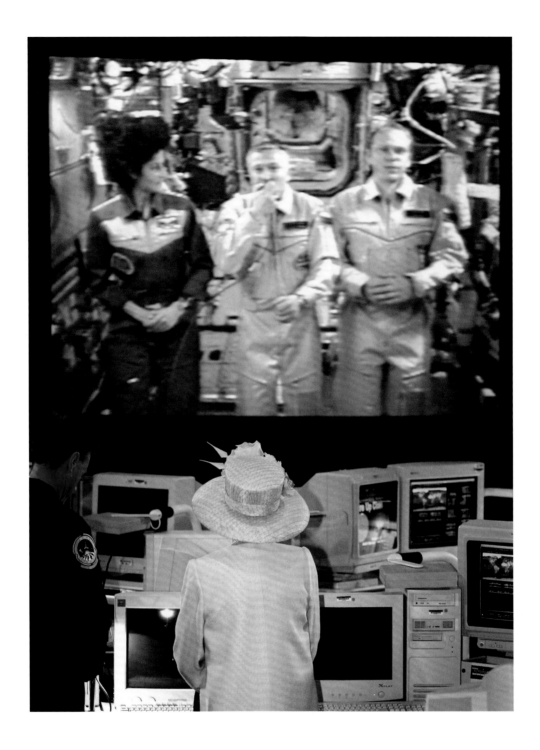

ROCKET QUEEN—VISITING NASA

This photograph was taken as the Queen paid a visit to mission control at NASA's Goddard Space Flight Center in Greenbelt, Maryland. This major space research lab was opened in 1959 as NASA's first space flight centre. The rather abstract image was captured as the Queen, instantly recognisable even from the back, toured the centre and chatted with astronauts on board the International Space Station. Expedition 15 Commander Fyodor Yurchikhin, flight engineer Oleg Kotov, and flight engineer Sunita Williams made history as they spoke to the Queen, highlighting the solidarity among countries and cultures that has made the space station such a success.

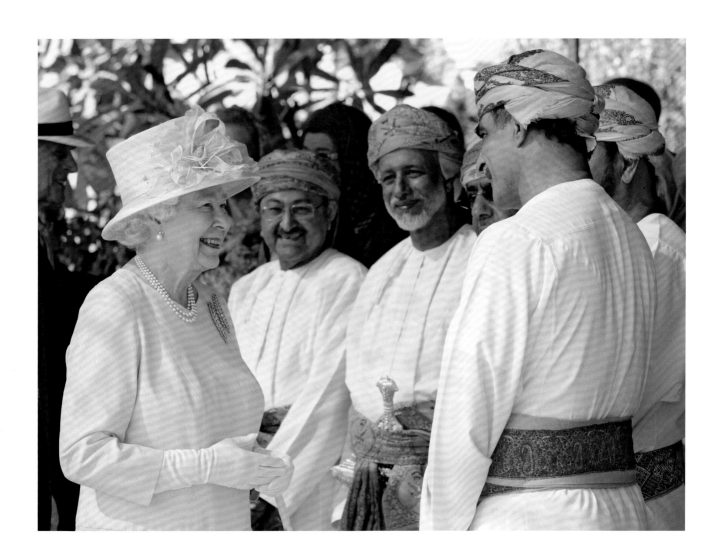

A VISIT TO OMAN

In November 2010, the Queen attended a reception at the Ambassador's Residence in Muscat, Oman. The Queen and the Duke of Edinburgh were on a State Visit to the Middle East and spent three days in Oman after visiting Abu Dhabi. The Queen and the Duke of Edinburgh met dignitaries at the Al Alam Palace in Muscat on that same State Visit.

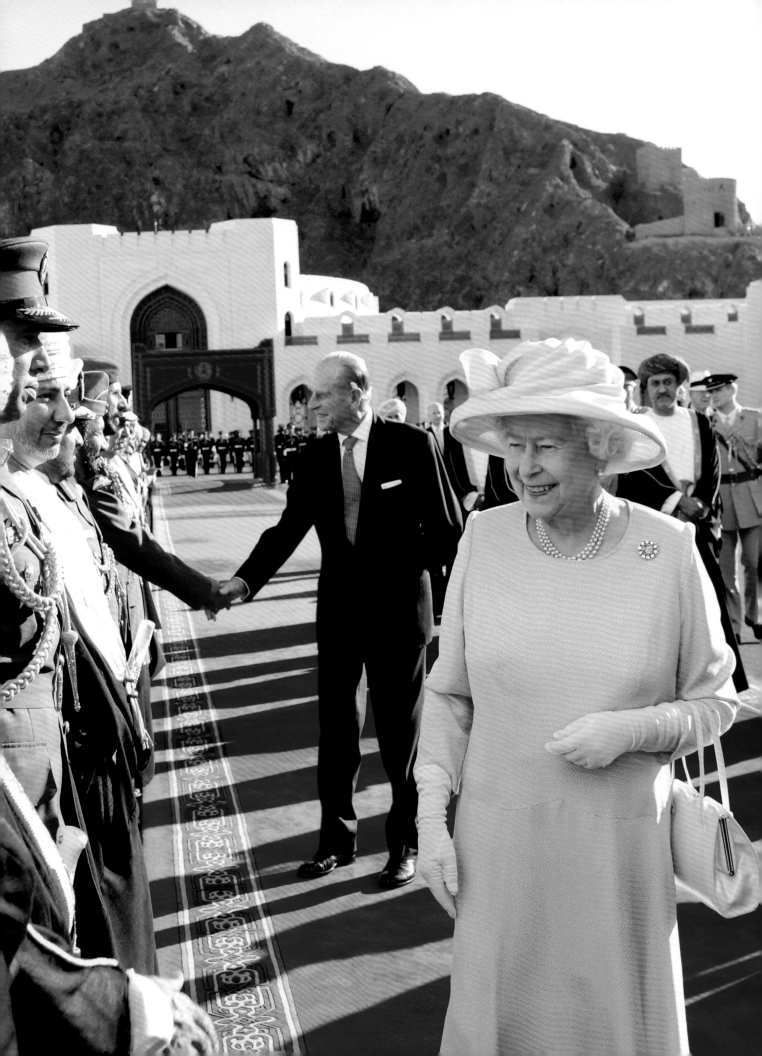

IV

NEVER OUT OF FASHION

Much has been made of the Queen's enduring style. Her unique ability to dress for the occasion while also standing out in a large crowd has long been admired. What are the tricks to this? Bold colour-blocking forms an important part of the technique. It is for this reason that you can often spot the Queen during a royal walkabout or at an event. In this chapter, my images illustrate how her outfits often combine historical references with a contemporary twist, reflect cultural and religious sensitivities, and convey messages with their colour, texture, and patterns. Hats are an integral and practical element of any outfit. They are often made bespoke to match the look. During Royal Ascot, racegoers even wager on the colour of the Queen's hat on that particular day. Such information, however, is known only by the Queen's closest aides, such as her dresser, Angela Kelly. This secrecy reflects the interest and focus on the monarch as she goes about her duties, and it remains an admirable achievement that she always dresses with an elegance and a finesse that is renowned around the world.

Page 144
Intricate detailing on the Queen's hat as she prepares to lay a wreath in the Dublin Memorial Garden during a historic visit to Ireland in May 2011.

The Queen is cheered by children as she arrives at Ninesprings Country Park in Yeovil, Somerset. The Queen and the Duke of Edinburgh spent much of 2012 criss-crossing the UK as part of the Diamond Jubilee tour.

Overleaf
(Left) All in blue! The Queen arrives by train at the town of Welshpool during a two-day visit to North Wales in 2010.

(Right) The Queen contrasts perfectly with her bouquet of flowers as she arrives at the Slovenian capital of Ljubljana in 2008 for a State Visit.

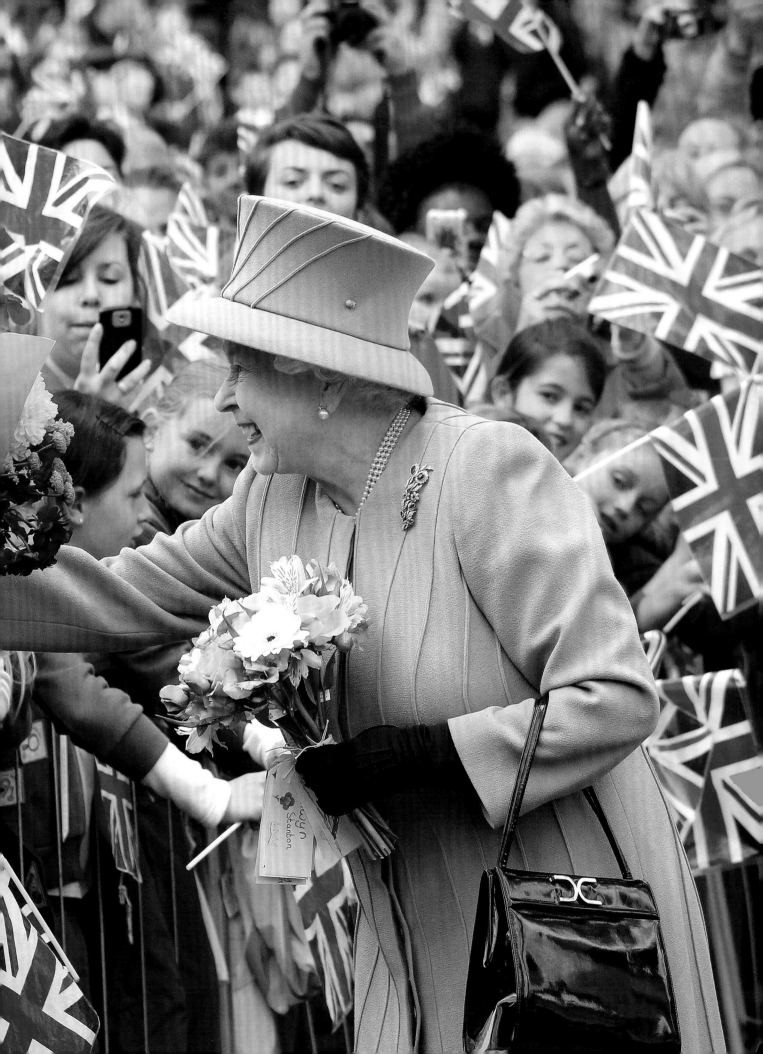

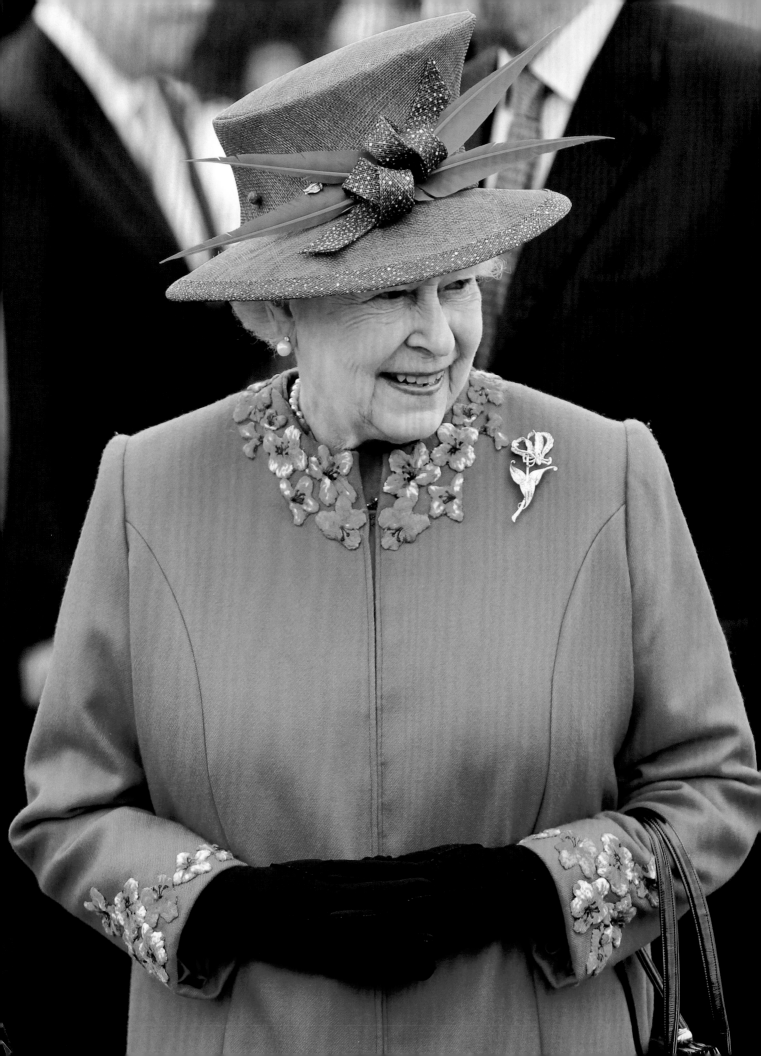

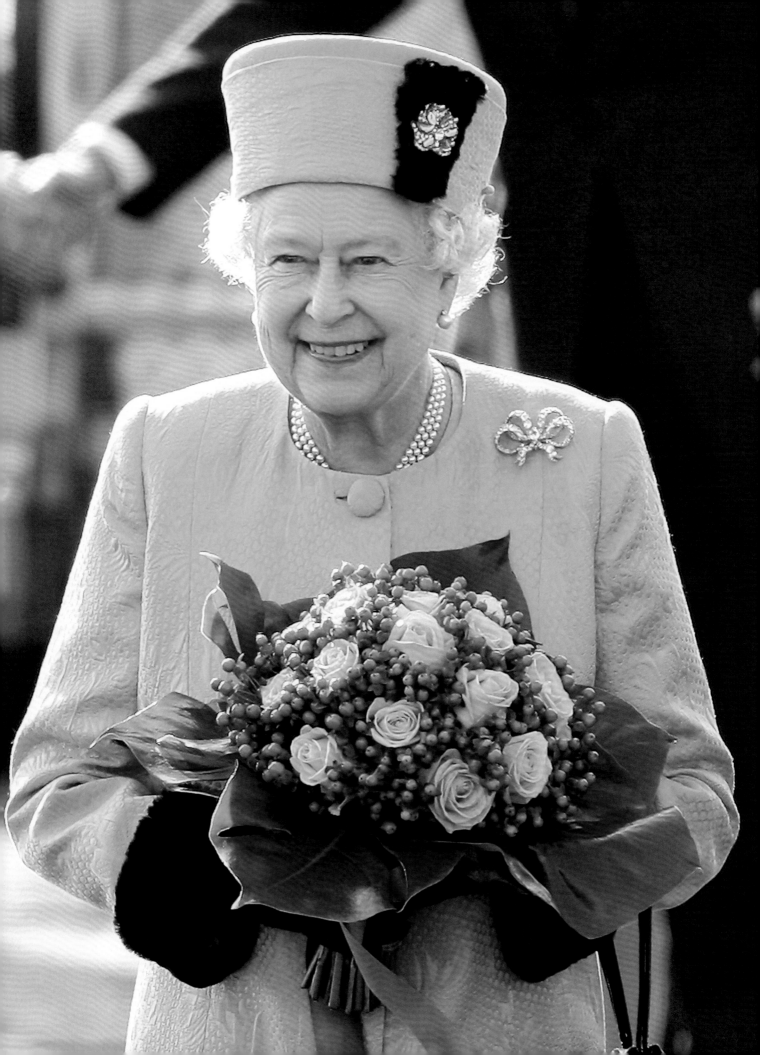

(Above) Carefully negotiating the steps into the State House in Entebbe, Uganda, the Queen attends a State Banquet during the 2007 Commonwealth Heads of Government Meeting.

(Opposite) The Queen wears the Girls of Great Britain and Ireland Tiara during a State Banquet at the Bellevue Palace, Berlin, in 2015.

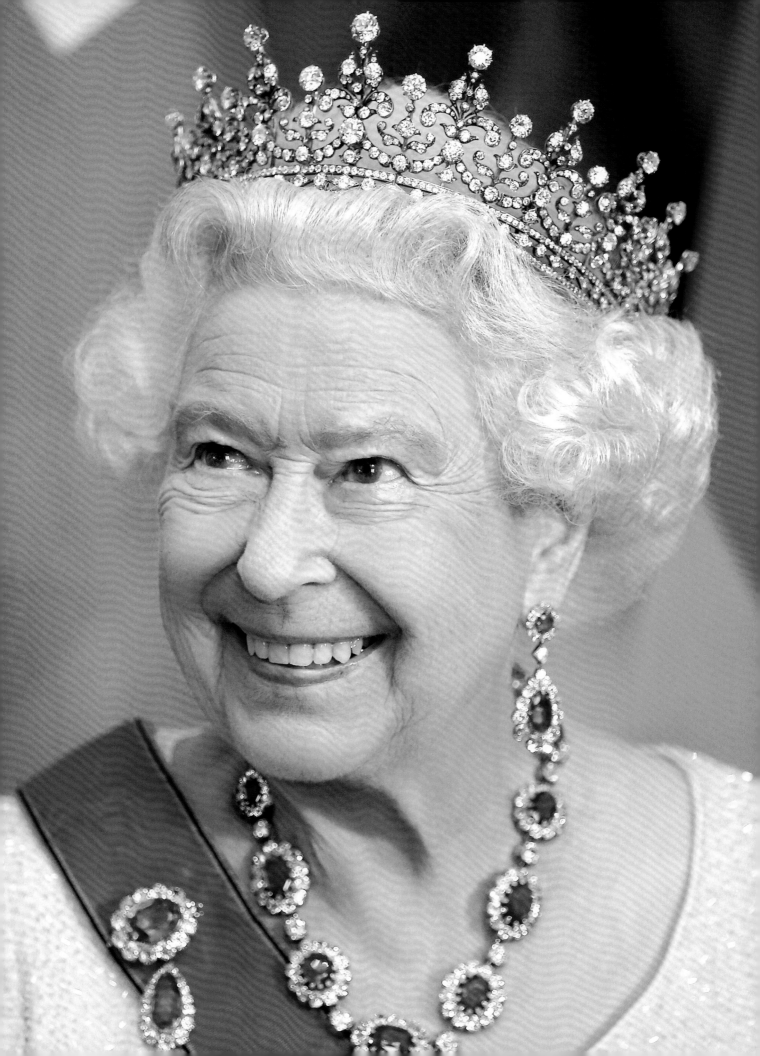

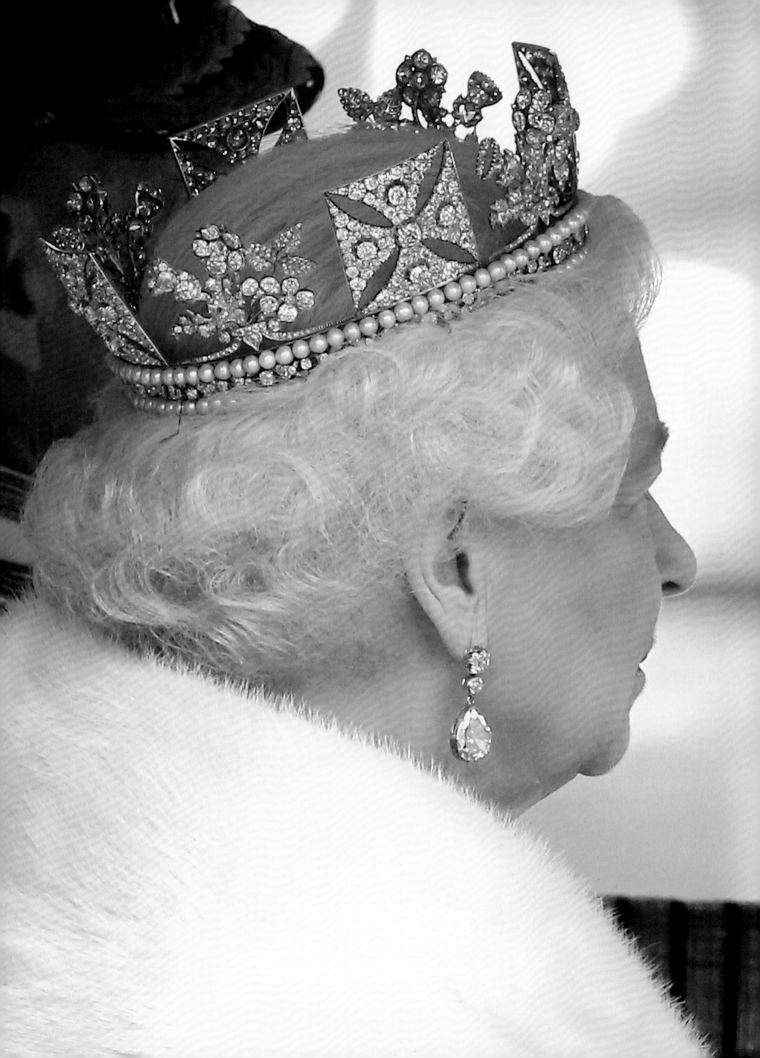

(Opposite) The Queen wears the George IV State Diadem as she travels to the State Opening of Parliament in the Diamond Jubilee State Coach, 27 May 2015.

(Below) Wearing the Grand Cross and Sash of the Order of Merit of the Federal Republic of Germany, the Queen attends a State Banquet at the Bellevue Palace, Berlin, during a visit in 2015.

(Below) Wearing the Burmese Ruby Tiara, the Queen attends a State Banquet for the visit of the President of the Republic of India, Pratibha Devisingh Patil, at Windsor Castle in October 2009.

(Opposite) The Order of Queen Elizabeth II (a brooch featuring a young Queen Elizabeth II) is worn by the Duchess of Cornwall during a Commonwealth Heads of Government Meeting dinner at the Cinnamon Lakeside hotel, Colombo, Sri Lanka, in 2013. The Duchess was made a member of the Order after her sixtieth birthday in 2007.

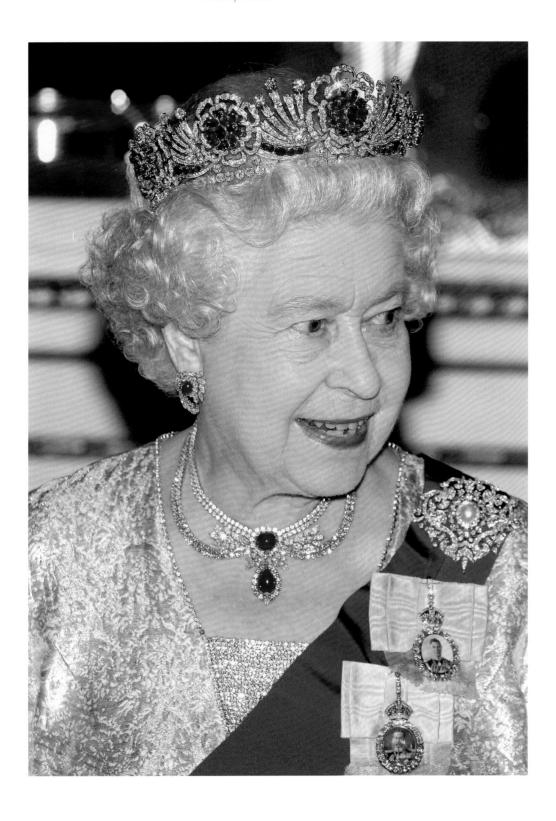

HATS

Any talk of the Queen's fashion cannot fail to include her iconic hats; rarely is she seen without one. The majority are custom-made to match the outfit. The level of detail and materials used by the milliners are second to none. Tradition forms such an important part of many of the Queen's outfits. Centuries of history are woven into the fabric of her robes and reflected in her jewels. Garter Day takes place on the Monday of Royal Ascot week in June and is an occasion that really exhibits much of the pomp and ceremony often associated with the royal family. Guests are invited into the grounds of Windsor Castle to witness the spectacle of the Queen in her blue velvet robe with its red velvet hood, and distinctive black hat with white plumed feathers.

(Right) Exquisite detail can be seen on the back of the Queen's hat during a visit to the Irish National Stud in Kildare, in 2011.

Overleaf
(Left) The Queen holds her patent leather Launer handbag during a visit to Charterhouse Square, London. Launer handbags remain the most popular choice of the Queen. She is rarely seen without one. Launer London was founded in 1940 by Sam Launer, who emigrated to London from Czechoslovakia during the Second World War. In 1968, he was given a Royal Warrant by the Queen.

(Right) In a rare black-and-white ensemble, the Queen laughs during a visit to Bratislava, Slovakia, in 2008.

Page 164
On a sunny June day in 2012, the Queen meets members of the public outside the Lister Hospital in Stevenage, Hertfordshire.

Page 165
The Queen's Launer handbag accompanies her as she visits the Royal British Legion Industries village in Aylesford, Kent, in 2019, the charity's centenary year.

Page 166
On a chilly February day in 2009, the Queen unveils a new statue of the Queen Mother on The Mall in London.

Page 167
The Queen keeps warm as she tours the Hrebienok ski resort in Slovakia in 2008.

Page 168
Shades of blue: detailing on the Queen's hat as she arrives at Tweedbank station in Scotland in 2015.

Page 169
On the same visit, the Queen searches for her spectacles in her handbag before giving a speech on the day she became the Britain's longest reigning monarch.

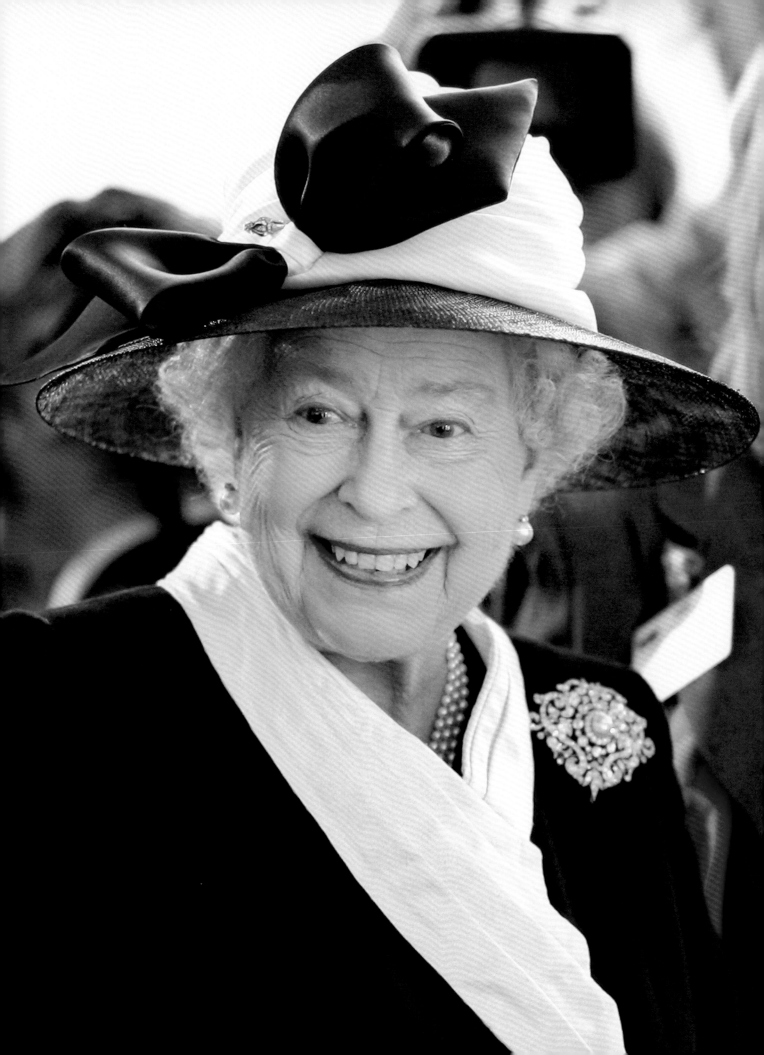

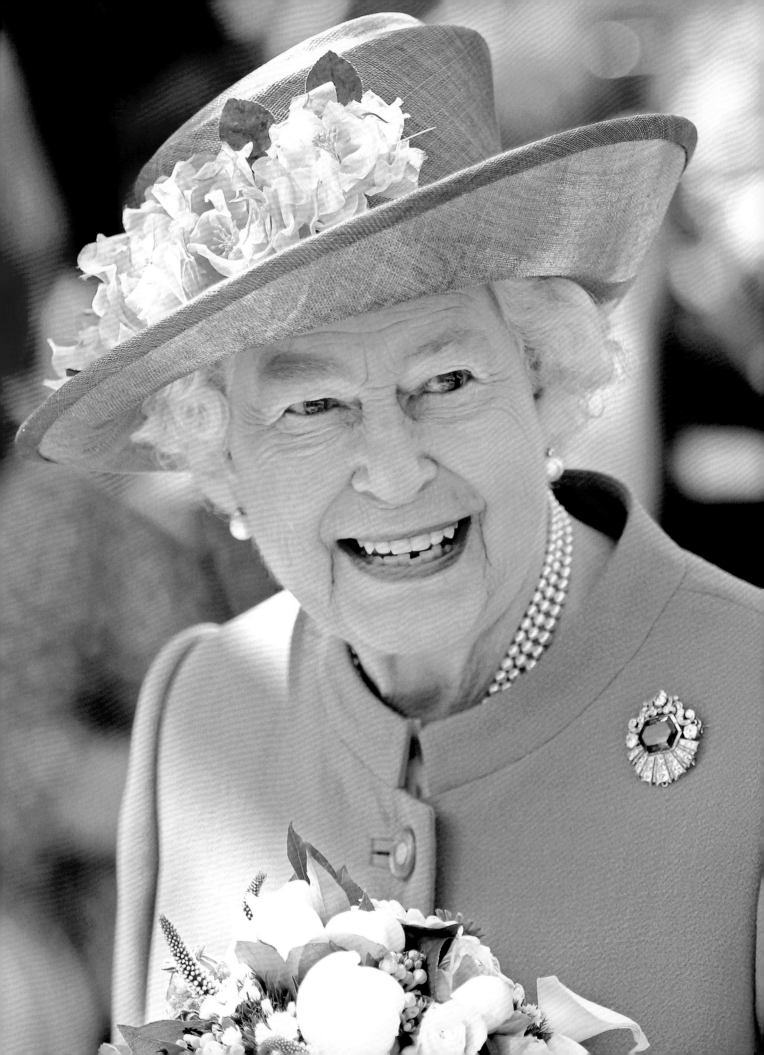

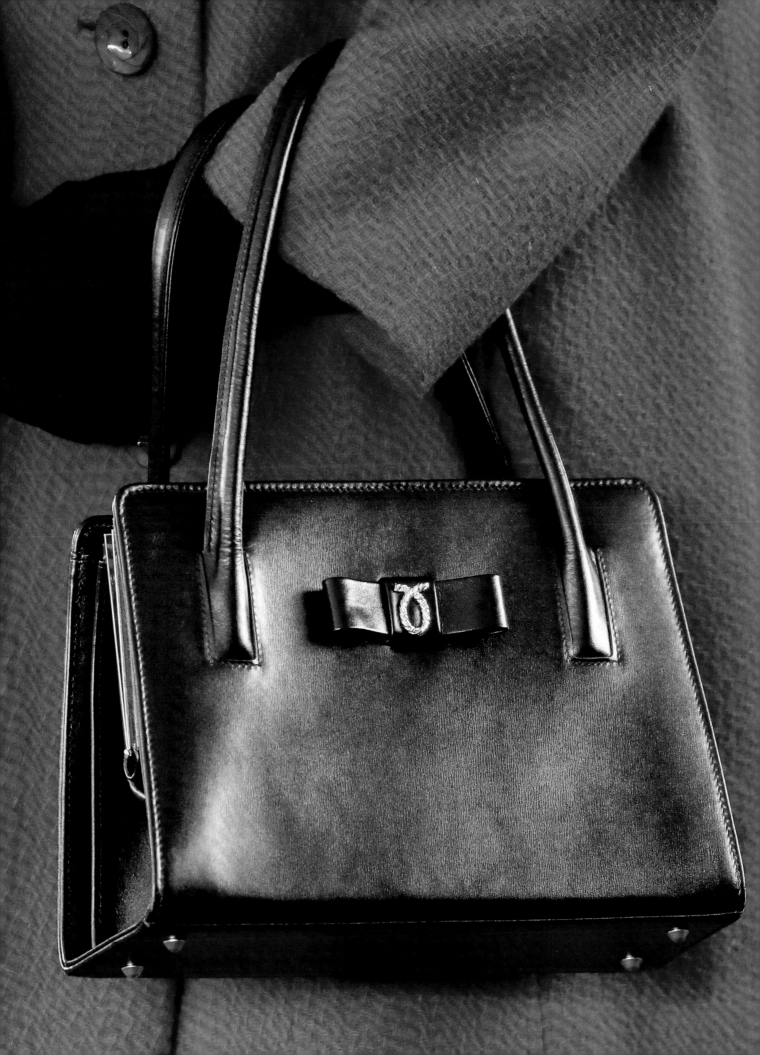

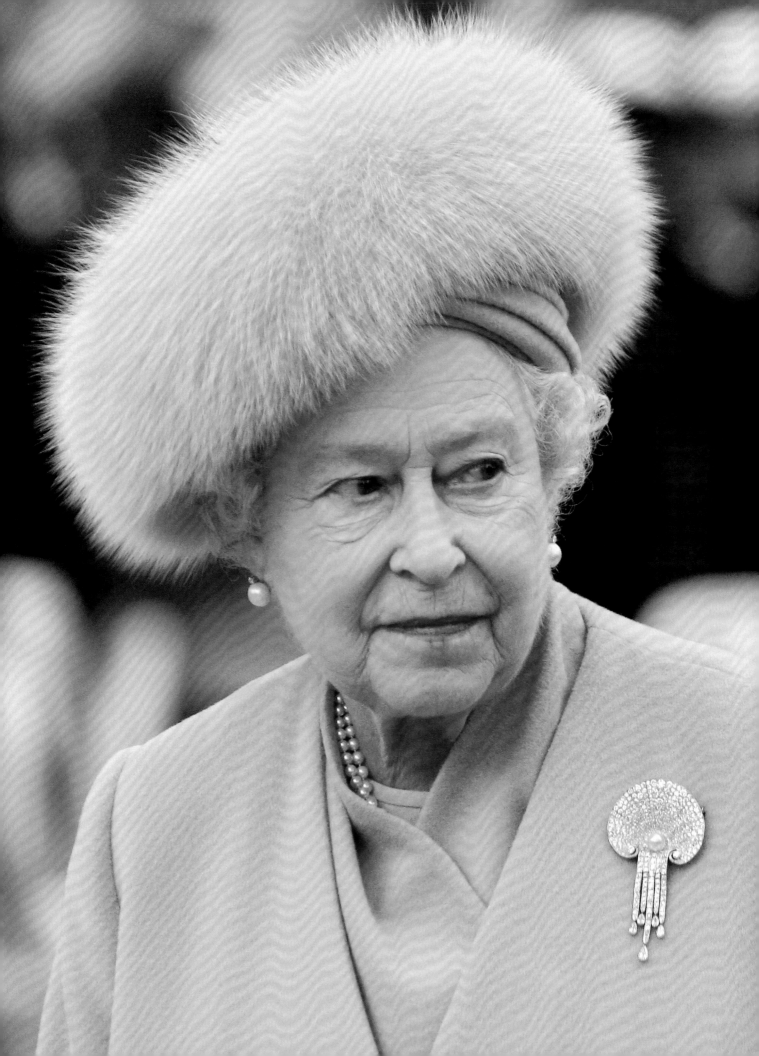

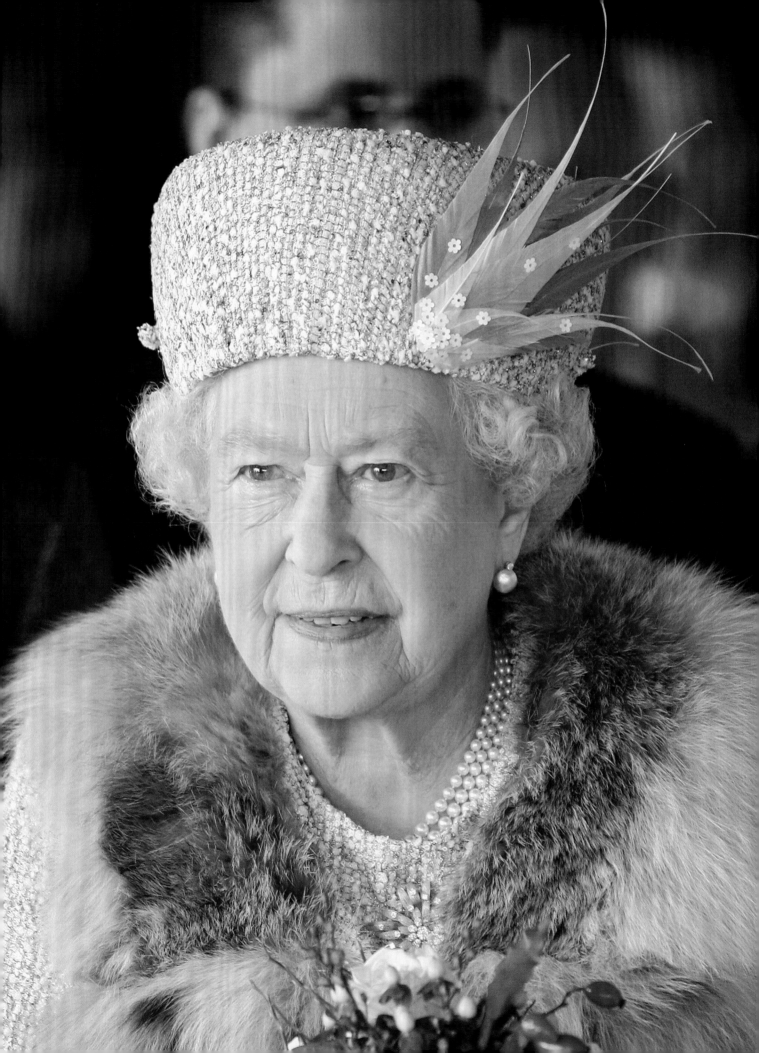

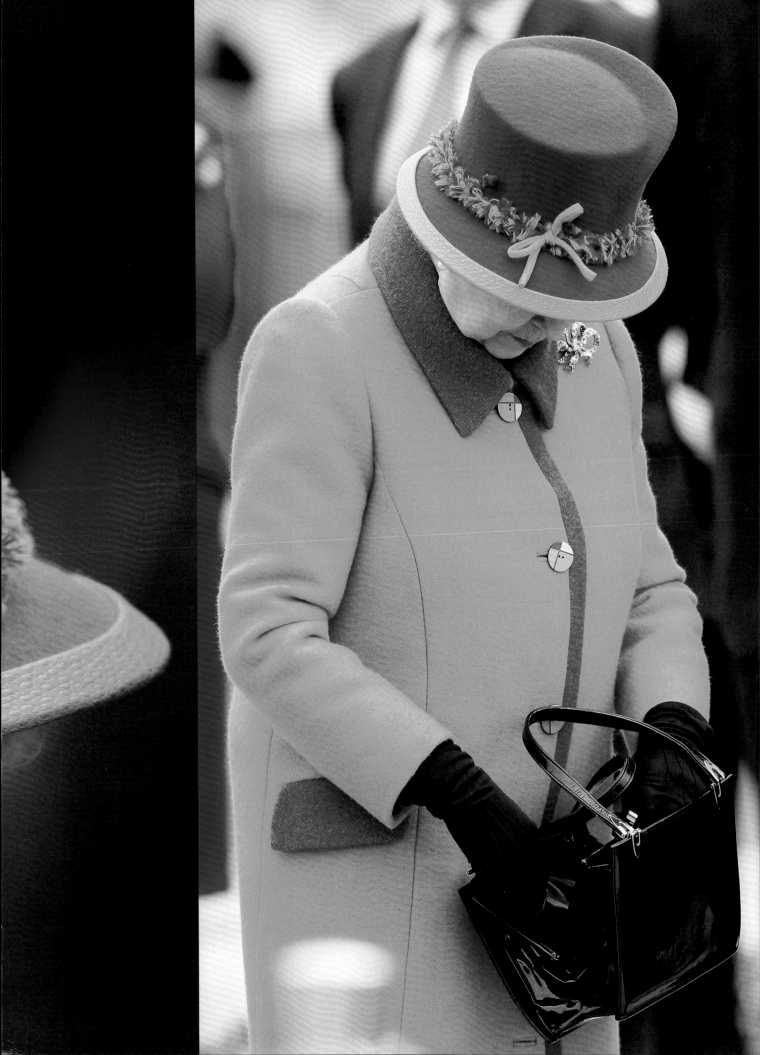

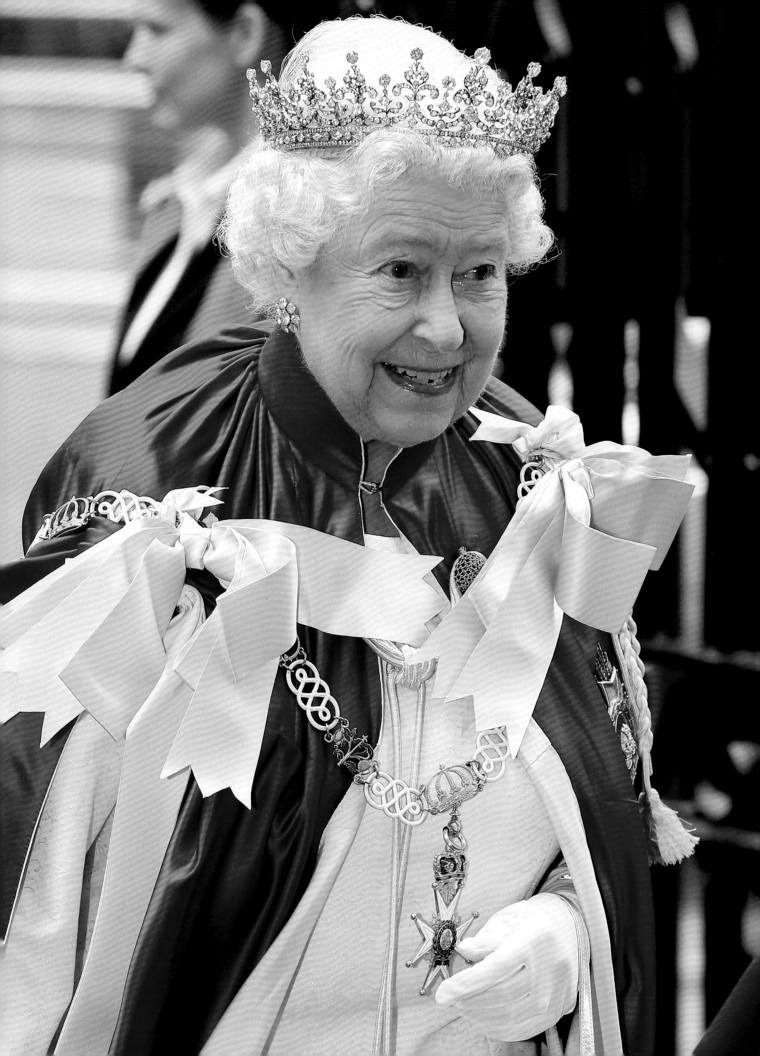

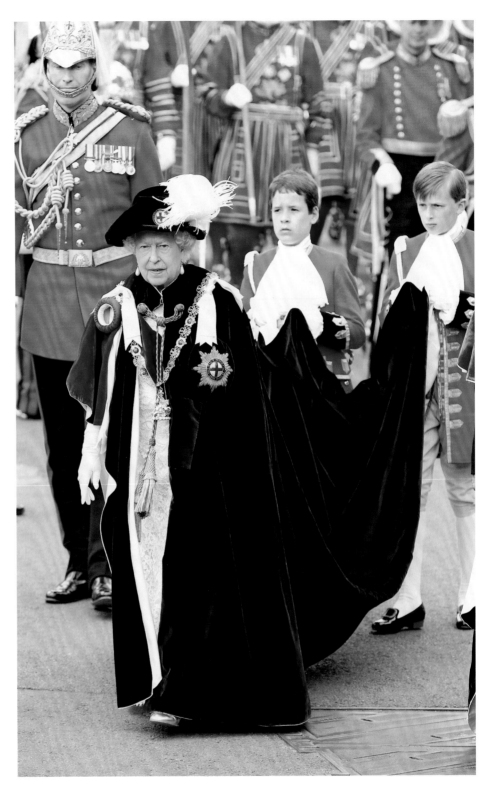

(Opposite) The Queen attends the service of the Order of the Bath at Westminster Abbey, London, an order of chivalry founded by George I in 1725. The name derives from the medieval custom when, before the ceremony for appointing a knight, he would take a ritual bath, symbolic of spiritual purification.

(Above) The Queen at the Order of the Garter ceremony at St George's Chapel in Windsor Castle. The Order of the Garter is the oldest British order of chivalry, founded by Edward III in 1348. The blue velvet robes worn by the Queen are adorned with the Order of St George's Cross.

Overleaf
Yeomen Warders are seen in the background in their distinctive uniforms as the Queen attends the Order of the Garter ceremony at Windsor in 2009.

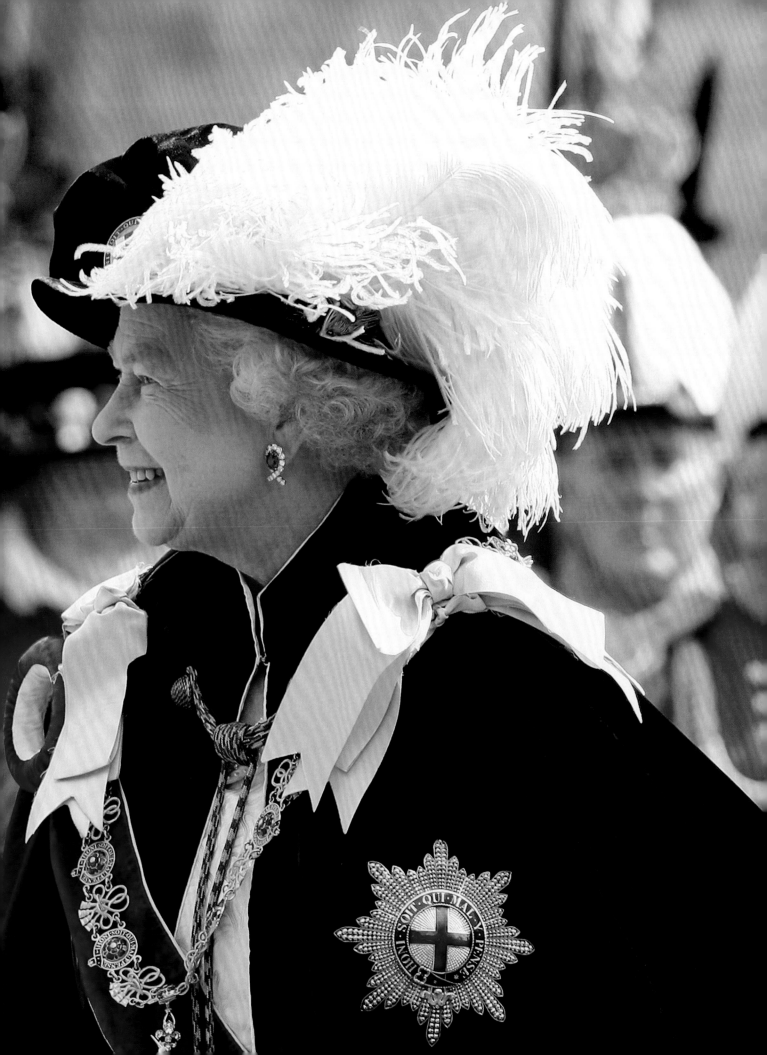

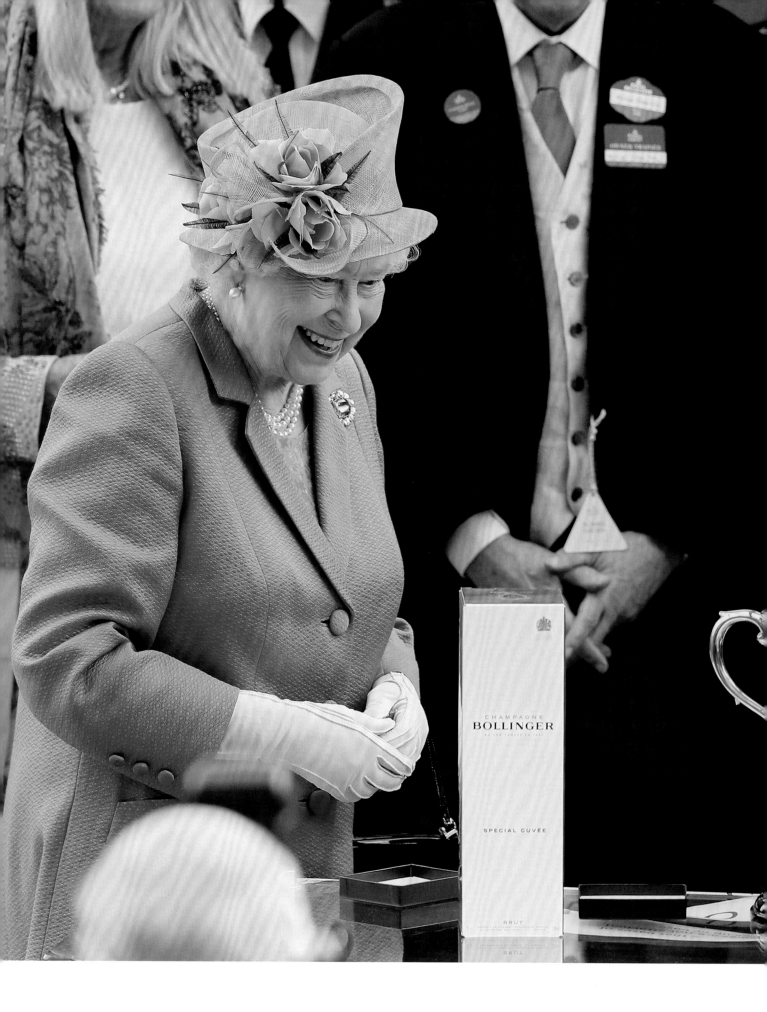

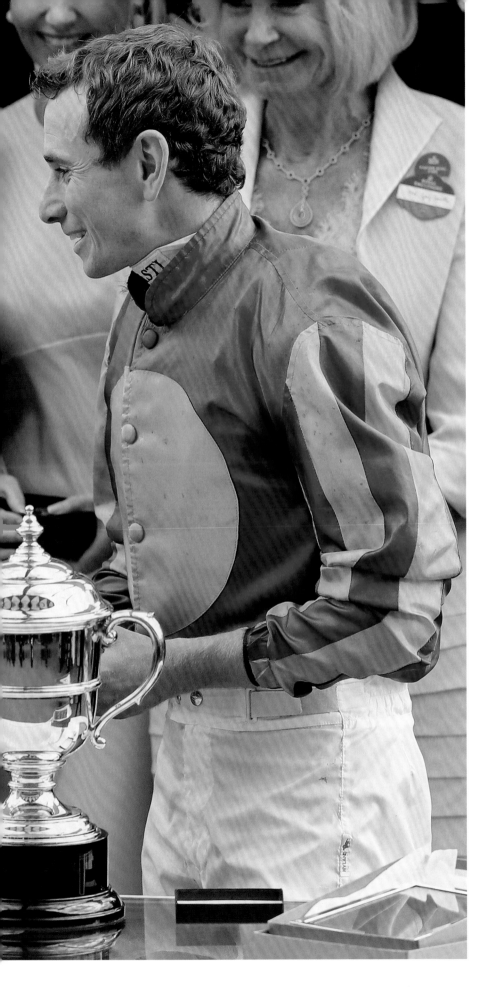

MEETING A JOCKEY IN MATCHING COLOURS

After the historic win with her horse Estimate in 2013 in the Gold Cup at Ascot, 2016 was not to be the Queen's year. She looked incredibly jovial, however, as she handed the trophy to Ryan Moore, the same jockey who had ridden her horse to victory those three years before. What stood out for many observing was the fact that the Queen and the jockey were both wearing matching colours—a lovely touch that clearly made them smile.

RECYCLING

While many would not be surprised that the Queen's outfits sometimes cost thousands of dollars, reusing and recycling remains an important policy: you will often see iconic ensembles worn for certain events making a reappearance months or even years later. It is not unusual for the Queen's clothes to combine fabrics and materials gifted on previous royal tours or visits, which are integrated into a new look. This textured white coat with gold and silver spots has been seen on a number of occasions, including at the Bellevue Palace during an official visit to Berlin in June 2015 (left), as well as during the Diamond Jubilee weekend in 2012, as the Queen made her way down the River Thames on the royal barge MV *Spirit of Chartwell* (right).

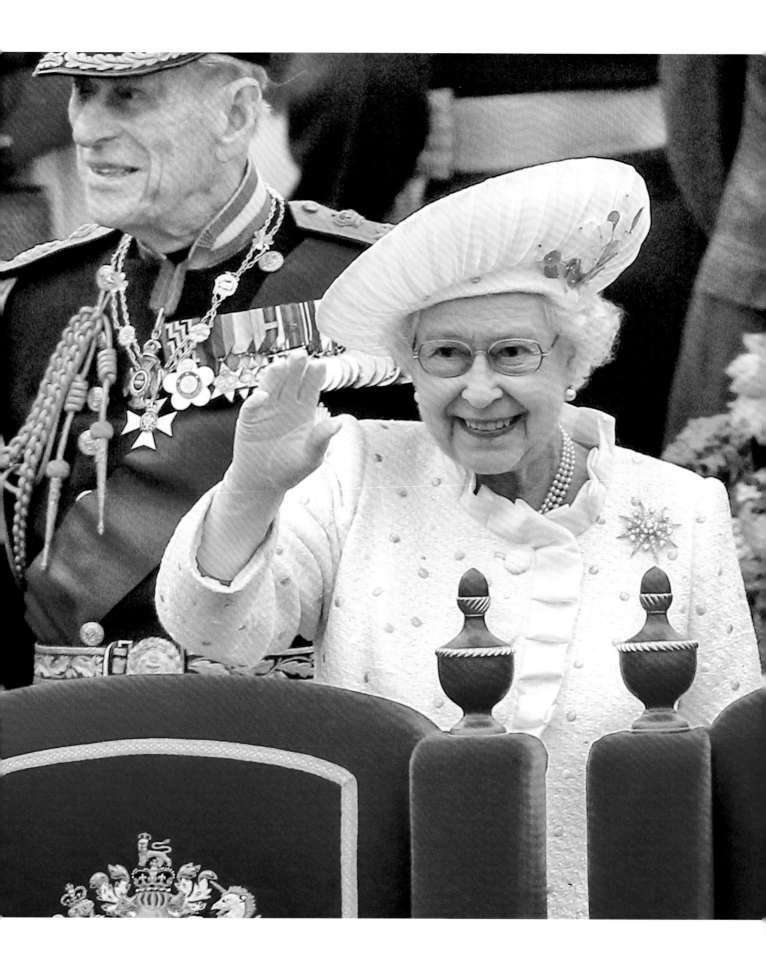

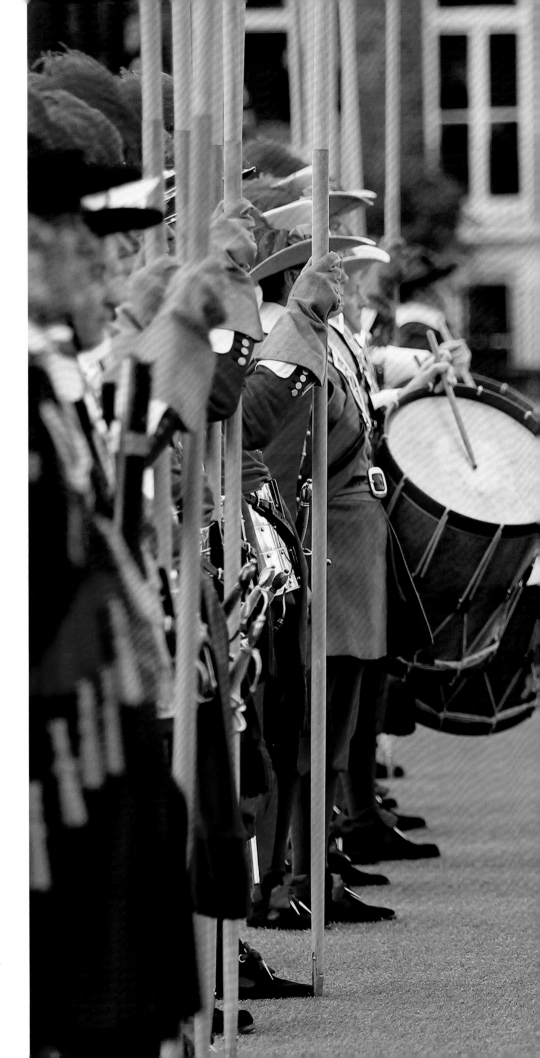

The Queen reviews the Company
of Pikemen and Musketeers at the
Honourable Artillery Company's
Armoury House, London, in 2010.
This was one of the rare occasions
when the Queen was dressed in white.

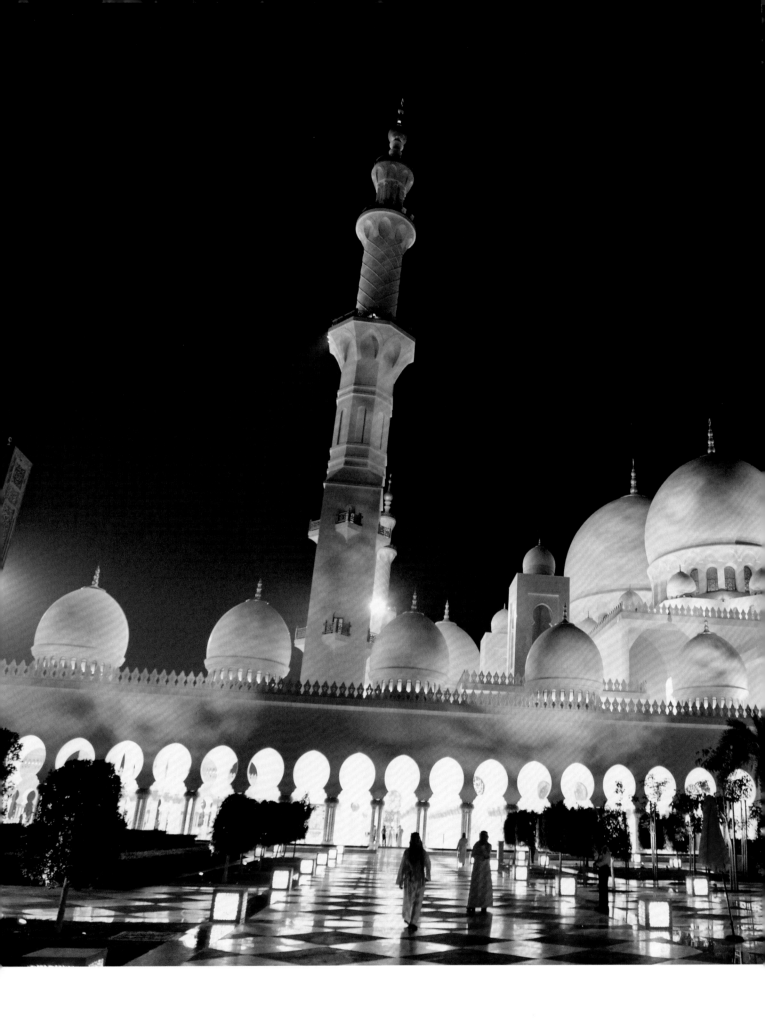

SHEIKH ZAYED GRAND MOSQUE

Cultural considerations form an important part of
planning the Queen's wardrobe. On a royal tour
such planning is an absolute priority. This photograph
was taken in the magnificent Sheikh Zayed Grand
Mosque in Abu Dhabi, United Arab Emirates, in 2010,
during a five-day State Visit by the Queen and the
Duke of Edinburgh to the Middle East. The spectacular
surroundings and warm weather complemented the
Queen's carefully considered gold ensemble. She took
off her shoes behind a privacy screen and changed into
a longer coat, respecting the customs of the country
and the mosque.

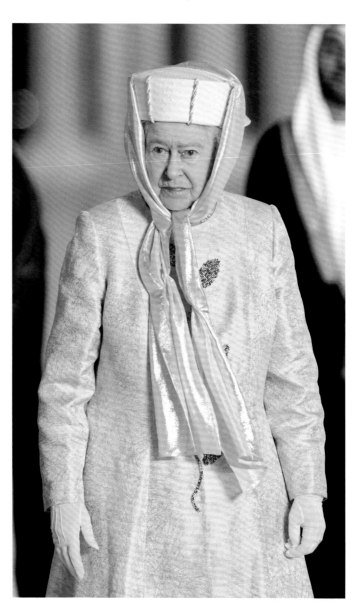

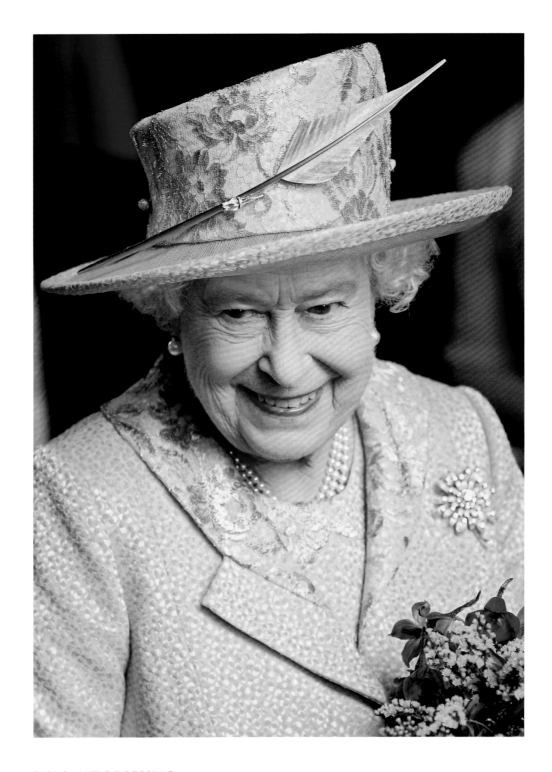

DIPLOMATIC DRESSING

For the Queen, fashion has an incredible power to send
a message out to the public and the world at large.
Diplomatic dressing is a key way the Queen shows her
respect for a country, culture, or religion. Colour is the
most obvious medium: red for Canada Day and green
during a visit to Ireland, as these two pictures illustrate, but
texture and pattern can also reference the local culture.

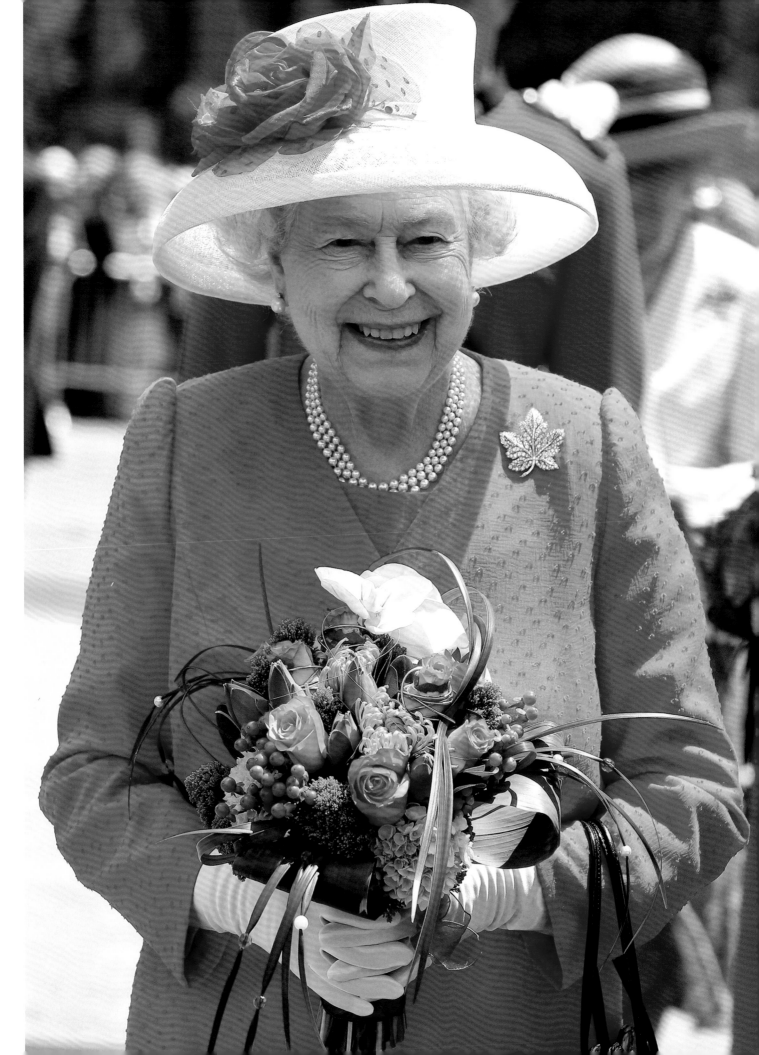

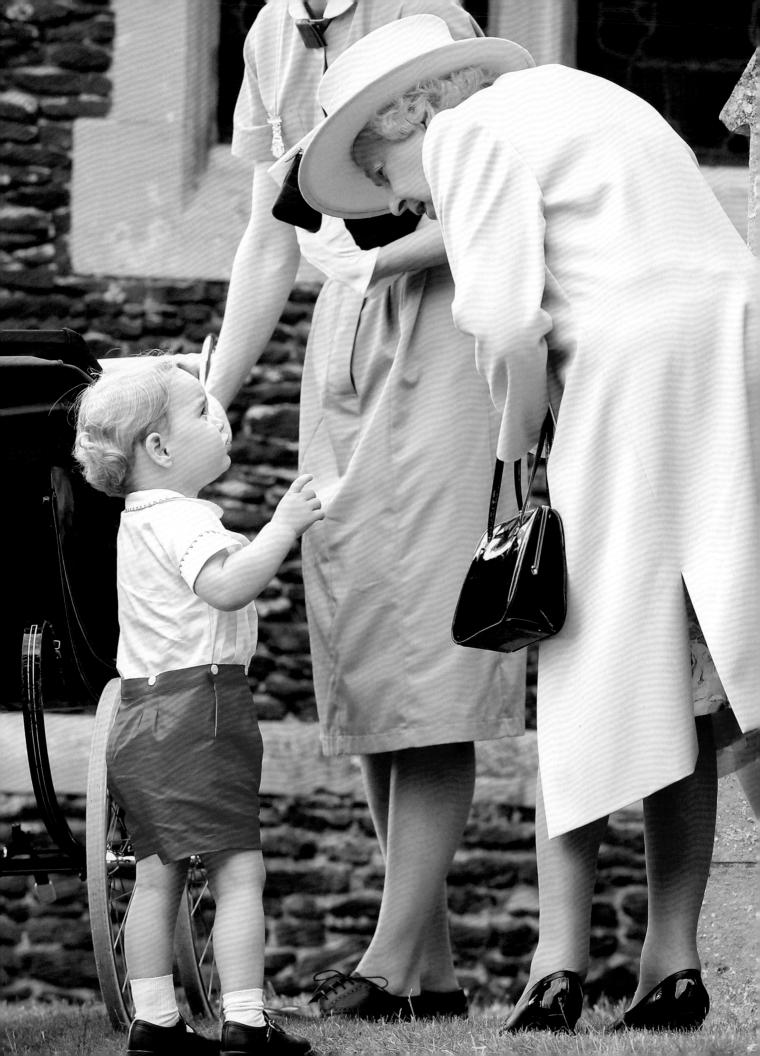

V

FAMILY FIRST

The Queen radiates with pride and happiness when she is surrounded by her family, especially some of the younger (and less formally inclined!) members. The public can sometimes witness this at rare family occasions, such as weddings and christenings, or during public engagements, such as Trooping the Colour. She has an incredible warmth and affection for her grandchildren and great grandchildren, evident by the way she lights up when she is around them. For a photographer, the opportunity to capture these genuine and warm interactions is always so special. With all the ceremony and pomp that surround the Queen's role as monarch, it is often easy to forget her pivotal role as a grandmother and great grandmother within the family, a position highlighted by some of the heartwarming images released by Buckingham Palace after the death of Prince Philip.

Many of the photographs in this chapter demonstrate the considerable support the Queen is provided by her family on her official duties. They also illustrate moments of lighthearted humour that, while not detracting from the importance of the ceremony, must surely make for a more enjoyable experience. While she occupies a position that must, at times, be solitary and challenging, it is clear she can always rely on her close bonds to family to help her carry out her duty.

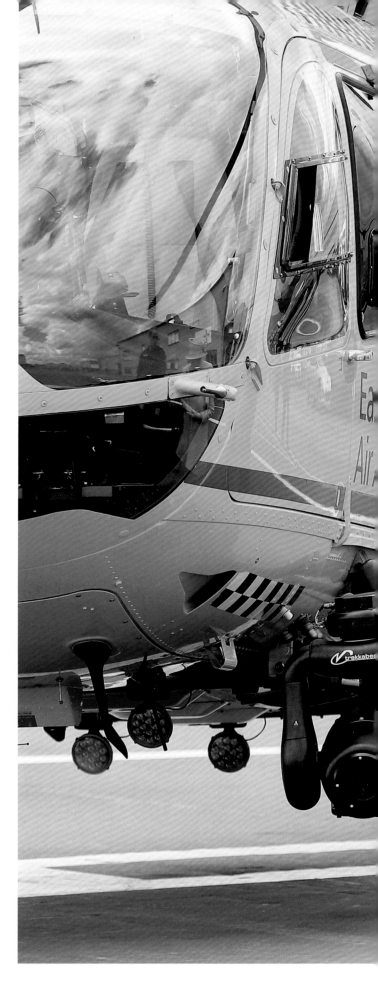

THE DUKE OF CAMBRIDGE AND HIS AIR AMBULANCE

Following on from his successful career in the Royal Air Force, the Duke of Cambridge worked as a pilot for the East Anglian Air Ambulance between March 2015 and July 2017. It was clearly a great opportunity to use his skills and connect directly with the community in a valuable and rewarding way. In July 2016, the Queen and the Duke of Edinburgh arrived at the air ambulance facility to open the new base, appropriately enough in the maroon-coloured Sikorsky S-76C+ helicopter that has become familiar on royal engagements. They were given a personal tour by their grandson. They looked on intently as he showed them around the different aspects of the specially designed air ambulance helicopter before officially opening the base.

Page 184

The photograph of the Queen chatting with Prince George at Princess Charlotte's christening was one of the most notable images of the day. The christening took place in the church at Sandringham, on the Queen's Norfolk estate, on 5 July 2015. Two images particularly struck me on the day: The first was Prince George on tiptoes looking into the traditional Silver Cross pram, eager to catch a glimpse of his little sister in her Honiton lace christening gown. The second was this photograph of the Queen and Prince George. Who knows what the conversation was about, but he was clearly interested in his great-grandmother's pink hat, as he pointed up towards it!

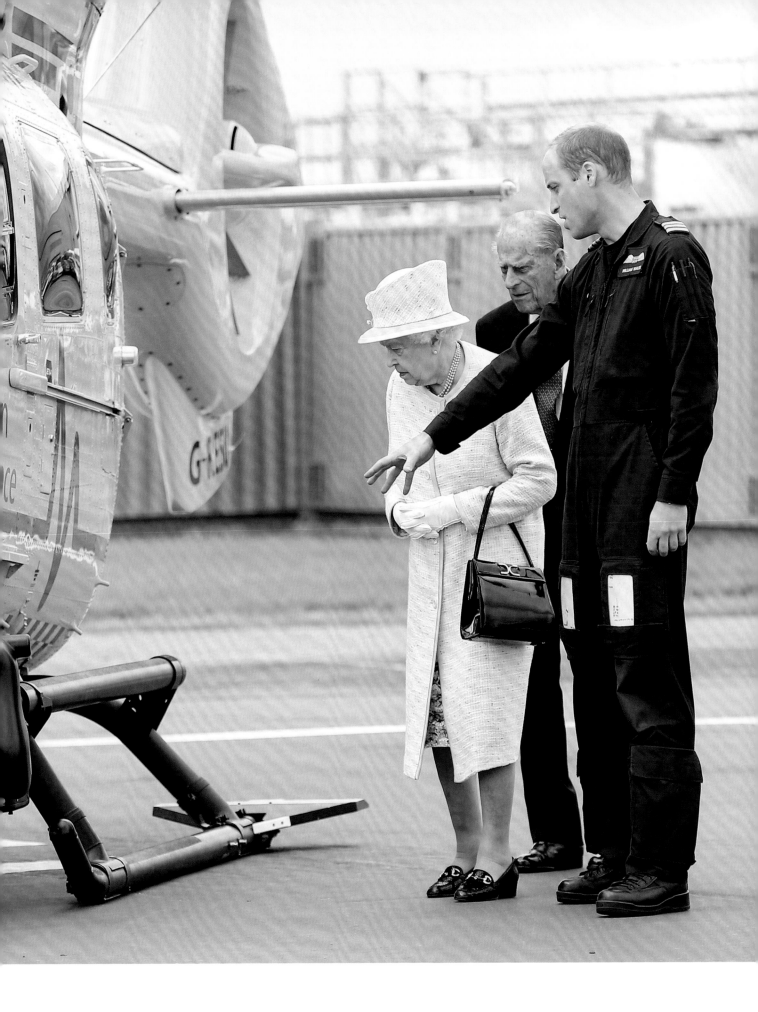

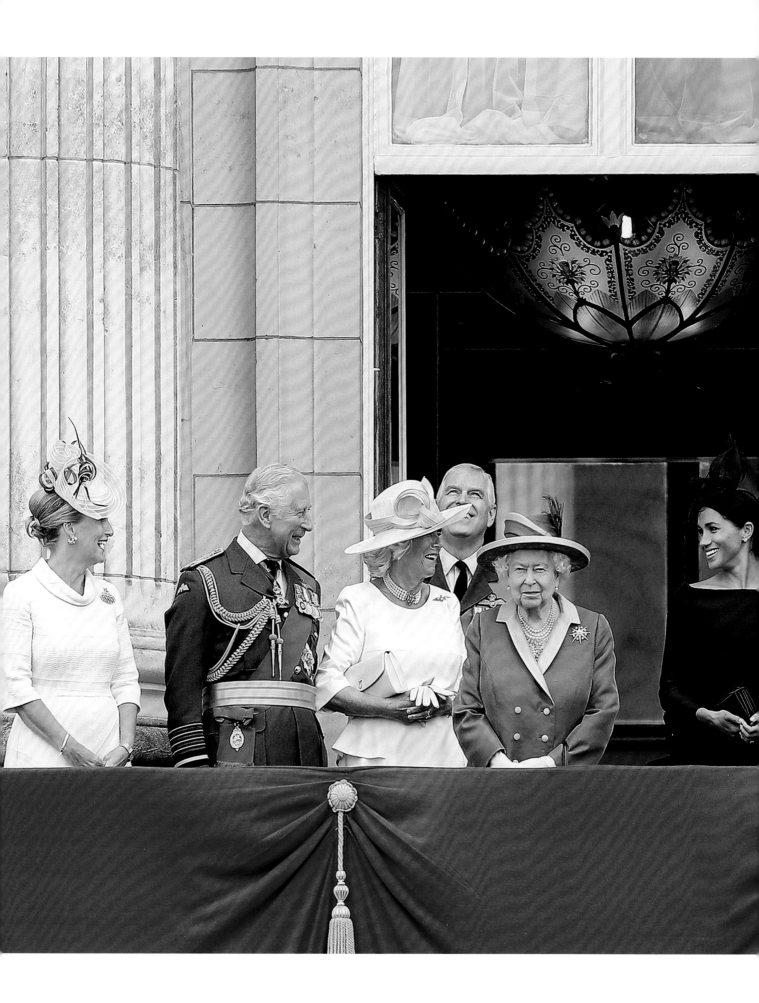

THE RAF100 COMMEMORATIONS

There is one thing that always makes me feel a little stressed as a photographer, and that is moving between two different shooting environments very quickly. In 2018, there was a great example of a situation that dictated a swift and decisive change of photographic technique. I rushed from taking a portrait of the Prince of Wales with his two sons in the gardens of Buckingham Palace to photographing the spectacular flypast with a long lens trained on the balcony of the palace from the Queen Victoria Memorial, as the whole family came together to celebrate the hundredth anniversary of the Royal Air Force. As I frantically packed up my lighting equipment in the gardens and hurried to switch to a long 800mm lens and tripod for the balcony shot, I was lucky to be helped out of the palace by some very patient staff from the Prince of Wales's office.

This application of a variety of techniques is what is so fantastic, but also challenging, about royal photography. After photographing the balcony, I was escorted straight back into the palace to shoot on a wide lens at a reception with the Prince of Wales. They were three contrasting sets and styles of images, but all equally important. As always, the end result was worth all the effort: my portrait became a stamp to celebrate the Prince of Wales's seventieth birthday.

(Left) Members of the royal family laugh before watching a flypast on the balcony of Buckingham Palace during a celebration of the centenary of the Royal Air Force on 10 July 2018.

Overleaf
Prince Charles greets his mother with a kiss on the hand as she arrives for her ninetieth birthday celebrations at Windsor on 15 May 2016.

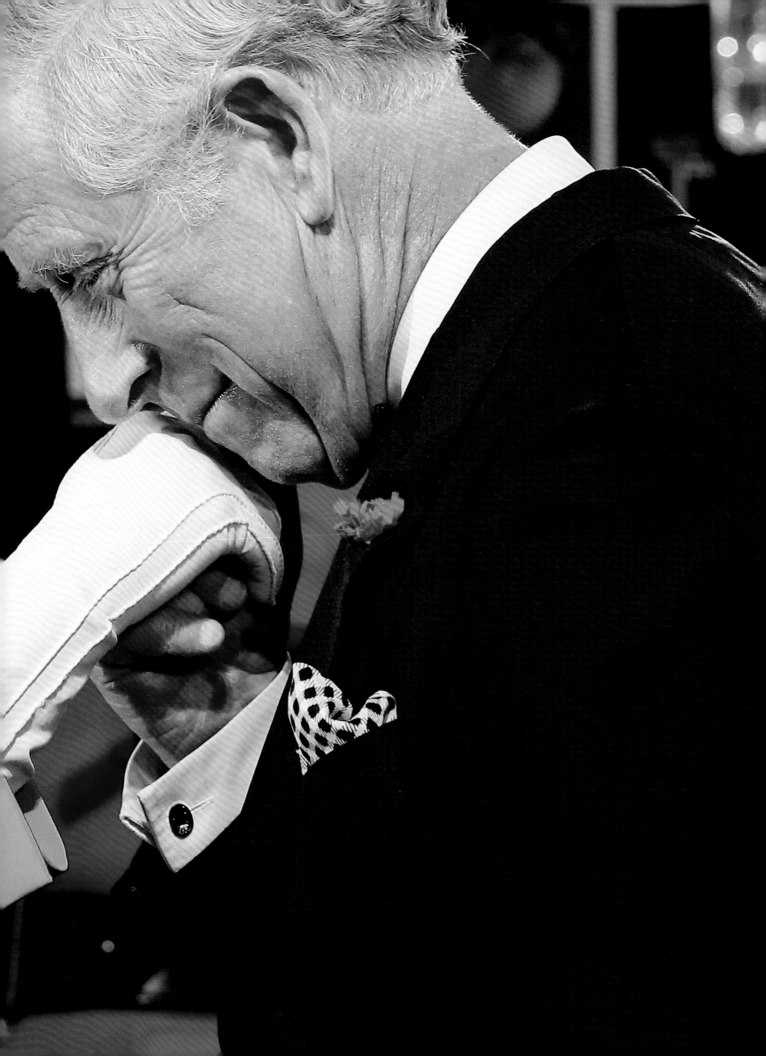

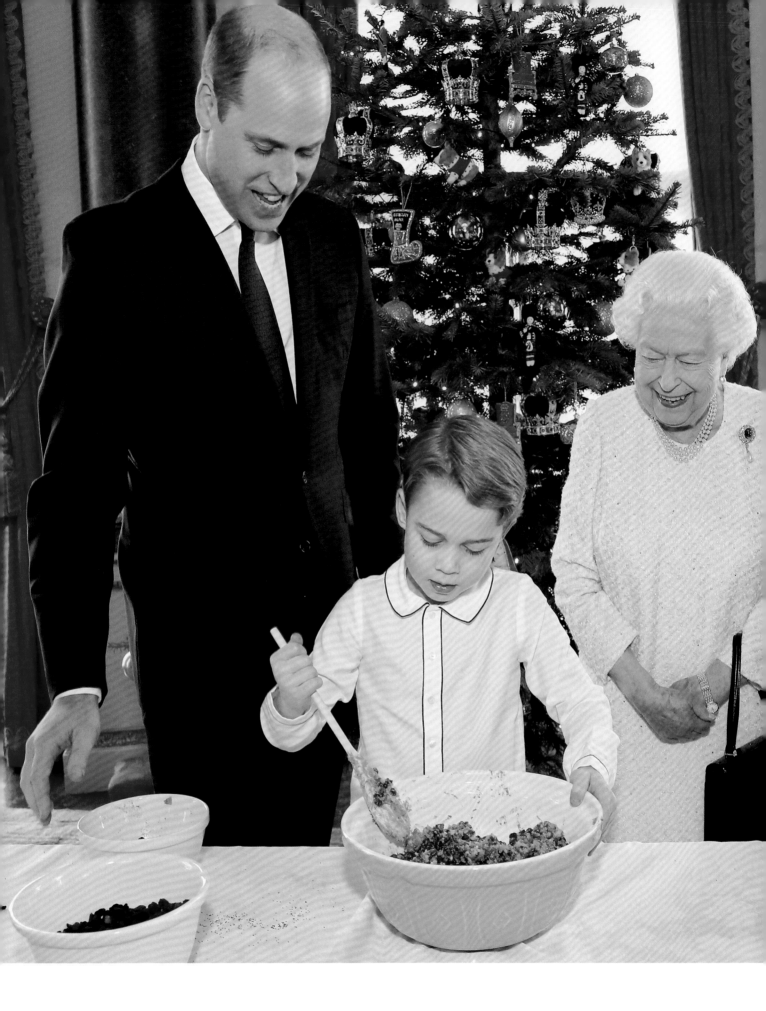

MAKING CHRISTMAS PUDDING WITH HEIRS TO THE THRONE

A special and significant image for me shows the Queen and three heirs to the throne preparing Christmas pudding at Buckingham Palace in 2019 as part of the Royal British Legion's "Together at Christmas" initiative. The initiative encourages the public to provide extra support to the armed forces community at festive get-togethers, in the hope of combating the loneliness and isolation experienced by many at this time of year. This was a big moment for me to get right. Never before had I had the opportunity to take such a rare historic photograph.

The Christmas pudding mixing session was led by Chef Alex Cavaliere, who possibly felt more nervous than me ahead of the photo shoot. When the time came, he was integral in directing proceedings, although Prince George was keen to get stuck in from the word go! Surrounded by the Queen, the Prince of Wales, and the Duke of Cambridge, George gave the mixture an energetic stir, adding poppy seeds and commemorative sixpences as he went. Stirring four Christmas puddings together was important, as it traditionally brings good luck. The opportunity for the four generations to interact in this way probably helped them to relax and enabled me to capture what felt like a much more *real* moment than a formal portrait could ever convey.

SHARING A JOKE WITH WILLIAM

The Order of the Thistle is the greatest order of chivalry in Scotland. In 2018, the Duke of Cambridge and the Princess Royal joined the Queen at the special ceremony in Edinburgh, which took place on a sunny day at St Giles' Cathedral on the famous Royal Mile in what I feel is one of the most beautiful cities in the UK. I love this moment of relaxed interaction between the Queen and the Duke, who clearly have a very special bond, sharing a joke before stepping out to walk past a Guard of Honour at the cathedral door. Clad in green velvet robes and plumed hats, the Queen, Duke, and Princess Royal looked resplendent. It is often these little flashes of genuine engagement either before or after the formal event that I look out for on occasions like this.

THE QUEEN AND THE DUKE OF CAMBRIDGE AT THE FESTIVAL OF REMEMBRANCE

The Royal British Legion's Festival of Remembrance takes place at the Royal Albert Hall in London the night before Remembrance Sunday each year. It is a live event broadcast on television. I normally get the opportunity to capture the royal family arriving and for a period after they are seated and proceedings begin. Although a sombre and reflective occasion, it is not without its lighter moments, such as that shared by the Queen and the Duke of Cambridge while the Queen searched for her spectacles in her handbag.

THE CAKE AT THE WOMEN'S INSTITUTE CENTENARY

The Women's Institute centenary celebrations at the Royal Albert Hall in 2015 were attended by the Queen with the Countess of Wessex and the Princess Royal. The event brought together an incredible group of women whose collective enthusiasm and humour were infectious. It was a unique experience for me to walk onto the iconic stage and see the huge arena filled with so many inspiring women. After the speeches had taken place, the royal party was led to the foyer to witness the Queen cutting the cake.

Cake cutting, alongside tree planting, ribbon cutting, and hand shaking, is an integral and important part of royal life. The royals approach this duty with different techniques and levels of aplomb. On this occasion, however, disaster struck. As the Queen plunged the knife into the cake, it stuck fast. Only when the Princess Royal offered to lend a hand was the offending knife freed.

"Women have been granted the vote. British women have climbed Everest for the first time, and the country has elected its first female Prime Minister. The Women's Institute has been a constant throughout, gathering women together, encouraging them to acquire new skills and nurturing unique talents."

QUEEN ELIZABETH II

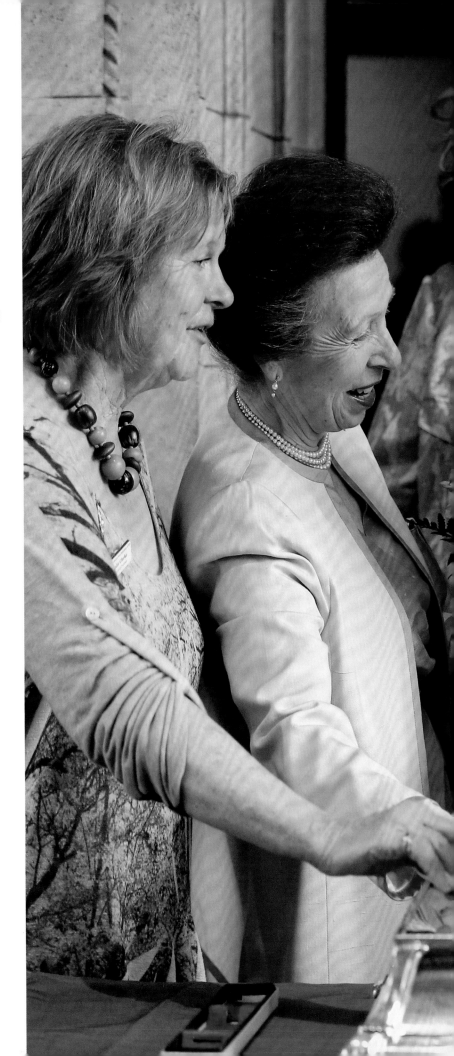

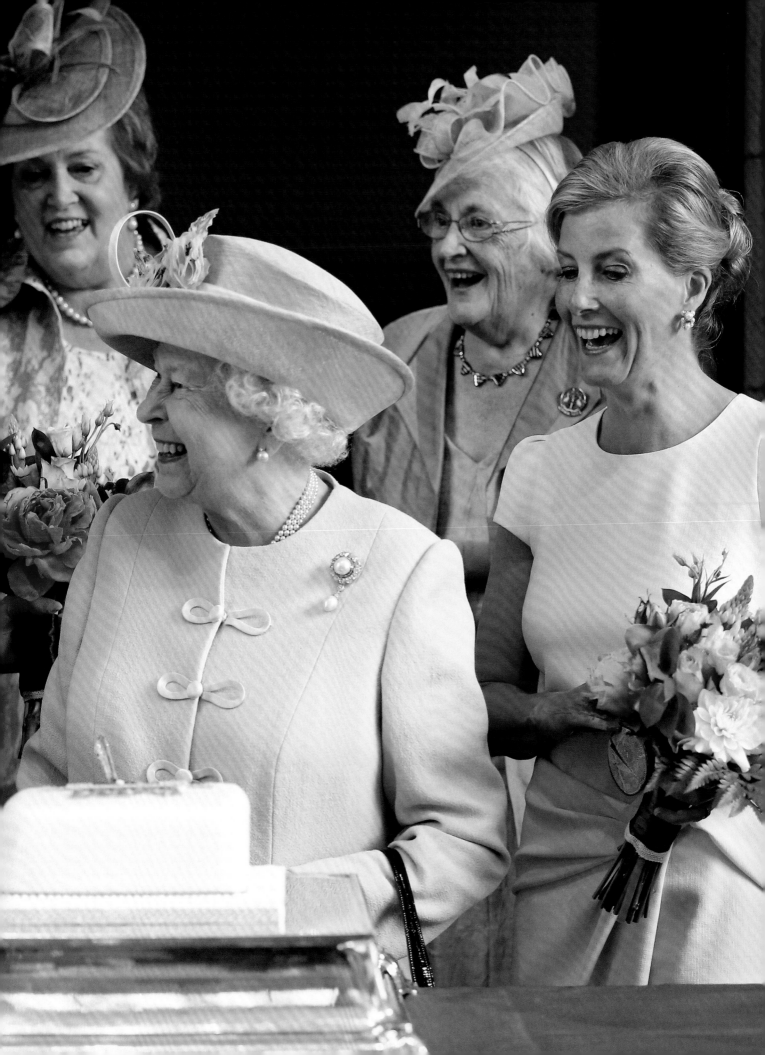

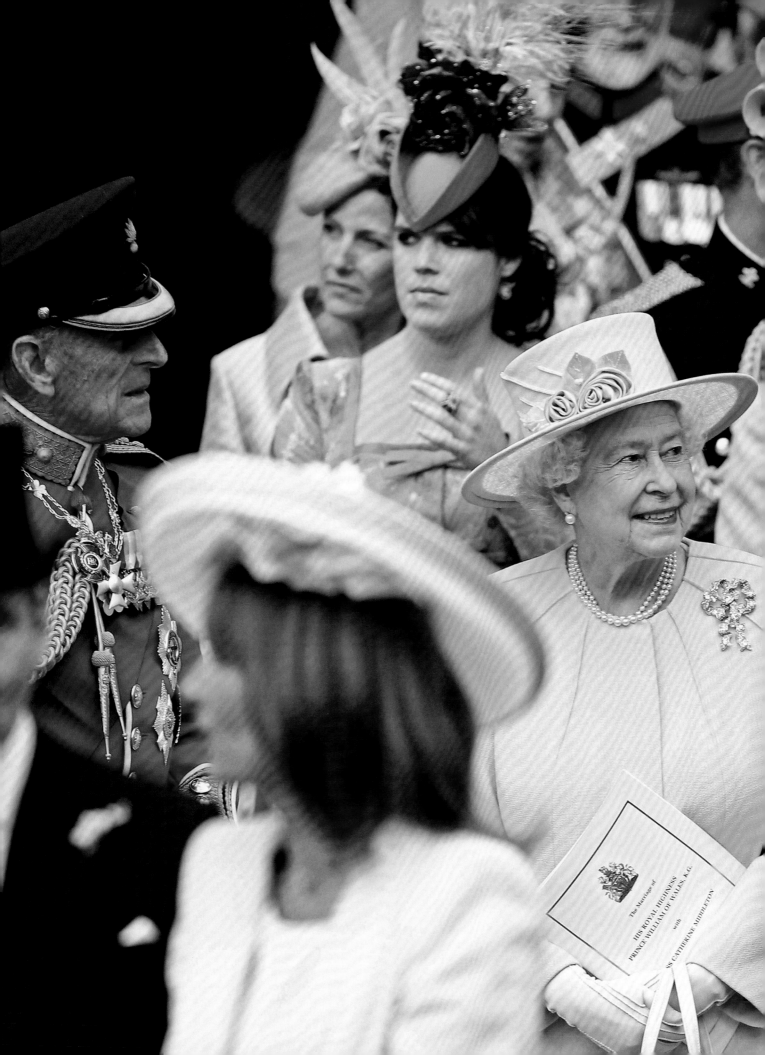

WEDDING PARTY

The Wedding of the Duke
and Duchess of Cambridge
at Westminster Abbey on
29 April 2011. The Queen
instantly stands out in pale
yellow on the steps of the
Abbey as the royal family
departed after the ceremony.
I was positioned opposite
the entrance to the Abbey,
primarily to capture those first
moments of the newly married
couple as they emerged into
the stunning spring sunshine.
There was a sense of joy and
excitement as the crowds
cheered this historic occasion
and billions watched on their
televisions around the world.

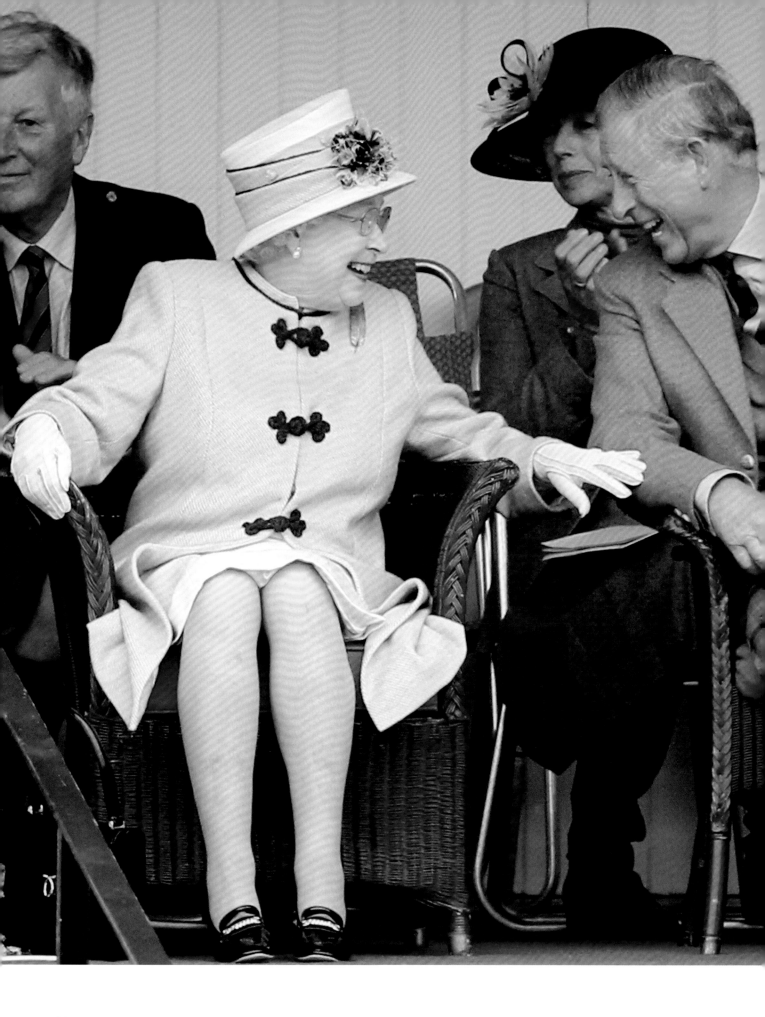

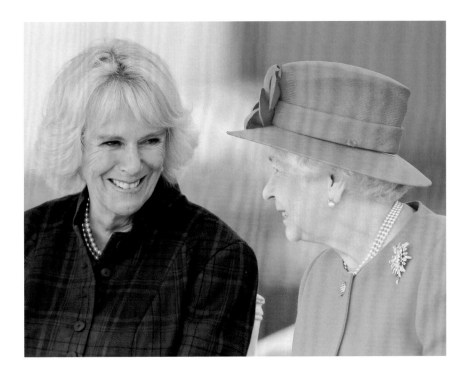

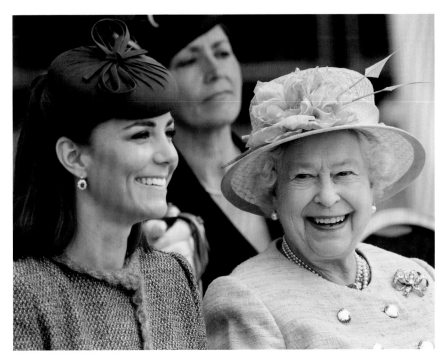

(Left) Mother and son, Queen and Prince, enjoy the action at the 2010 Highland Games in Braemar, down the road from the Queen's summer retreat in Balmoral.

(Above, top) The Queen is supported by the Duchess of Cornwall during a visit in 2013 to the inner-city riding centre, Ebony Horse Club, in Brixton, London.

(Above, bottom) The Duchess of Cambridge and the Queen enjoy themselves as they pay a Diamond Jubilee visit to the city of Nottingham in 2012.

FROGMORE HOUSE AND GARDENS

In March 2021, Buckingham Palace asked me to photograph the Queen and the Prince of Wales at an event at Windsor Great Park. After capturing the initial photographs of the event at Windsor, I walked back to my car and waited to hear if the group would move to Frogmore for a second photo session. After a short wait, I received the signal that it was all systems go.

I was confused about how to get to the second location. When I was told to, "Lead the way," in a matter-of-fact manner, I did not understand. Me?! Lead the way?! I slowly edged my car around the Queen's and Prince's cars and took the lead of guiding this exclusive convoy in the Queen's own backyard. I nervously glanced in my rearview mirror to see the Head of the Commonwealth driving herself, with the Prince following her. I came to a junction. I had only been this way once before on a brief recce, and nerves made me doubt what common sense dictated. I gingerly drove toward Frogmore House. As I approached, I realised that I was not sure which of the two entrances was the correct one. I chose the main entrance and eased my car into the driveway in front of the historic building.

I parked my car and began unloading my equipment. Just then, whizz!, the Queen's and Prince's cars sped past me toward a road leading to the back of the house. A sense of panic overtook me as I realised that I had stopped short and would have to run after them with my heavy camera equipment. I jumped out of the driving seat and sprinted around the back of the house in hot pursuit, cameras bouncing around my shoulders. Breathing heavily, the requisite Covid facemask blocking the air in and out, I eventually arrived at the stunning location for the photographs. Straightening my tie and catching my breath I said, "Your Majesty, Sir, this way, please."

PRINCE PHILIP, THE DUKE OF EDINBURGH

For more than seven decades, the Duke of Edinburgh was by the Queen's side. His unique sense of humour, as well as his incredible and enduring commitment to duty, made him the ideal consort to Her Majesty the Queen. The Duke first had a direct impact on my life while I was at school and completed my Duke of Edinburgh Gold Award. The awards scheme was one of the Duke's greatest achievements. Launched in 1956, it has influenced millions of young people around the world. The awards aimed to help children in the UK and

Commonwealth attain standards of achievement in a wide variety of activities and interests. While the Duke achieved a huge amount in his own right, it was because of his commitment to his primary role, supporting the Queen, that for so long the couple have been respected and revered around the world. His depth of knowledge on many subjects was renowned, and I remember how his probing questions while on royal engagements always seemed to go beyond the purely conversational to touch on something genuinely intellectually inspiring.

(below) The Queen and the Duke of Edinburgh chat as they watch a performance of "A Celebration of Nova Scotia" at the Cunard Centre in Halifax, Canada, in 2010.

(Opposite) The Queen, standing out in pink, with the Duke of Edinburgh in the parade ring at Royal Ascot in 2016.

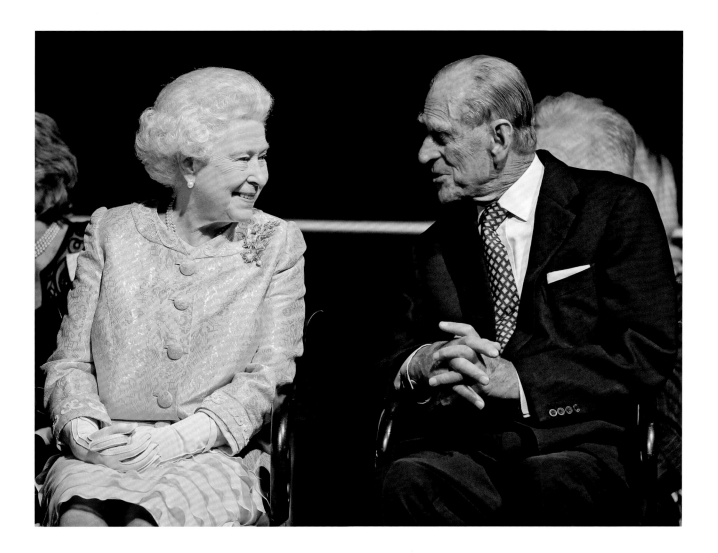

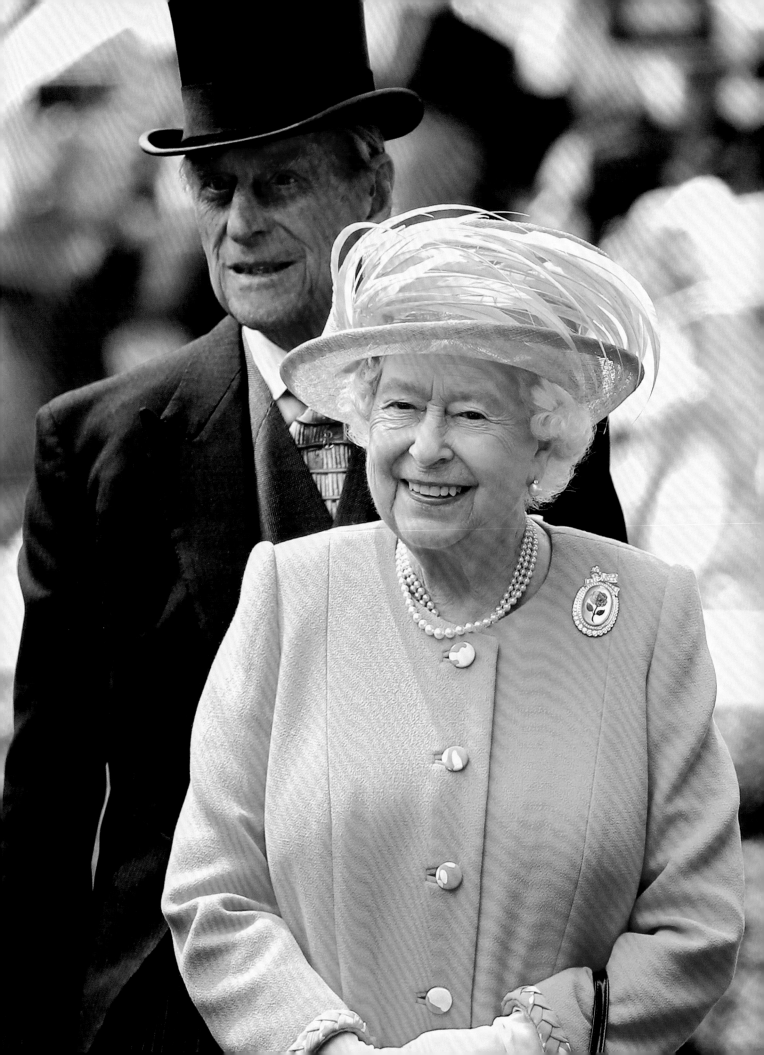

AN ANNIVERSARY IN LOCKDOWN

During the UK's second lockdown in November 2020, I was invited to photograph the Queen and the Duke of Edinburgh when they were celebrating their seventy-third wedding anniversary. I received the news of the commission while I was taking some time off in Cornwall. I was immediately buzzing as I nervously thought through the planning required for the photo shoot on my journey back to London. There was an air of quiet over Windsor Castle as the Queen and the Duke operated with a skeleton staff throughout the period of tightened restrictions around the country.

I worked alone for this shoot and, of course, was required to observe a number of safety precautions to be able to even enter the castle. As I carried my equipment across the quadrangle, I contemplated the enormity of celebrating seventy-three years of marriage. What an astounding achievement, irrespective of their roles as royals. The resulting image, taken in the Queen's sitting room, known as the Oak Room, was a candid photograph of the Queen and the Duke as they opened a home-made anniversary card from their great-grandchildren, Prince George, Princess Charlotte, and Prince Louis. The card featured a multicoloured "73" on the front. The Duke's face lit up as he opened it. I loved that link between one generation and another at a time when families were unable to meet in person. It was such a special, genuine moment.

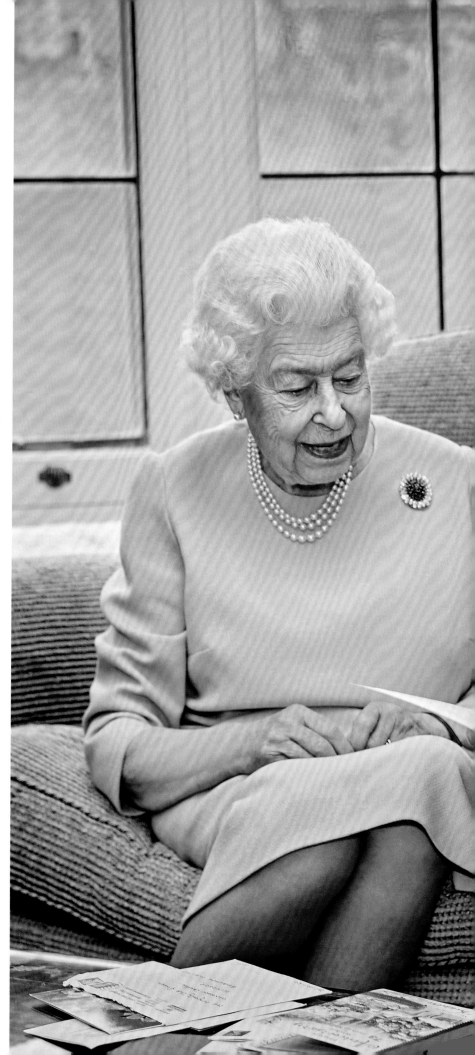

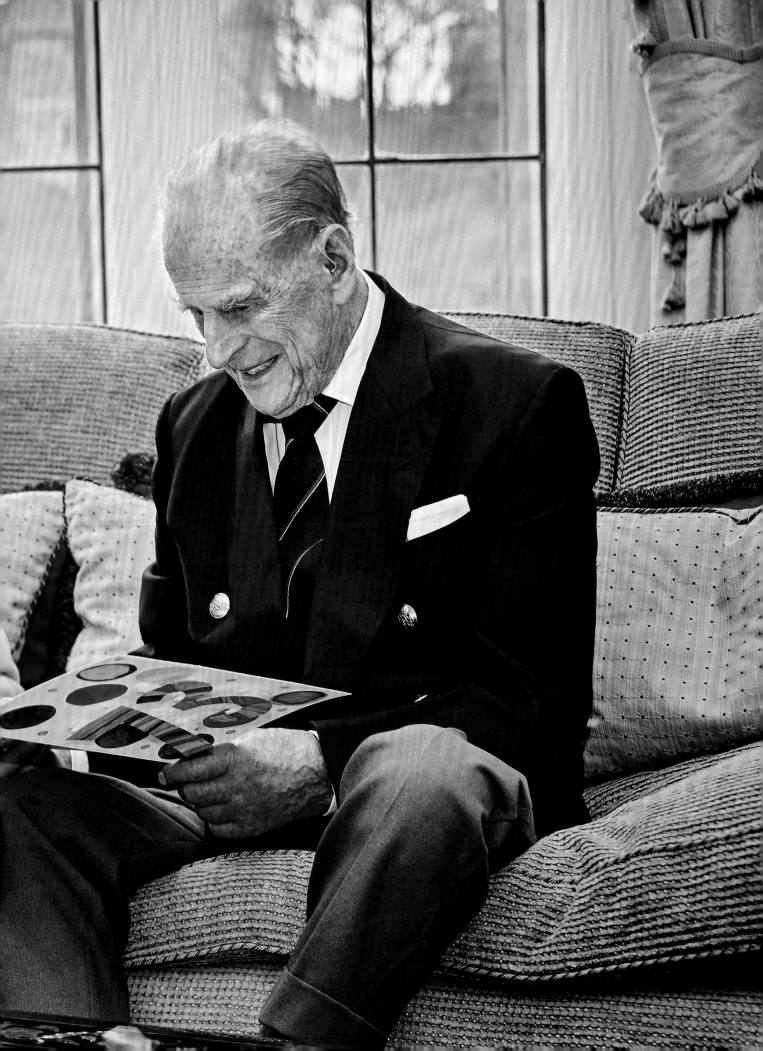

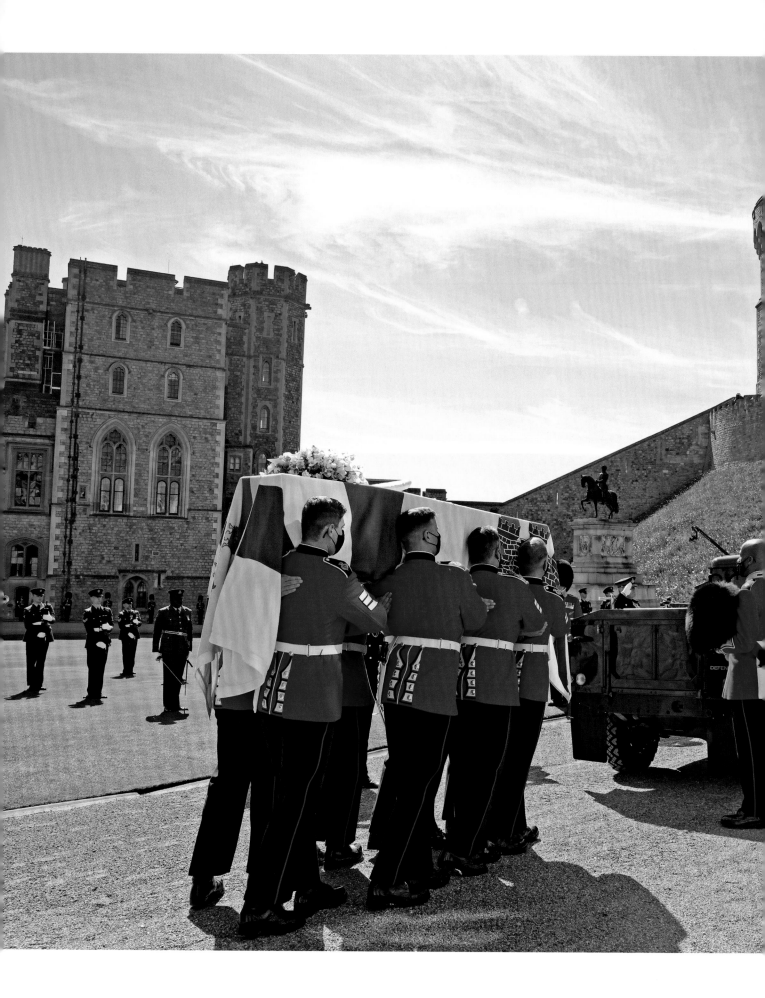

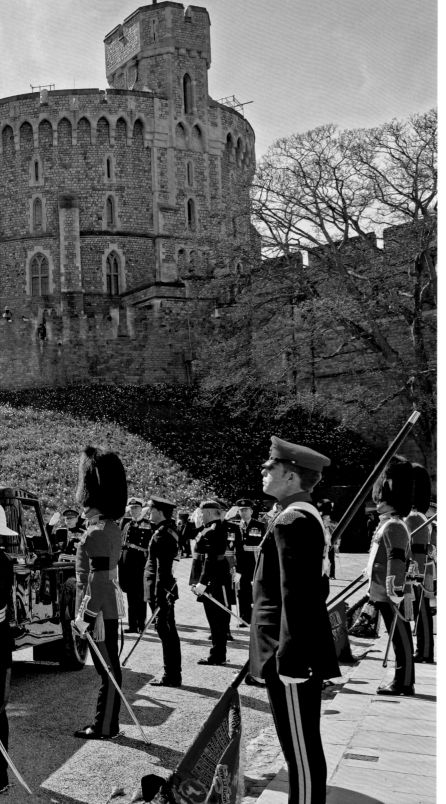

A DUKE'S FAREWELL

As the spring sunshine shone down on the stunning array of daffodils surrounding the Round Tower of Windsor Castle on 17th of April 2021, the pallbearers carried the coffin of Prince Philip, the Duke of Edinburgh, to the customised military green Land Rover Defender TD5 130 that the Duke himself had helped design, I thought back to the morning not that long ago when I photographed the Queen and the Duke on their seventy-third wedding anniversary in the Oak Room of Windsor Castle, that same iconic Round Tower visible in the background through the window in my photograph.

The country and the Commonwealth had been in mourning for a week ahead of the funeral. In my privileged position next to the state entrance of Windsor Castle, I watched as the Duke made the final journey to his ultimate resting place in St. George's Chapel. It was impossible not to be moved by the emotion of the moment. I felt the enormity of what a historical day this was, but ultimately a sad one, too. The Duke was a man who had devoted his life to service, the Queen, and his country as the longest reigning royal consort in history. He had given more than seven decades of service to the country with a unique wit and incomparable sense of duty and professionalism.

It was a privilege to have such an intimate view of the Duke's final farewell, to document a royal family so clearly saddened by their loss. I was required to use cameras with totally silent mechanisms and had to learn a new mirrorless system in the run-up to the funeral. On the day of the funeral, it became clear how essential these silent cameras were to maintain the decorum and solemnity of the moment as the procession passed me on the way to St. George's Chapel. Because of Covid-19 restrictions, the funeral itself was private and limited to thirty family members.

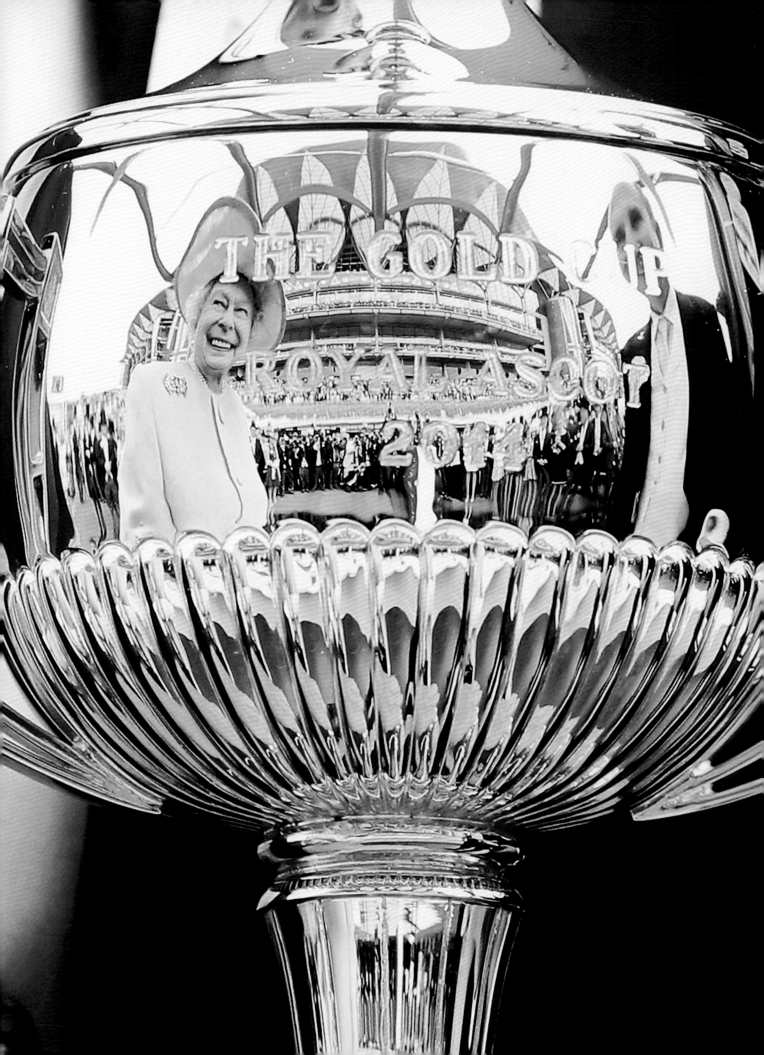

VI

HORSES AND HIGHLANDS

It is no secret that the Queen is an incredibly passionate horsewoman, and that she still enjoys riding in her nineties. Horses have always been and remain an important part of her life. This passion started at a young age when she was given her first horse, Peggy, as a fourth birthday present, by her grandfather, George V. The young princess inherited a love of breeding and racing horses from her mother. As a photographer, I often capture the monarch at her happiest when she is around horses. Horses permeate every facet of the Queen's life—from her ceremonial duties to her private pursuits. Her devotion begins with her in-depth knowledge of the breeding process and extends to her continuing quest to breed the ultimate racehorse. Horses bred by the Queen have gone on to win more than 1,600 races. This passion for all things equine mirrors the monarch's love of Scotland and, more specifically, her summertime residence of Balmoral in the Scottish Highlands. It is in the stunning heather-strewn landscape of Royal Deeside that the Queen enjoys some of her most relaxed and private pastimes. The public highlight of this period is the Braemar Gathering, always held on the first Saturday of September. The Queen's relaxed nature is often reflected in photographs taken during this event, which she attends with other members of the Royal Family.

Page 210

THE QUEEN REFLECTED IN THE GOLD CUP

While 2014 was not to be the Queen's year in the famous Gold Cup at Ascot. I decided to take a more creative approach to photographing the monarch at the event. I noticed the Queen's reflection in the much-coveted gleaming trophy as I waited for her to present it to the winning jockey. Using a long (500mm) lens, I was able to capture a smiling Queen with the iconic Ascot building behind her.

ROYAL ASCOT

By far the most prestigious event in the racing calendar is Royal Ascot. A staple in the royal diary for well over a century, Ascot is the working highlight of the summer season for a royal photographer. The story of Ascot began in 1711, when Queen Anne, a keen equestrian, spotted a perfect clearing for horse racing in the forest near Windsor Castle and promptly bought it for the equivalent of $786. George IV initiated the first royal carriage procession on the track in 1825, and the tradition has continued ever since. The event is a triumph of all things British.

On each day of Royal Ascot week, the Queen and members of the royal family travel to the parade ring in the famous carriage procession that starts in the grounds of Windsor Castle. A tsunami of cheers accompanies the carriages as they proceed down the racetrack in front of the stand designed by renowned architect Rod Sheard, and continues as they enter the parade ring. Racegoers in top hats and women dressed up to the nines all crane their heads to catch a glimpse of what colour hat the Queen is wearing that day.

Overleaf
The royal procession arrives at Royal Ascot's immaculately turfed parade ring—a truly British spectacle!

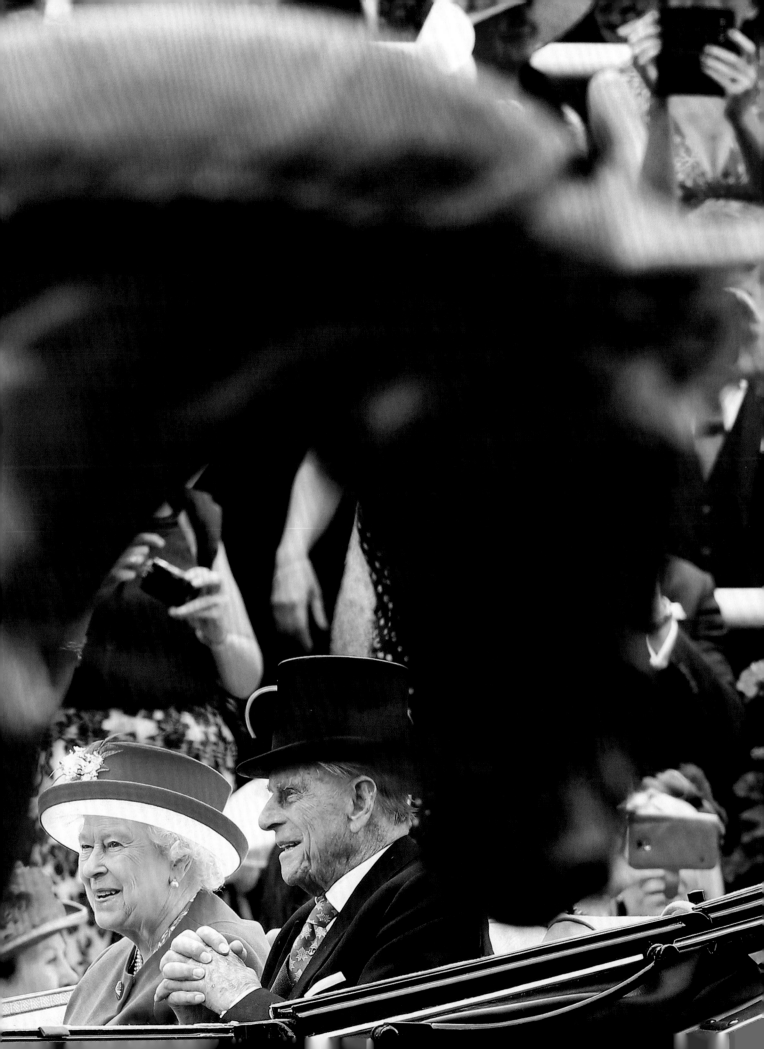

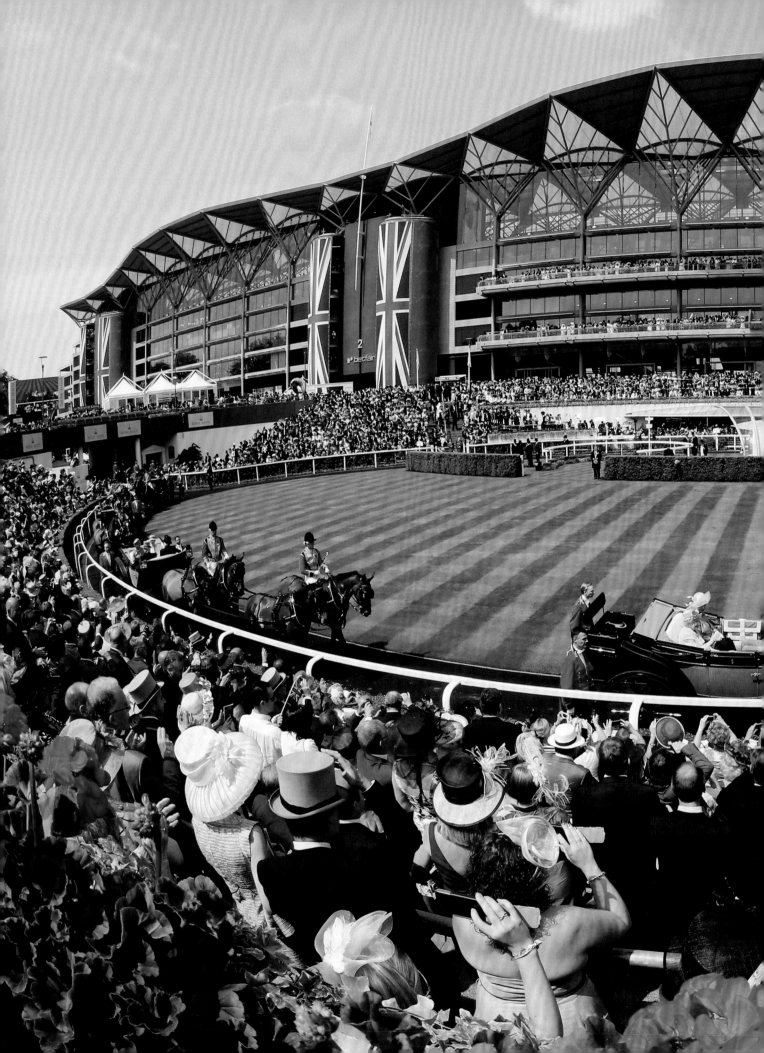

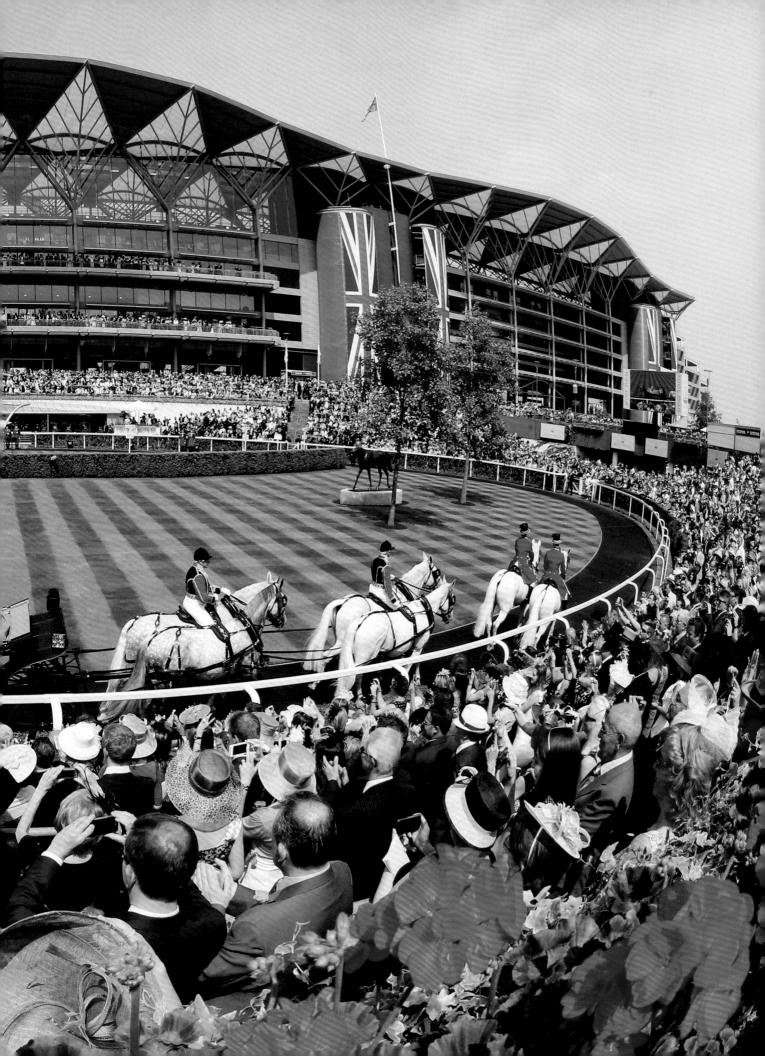

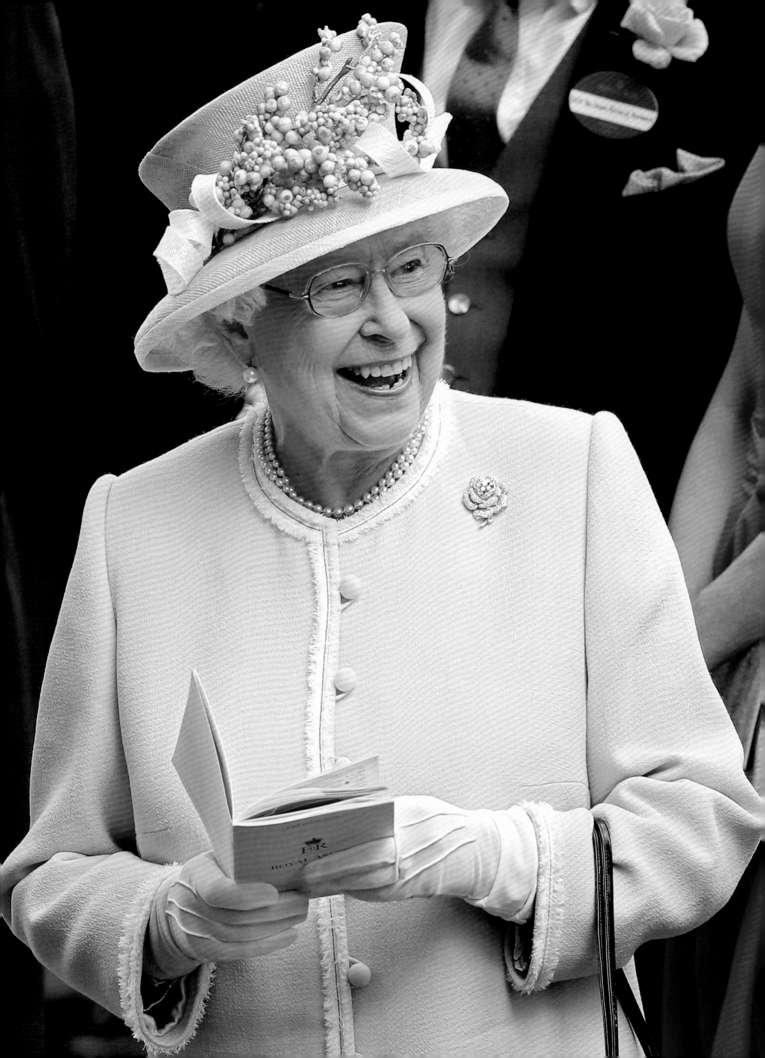

TRIUMPH IN THE GOLD CUP

The Queen can often be spotted checking her race card in the parade ring of Royal Ascot (left), clearly enjoying the afternoon's racing, seen here in a pastel pink ensemble. One of my most memorable images was taken on Ladies Day in 2013. There was a real buzz around the parade ring ahead of the parade ring ahead of the Gold Cup, the most coveted event of the week's racing. Never had a reigning monarch in the race's 207-year history triumphed in this highlight. The Queen's horse, Estimate, an Irish-bred, British-trained thoroughbred racehorse trained by Sir Michael Stoute, was the 7/2 favourite for the Cup, but many could not believe their eyes as the filly battled all the way to the finishing line in just the seventh race of her career. The roar of the crowd must have been ringing in the ears of jockey Ryan Moore as the horse powered him down the famous final straight. Estimate crossed the finish line to riotous cheering from normally restrained crowds. Everyone knew how much this would mean to someone as passionate about racing as the Queen. I soaked up the heady atmosphere in the parade ring before taking this shot of the Queen being presented with the trophy, her eyes lighting up with joy. It was certainly one of the most enduring royal moments of the year for me.

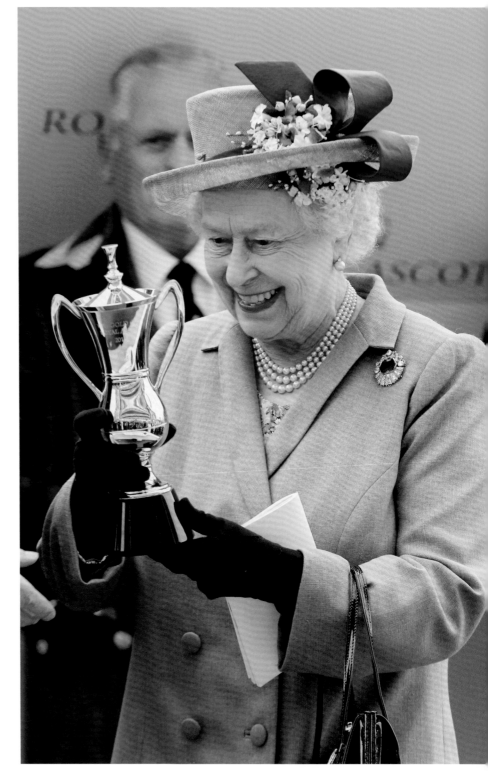

(Above) Wearing the prerequisite morning dress that allows access into the Royal Enclosure at Ascot, these two gentlemen run for cover during a passing rain shower.

(Opposite) The Queen always takes the rain in her stride and has a vast collection of transparent umbrellas, more often than not edged to match her outfit.

Overleaf
The impressive sight of the Trooping the Colour procession making its way down The Mall towards Buckingham Palace in 2014.

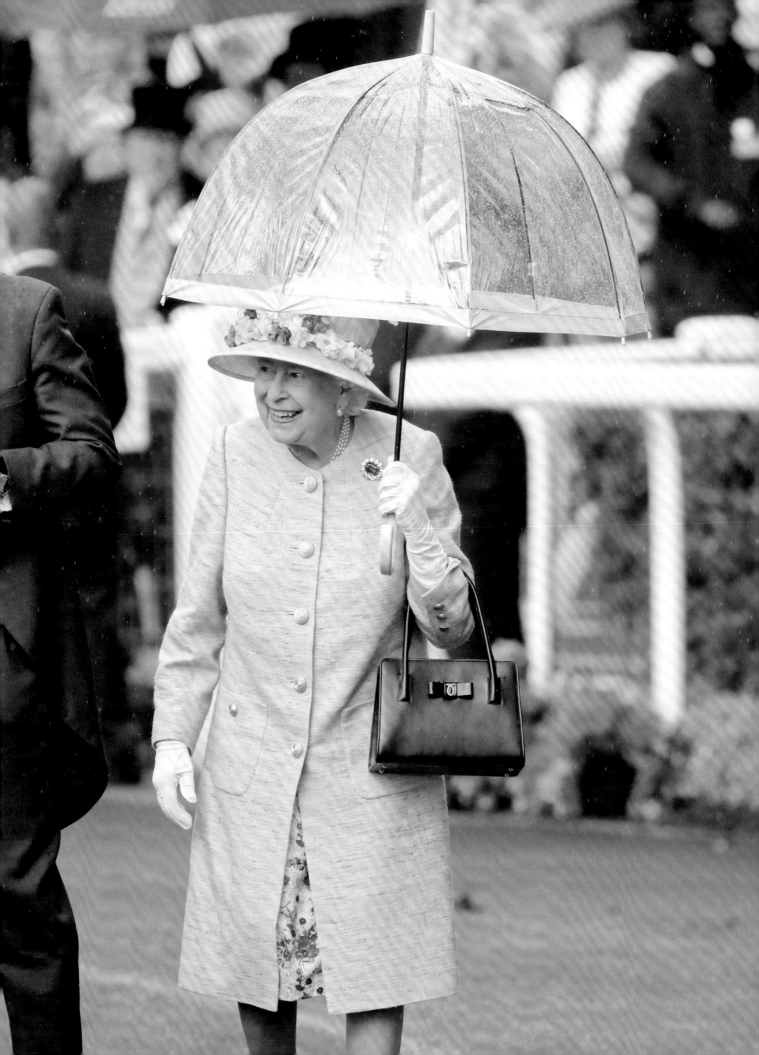

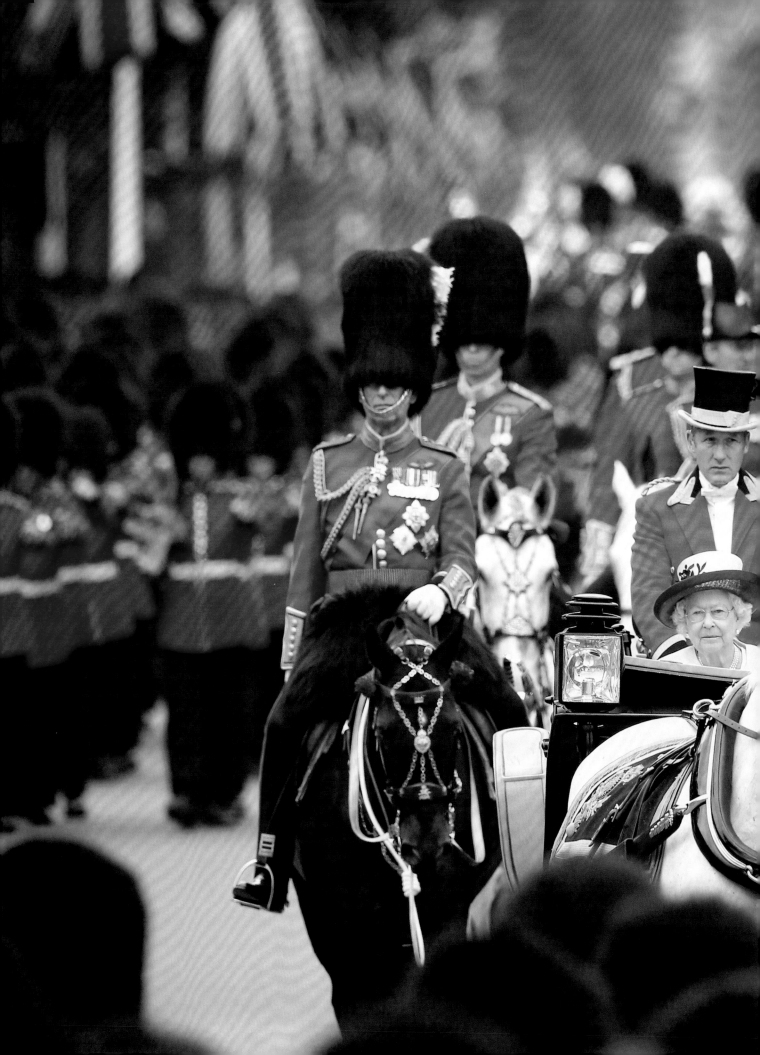

KING'S TROOP SEVENTIETH ANNIVERSARY

It was a drizzly and windswept autumnal day in 2017, when the Queen took to the back of her open-roof Range Rover Vogue in Hyde Park to review the elegant horses and proud riders of the King's Troop Royal Horse Artillery. The King's Troop was formed, as the name suggests, by King George VI in October 1947. It is more commonly known by its colloquial handle, "The Gunners." The King's Troop Mounted Ceremonial Battery is responsible for the firing of royal salutes to mark grand occasions of state including the Queen's birthday parade and other royals' births and birthdays. The Troop also played an important role at Princess Diana's funeral, carrying the coffin through the streets of London.

To mark its seventieth anniversary, the King's Troop presented an incredible spectacle and impressive display of horsemanship. Recognising this important moment in the history of the regiment, the Queen took to the podium for the final part of the review, which was watched by the families of the soldiers.

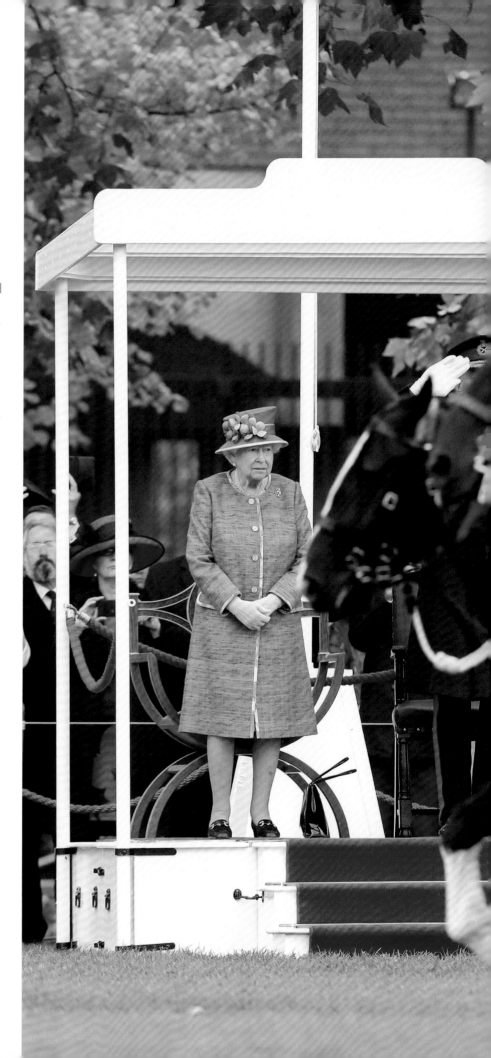

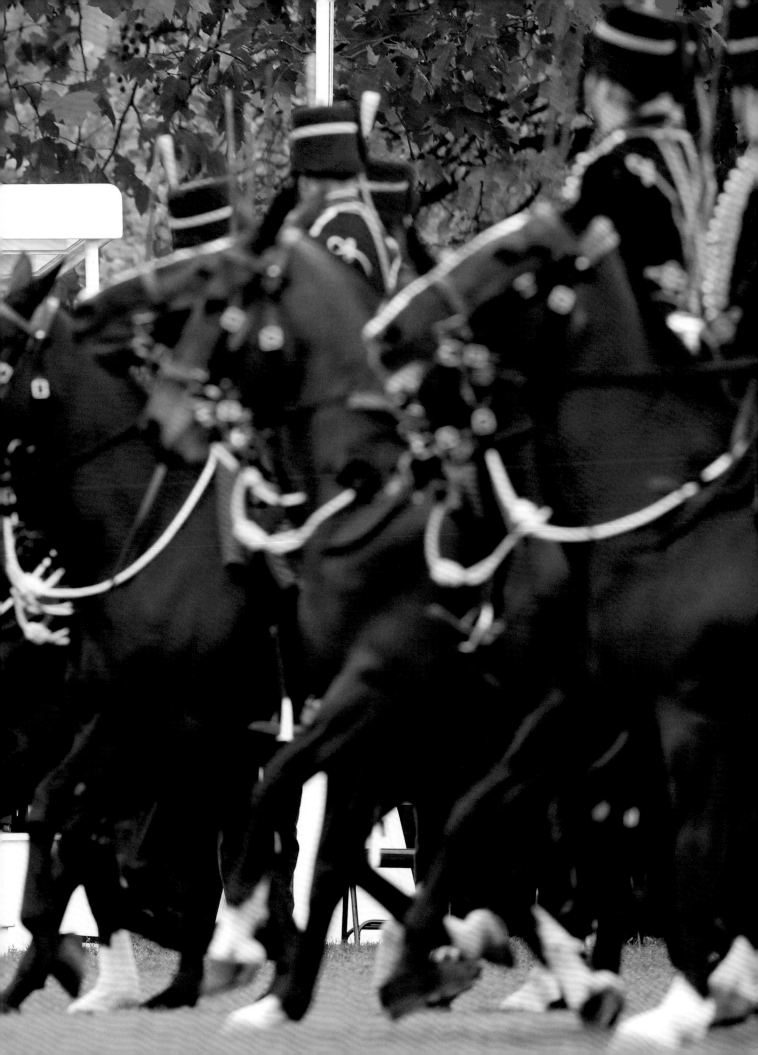

THE QUEEN VISITS THE LIPICA STUD IN SLOVAKIA

As a connoisseur of horses, the Queen could not fail
to be impressed by the horses at the Lipica Stud in
Slovenia in 2008. This stud is renowned for producing
Lipizzaners. With their white coats and graceful
performances, these horses are famed for their
involvement in the Spanish Riding School in Vienna.
The royal couple were treated to an incredible display
of horsemanship from the unbelievably elegant and
rare Lipizzaner horses during their visit to the farm and
riding school, near the Italian border. After watching the
display, the Queen was presented with Kanizo, a sixteen-
year-old stallion. Of course, a horse is not the kind of
thing that is very easy to take back on a plane, so at the
Queen's request Kanizo remained at the centre to be
cared for.

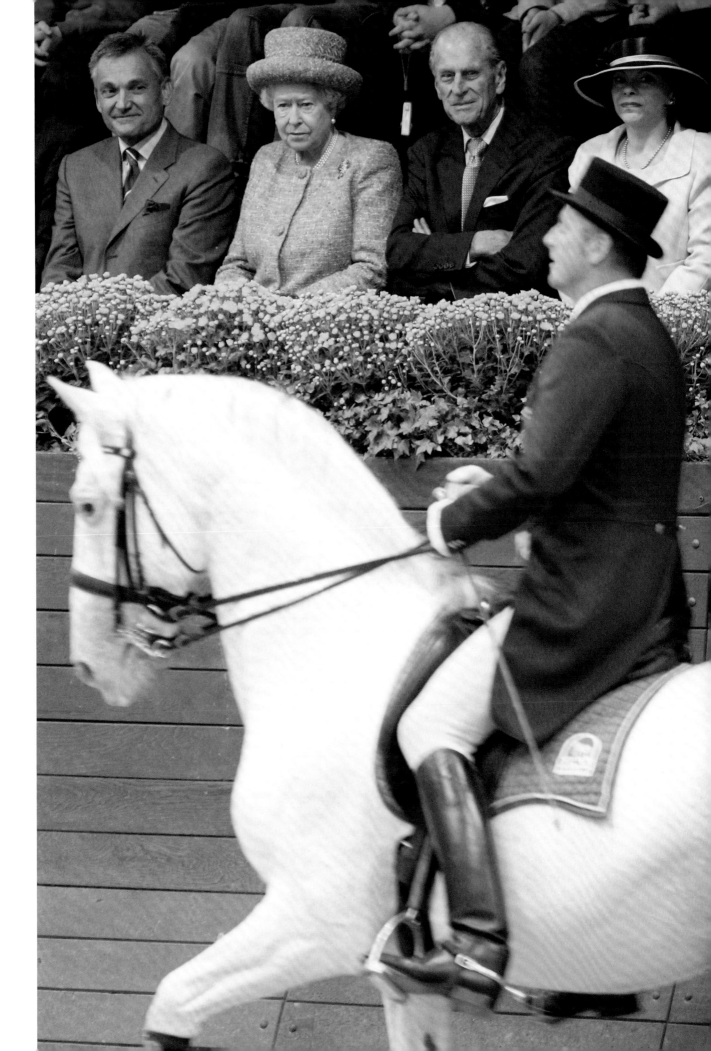

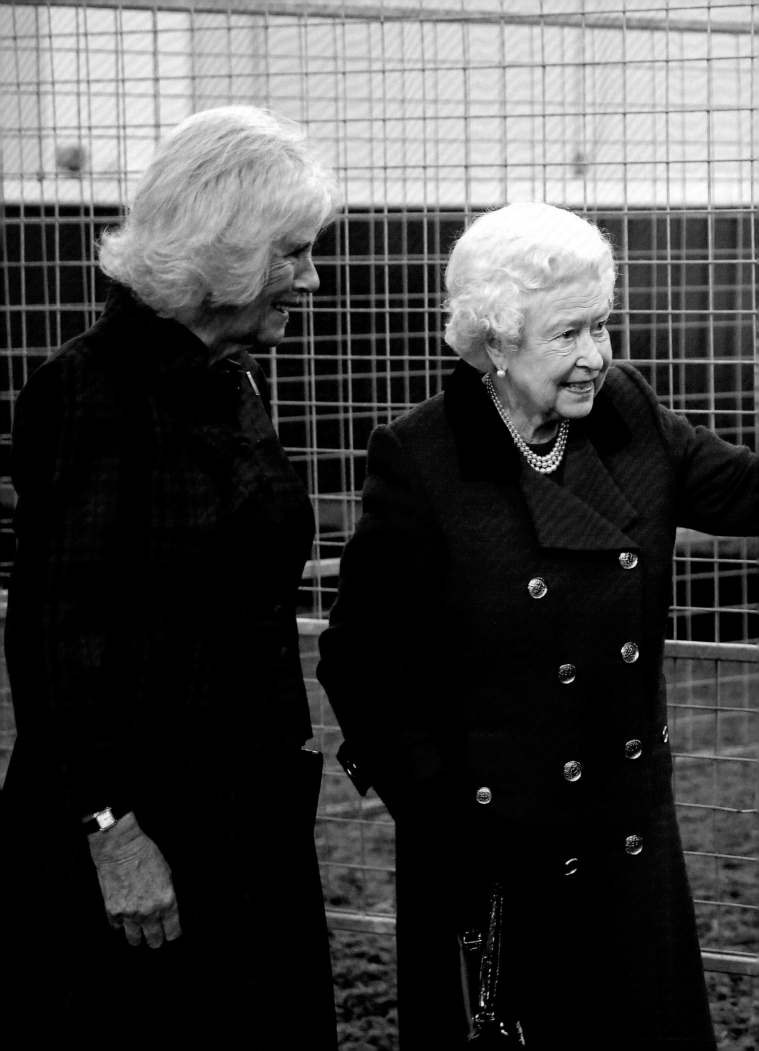

THE HORSE WHISPERER

In 2015, I took this photograph of the Queen and Duchess of Cornwall attending a horse-whispering demonstration by the legendary Monty Roberts at the Royal Mews stables in Buckingham Palace. Roberts believes you can communicate with horses through the medium of a nonverbal language he calls Equus. The demonstration was organised by the Brooke charity, which campaigns for the better treatment of equine animals, and Roberts, who serves as its ambassador. The Queen has a long history with Monty Roberts, having first met him in 1989 when he worked with her own horses. Her subsequent support of Roberts techniques helped propel him to global fame. During a captivating display of "horse-taming," Roberts managed to get a young filly called Jess to wear a saddle for the first time in around fifteen minutes—impressive stuff!

Overleaf
Mist shrouds Burghley House, near Stamford, Lincolnshire, on the morning of the famous Horse Trials in September 2006.

A32 A31 A30 A29 A28

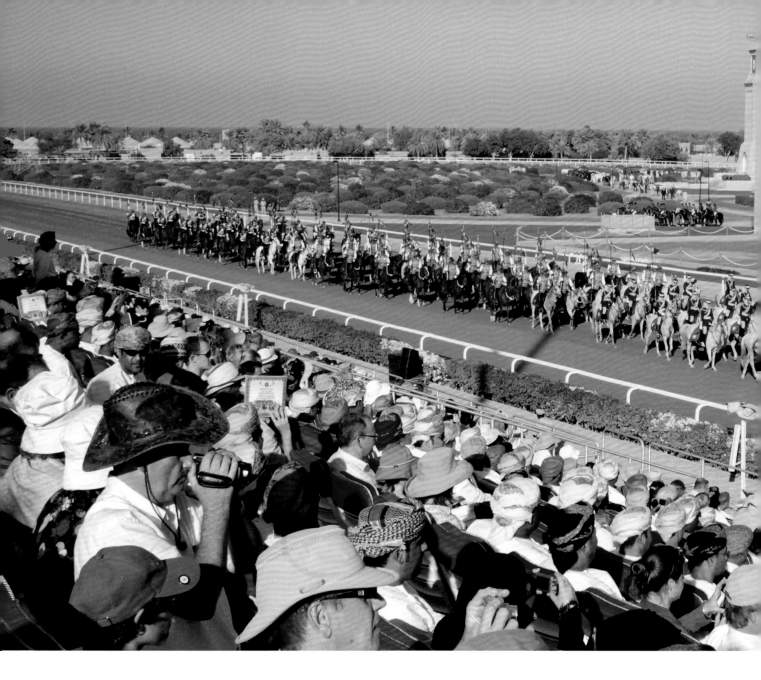

THE OMANI ROYAL CAVALRY PUT ON A SHOW

In 2010, I visited Oman to document the Queen and the Duke of Edinburgh's State Visit to the desert country to mark forty years of the late Sultan Qaboos's reign. Oman has a strong history of links with the UK, and its relationship with the Arabian horse breed is legendary.

One of the highlights of the visit was an event put on by the Oman Royal Cavalry, which featured its renowned horsemanship skills. The cavalry was founded in 1974 by the Sultan, and its accomplished members have built a reputation as an impressive performing and ceremonial group. Knowing the Queen's passion for all

things equestrian, Sultan Qaboos, a devoted horse lover, was keen for her to witness the spectacle of the cavalry's famous horsemen and women, and they certainly did not disappoint. There were equestrian skill-at-arms, arrow shooting, and some incredible pyramid formations, as well as pure Arabian horses. The sheer scale of the show was magnificent with more than 840 horses and 2,000 riders taking part. In the hot weather, visitors covered their heads with hats. After an incredibly hot day the sky began to turn pink, topping off a once-in-a-lifetime demonstration of Oman's incredible relationship with horses.

POLO PASSIONS

The royal family is inextricably linked with the aptly titled "sport of kings." Many of the younger members of the family, such as the Duke of Cambridge, use polo as an enjoyable and effective way of raising huge sums of money for their charities. The Prince of Wales, long since retired from the sport, was an avid player who would often arrive at the polo field in his Aston Martin Volante. The Queen's Cup was first presented by the Queen when it was founded on 25 January 1955, with the Duke of Edinburgh as president. It is intimately associated with its sponsor Cartier, since 2012, and its traditional location at the Guards Polo Club. The competition is regarded as one of the world's leading high-goal polo tournaments at what is among the largest and most respected polo clubs in Europe. It is attended by many high-profile guests and celebrities every year.

(Below) Polo fans watch the action from a carriage during the Queen's Cup final in 2008.

(Opposite) The Queen presents an award to a polo player in an iconic Cartier red box at the Queen's Cup final at Guards Polo Club in 2013.

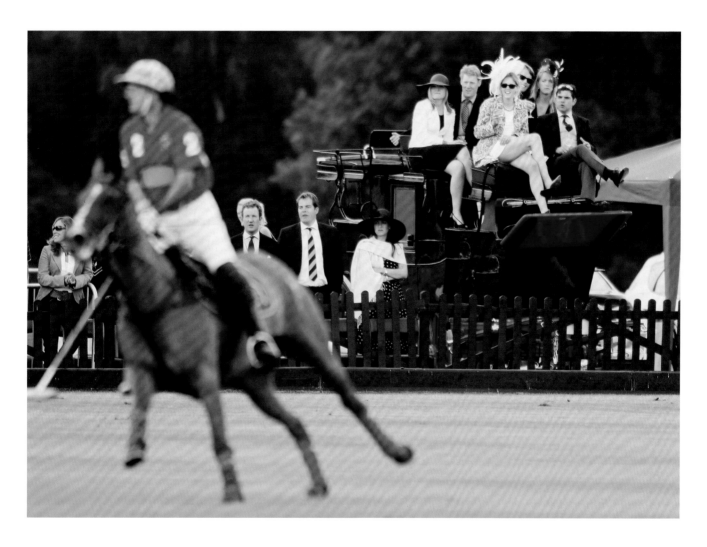

Overleaf

WINDSOR HORSE SHOW

Located in the grounds of Windsor Castle, effectively the Queen's back garden, nothing seems to give the monarch more pleasure than the Royal Windsor Horse Show. The event, which features carriage driving, dressage, and endurance riding, has taken place since 1943, and is held over a period of five days. The Queen often arrives unannounced, clad in an understated Hermes headscarf, driving herself in her green Land Rover. When she watches the competitions and chats animatedly with judges and competitors, it is a fantastic opportunity for a photographer to capture some of her real passion for all things equine. You can see how intently the Queen examines the horses, the riders' techniques, and form, as she takes it all in whatever the weather.

(Left) The Queen holds on to her programme as she visits the trade stands at the Windsor Horse Show.

(Right) Two riders take in the competition on the second day of the Windsor Horse Show in 2008.

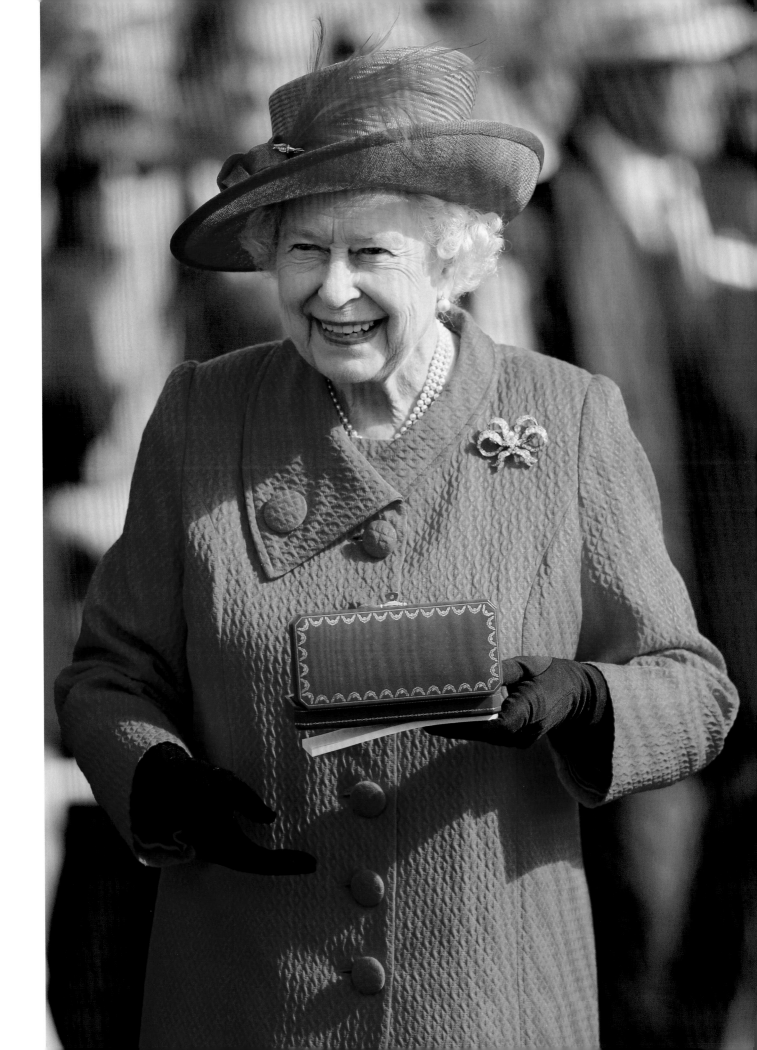

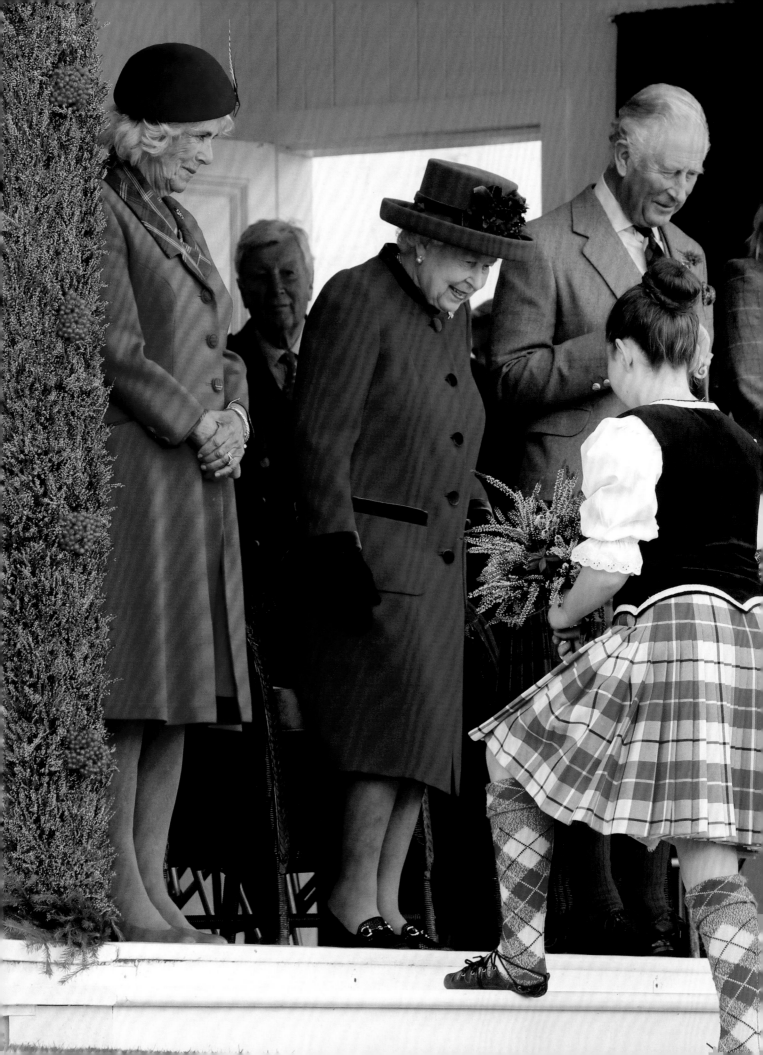

HIGHLAND GAMES

Whenever I pick up the keys to my hire car at Aberdeen Airport feel a sense of impending excitement about the drive along Royal Deeside in some of the most spectacular countryside the UK has to offer. The Braemar Highland Gathering is one of my favourite highlights in the royal calendar. Held on the first Saturday of September, the Highland Games generally signal a return to work after the royal family's summer break in August.

I get to the event early to capture some of the action, such as the caber tossing or Highland dancing. Early in the afternoon, the royal party arrives, led by the Queen. Being in Scotland undoubtedly means she feels a little more relaxed and this mix of informality and the presence of her family often results in some lovely natural images. Having said that, as a photographer, you certainly have to be on your toes as it would be easy to miss these interactions during the hour-long period in which the royal party watches the action taking place in the arena. From caber tossing to the tug o' war, you never know when "the picture" will happen, so intense concentration is called for. The reward for a photographer's tired eyes is a drive back through stunning Highland scenery to a warm fire and some Scottish hospitality, which always keeps me smiling!

(Above) A favourite residence of Queen Victoria and Prince Albert, Balmoral Castle has remained a favourite residence for the Queen and her family during the summer holiday period in August and September. The Castle is located on the large Balmoral Estate, a working estate that aims to protect the environment while contributing to the local economy.

(Right) Purple heather covers much of the beautiful hillsides around Balmoral in Royal Deeside.

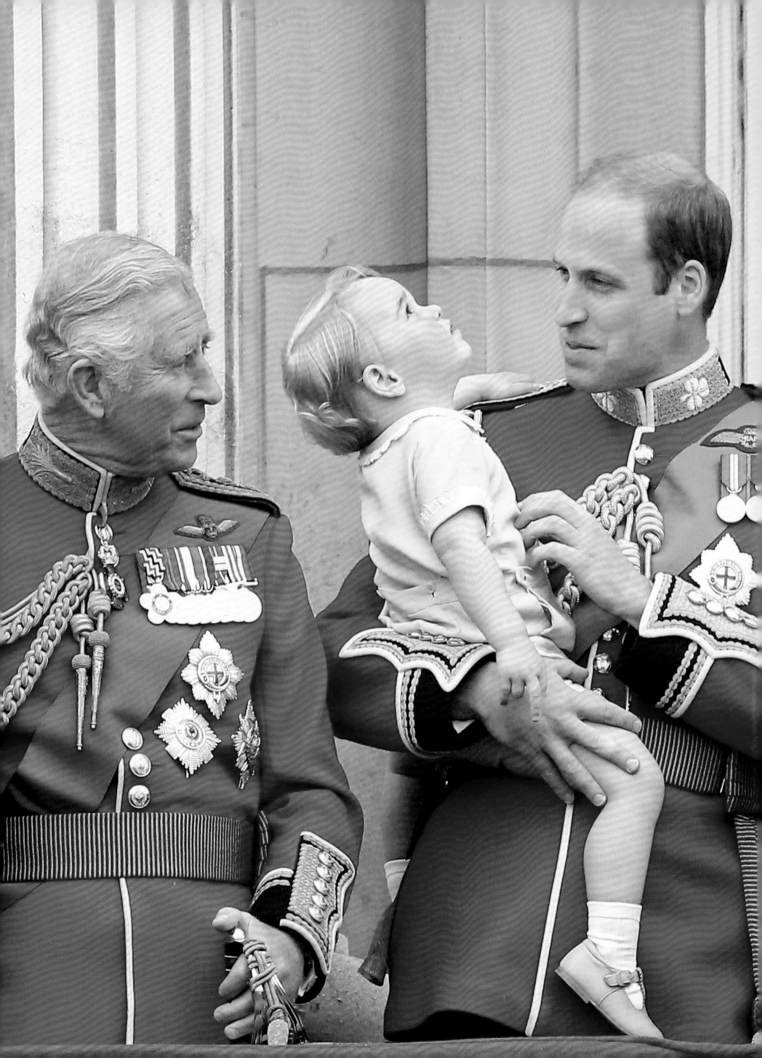

VII

PASSING ON THE BATON

Of all the Queen's duties, paying respects to those who have made the ultimate sacrifice on behalf of the nation remains one of the most solemn and important. Supporting and encouraging public and voluntary service as well as recognising achievement have always been integral to the Queen's role. Looking to the future involves a gradual handing over of the Queen's duties, many of which she inherited from her father, King George VI. It is a long and often poignant process, as some of the patronages and roles have been held by the Queen and the Duke of Edinburgh for more than half a century. These include not only ceremonial duties but also patronages of charities and military institutions from across the UK and the Commonwealth. Here I look at a few examples of this transition, an illustration of a future royal family in the making, a "modern monarchy" that will take the royal family forward, continuing the work of the Queen and adapting and modernising to appeal to a younger generation while upholding and protecting the values the royal family stand for.

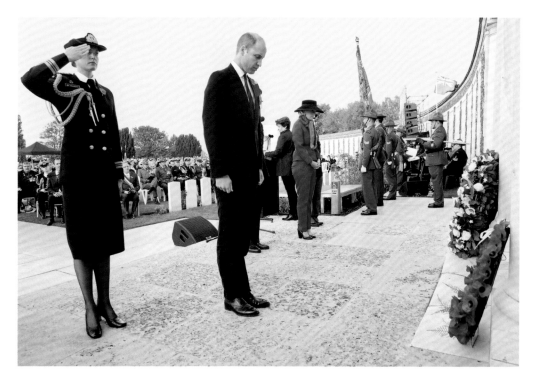

Page 246
Prince Charles, Prince William, and Prince George stand on the balcony of Buckingham Palace during Trooping the Colour, the Queen's Official Birthday celebrations, on 13 June 2015.

(Above) Sophie, Countess of Wessex, represents the Queen as the Reviewing Officer at the Sovereign's Parade at Royal Military Academy Sandhurst on 13 December 2019, in Camberley, England.

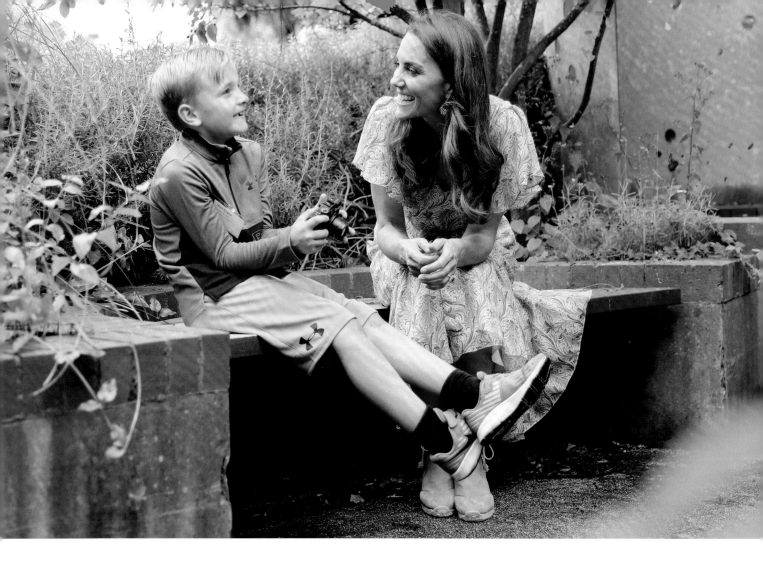

THE DUKE OF CAMBRIDGE LAYS A WREATH IN FLANDERS

The Duke of Cambridge has performed duties on behalf of the Queen on a number of occasions. A particularly sombre moment took place among the sea of white gravestones at Tyne Cot Cemetery in Flanders, Belgium, in 2017, when the Duke represented the Queen at the commemorations of the centenary of the Third Battle of Ypres during the First World War. Such moments of commemoration form an important part of what the British royal family does: recognising those who have paid the ultimate sacrifice. There may be no better sobering visual representation of this sacrifice than the sea of white gravestones at Tyne Cot.

THE DUCHESS OF CAMBRIDGE AND THE ROYAL PHOTOGRAPHIC SOCIETY

Much has been made of the Duchess of Cambridge's love of photography; indeed, she has released a number of her own beautiful photographs of her children. Her patronages of the National Portrait Gallery and the Victoria and Albert Museum are well known, but it is the Royal Photographic Society (RPS) patronage, directly handed to her by the Queen, that has a particular resonance. The society is close to my heart. Its director of public affairs, Dr. Michael Pritchard FRPS, wrote the foreword to my book, *Modern Monarchy*. The RPS has a long and illustrious relationship with the royal family. I especially love this image of the Duchess helping photography enthusiast Josh Evans, as she participated in a workshop with the charity Action for Children. I took a photo of Josh just enjoying using his camera while sitting on a log before meeting the Duchess. It reminded me of how photography is such a great thing for young people, inspiring creativity and independence.

The Queen's birthdays on the decade are always huge celebratory affairs. To mark the momentous occasion of the Queen's ninetieth in 2016, I found myself at a marvellous equine-themed event in the grounds of Windsor Castle, hosted by the Queen's son, the Prince of Wales. It took place one of the evenings of the Windsor Horse Show and featured more than 900 horses, representatives from fifty-three Commonwealth countries, military bands, dancers, and singers. My role was to capture the royal arrivals, before moving to the back of the arena to photograph the show itself and the reactions of those in the royal box. Not only were the Queen, the Duke of Edinburgh, the Prince of Wales, the Duchess of Cornwall, and the Duchess of Cambridge in attendance, but also pop royalty like Kylie Minogue and British acting legends such as Dame Helen Mirren. The theme of the show was the story of the Queen's life and her incredible reign of sixty-four years (at that point). Some royals, such as Prince Edward and Lady Louise Windsor, even wished the Queen a happy birthday on horseback (below, left).

The Queen arrived at the birthday celebrations at the Royal Windsor Horse Show in the magnificent Scottish State Coach. I remember how the cloud patterns in the sky beautifully balanced out the artificial lighting in the specially constructed arena, creating an unforgettable

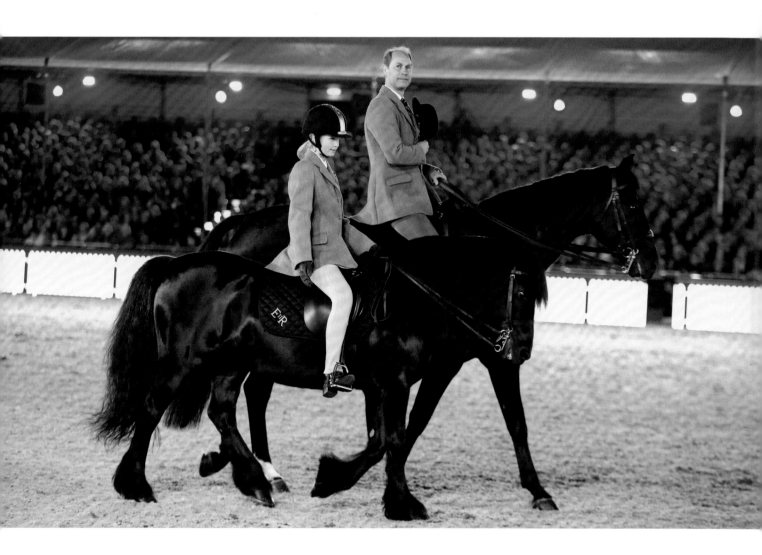

atmosphere for the spectacular pageant. As the Queen stepped out of the carriage, saluted by two Canadian Mounties, she put her hand up to her host for the evening, the Prince of Wales, who kissed it with a broad smile on his face. A dazzling night followed, in which horses were used to tell the story of the Queen's life from her birth in 1926 to the present day. At one point, an incredibly loud gun salute echoed around the arena causing many in the royal box to flinch, but the Queen remained unperturbed (below, right). The evening culminated with a giant birthday cake being wheeled into the arena while the crowd of more than 6,000 people sang happy birthday to Her Majesty.

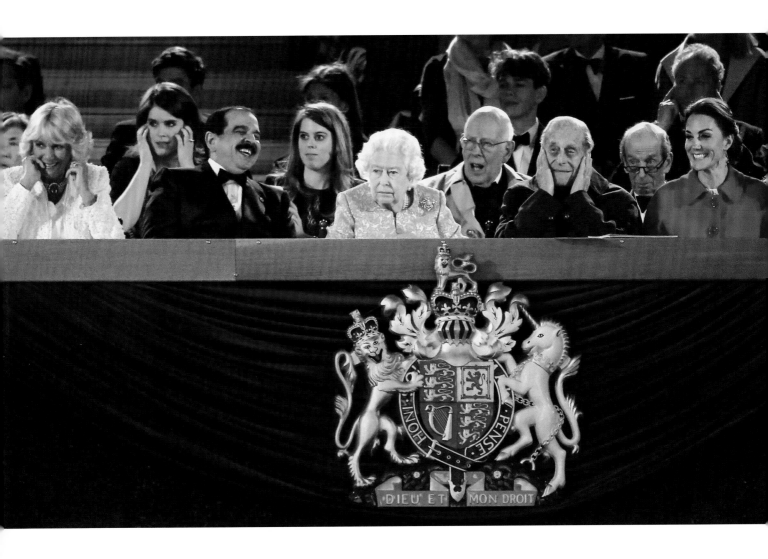

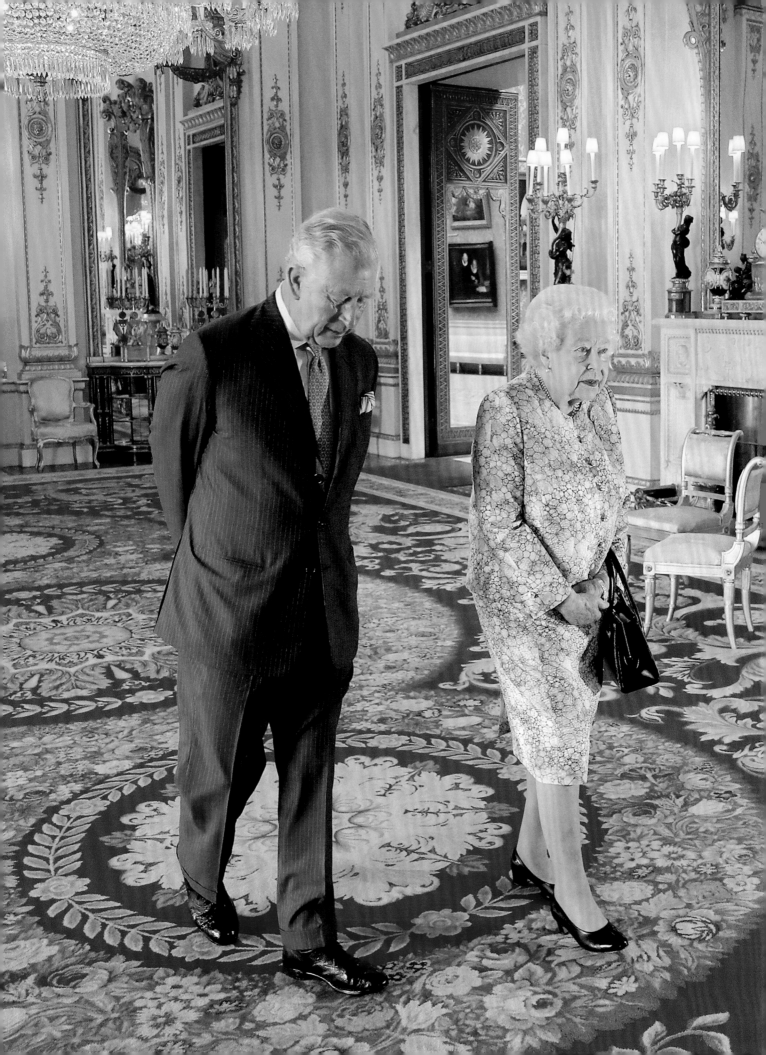

BEFORE A HISTORIC SPEECH

I was shooting a behind-the-scenes project on the Prince of Wales at the age of seventy, when one afternoon in 2018, during the Commonwealth Heads of Government Meeting in London, I was called to Buckingham Palace to photograph the Queen and the Prince of Wales ahead of the Queen's speech to the assembled Commonwealth leaders. The significance of this photo only became apparent after the event: the Queen had endorsed the Prince as the next Head of the Commonwealth, a move ratified at the meeting.

As I was preparing to take this historic photo, the leaders of the Commonwealth arrived and slowly filtered their way into the ballroom. I was near the door, so I was the first person that many of them saw on entry into the room. It was a slightly surreal experience for these instantly recognisable people to greet me with a smile and a nod of the head as they moved past. I suppose it was even more surreal to see all these world leaders queuing to get into a room!

This book is dedicated to my son, Theo.

ACKNOWLEDGMENTS

We put this book together during a strange time for the world. Covid-19 was on everyone's minds, and the UK (and the world) had been through a series of lockdowns. This period, of course, offered very limited "in person" royal duties for me to cover. In many ways, it was an ideal time for me to put this book together. Normally, I would be jetting around the world on a succession of royal tours, but 2020 and 2021 were certainly different. My previous book, *Modern Monarchy*, was written in the back of planes, taxis, and on royal tour buses around the globe, so it was a lovely contrast to be sitting at a desk with only the occasional exclamations of my young son to distract me. The last year has been a seminal moment for the British royal family, adapting to new and challenging ways of working and coping with the sad passing of the Duke of Edinburgh. It is a time of reflection and remembrance for the country. It is also an exciting time with so much to look forward to and an opportunity to celebrate a monarch who remains at the heart of a nation's affections. In 2022, the Queen will celebrate her Platinum Jubilee, and the country will unite behind someone who has steered the ship of monarchy though turbulent times toward a bright future.

Many people worked very hard to put this book together. I am hugely grateful for the professionalism and dedication of my editor, Giulia Di Filippo, at Rizzoli, for putting up with my mad requests at weekends and all hours for a second time. I also thank my publisher, Charles Miers, at Rizzoli, for the opportunity to work on a second book together. I am grateful for the expert eye and design skills of Ray Watkins, whose ideas and ability to dig out images that I had forgotten I had taken were never taken for granted. Eternal thanks to Rory Jerome Hunt for his skills and for his patience at all hours of the day. I would like to acknowledge Lisa Marie Rae at Getty Images for her constant support and opinion, as well as the wider team at Getty Images for allowing me this opportunity—specifically, Ken Mainardis and Kirstin Benson.

I have said it before, and I will say it again: I work on a regular basis with an amazing team of field editors whose patience and skill enable photographers at Getty Images to transmit and edit photos around the world in minutes. I would like to recognise the dedicated team on the Getty Images picture desks around the world and all my colleagues whom I have seen way too little of over the last year. In particular, I thank Rebecca Lewis for keeping the diary organised and making sure that I have had time to work on this book. I am proud to work with such an incredible team at Getty Images for what is rapidly approaching two decades. I look forward to many more years amongst a group of inspiring people who certainly live up to their mission to "move the world with images."

Importantly, I would like to thank the communication teams at both Buckingham Palace and Clarence House—Hannah Howard and her team at Buckingham Palace, and Julian Payne and everyone on the press office team at Clarence House—for their assistance not only with this book but also with the countless royal engagements over the years that we have worked on together. I would also like to thank the Government of Canada for its kind permission to use images from portrait shoots for which I was commissioned.

I express my gratitude to my family, my Mum and Dad, Nick and Sue for their help and support, and Bill Archer for his time and valuable opinion. Above all, I thank my wife, Tash, for her unwavering support and my son, Theo, for keeping me smiling throughout the whole project (despite all the distractions).

Elizabeth II: A Queen for Our Time

First published in the United States of America in 2021 by
Rizzoli International Publications, Inc.
300 Park Avenue South
New York, NY 10010
www.rizzoliusa.com

Publication © 2021 Rizzoli International Publications, Inc.
All photography © 2021 Chris Jackson / Getty Images
Text © 2021 Chris Jackson

Designed by Raymonde Watkins

Publisher: Charles Miers
Editor: Giulia Di Filippo
Text editor: Linda Schofield
Production manager: Alyn Evans

Printed in China

2021 2022 2023 2024 / 10 9 8 7 6 5 4 3 2

ISBN: 978-0-8478-7071-4
Library of Congress Control Number: 2021937248

Visit us online:
Facebook.com/RizzoliNewYork
Twitter: @Rizzoli_Books
Instagram.com/RizzoliBooks
Pinterest.com/RizzoliBooks
Youtube.com/user/RizzoliNY
Issuu.com/Rizzoli

RIGHT: The Queen waves as she leaves
St Macartin's Cathedral in Enniskillen,
Northern Ireland, after a visit on
26 June 2012.

FRONT COVER: Queen Elizabeth II poses
for an official portrait at Windsor Castle.
Her Majesty is wearing her Canadian insignia
as Sovereign of the Order of Canada and the
Order of Military Merit. She is also wearing the
King George VI Victorian Suite, a diamond and
blue sapphire necklace and earrings that were
given to her by her father, King George VI,
as a wedding present in 1947. The jewels date
back to circa 1850; the matching tiara and
bracelet were added to the suite in 1963.

BACK COVER: Queen Elizabeth II signs the visitors'
book at the Royal College of Physicians in
London on occasion of the 500th anniversary
of the institution's founding charter.

FSC
www.fsc.org
MIX
Paper from
responsible sources
FSC™ C007683